Mountain Ranch

NUMBER 24 // THE M. K. BROWN RANGE LIFE SERIES

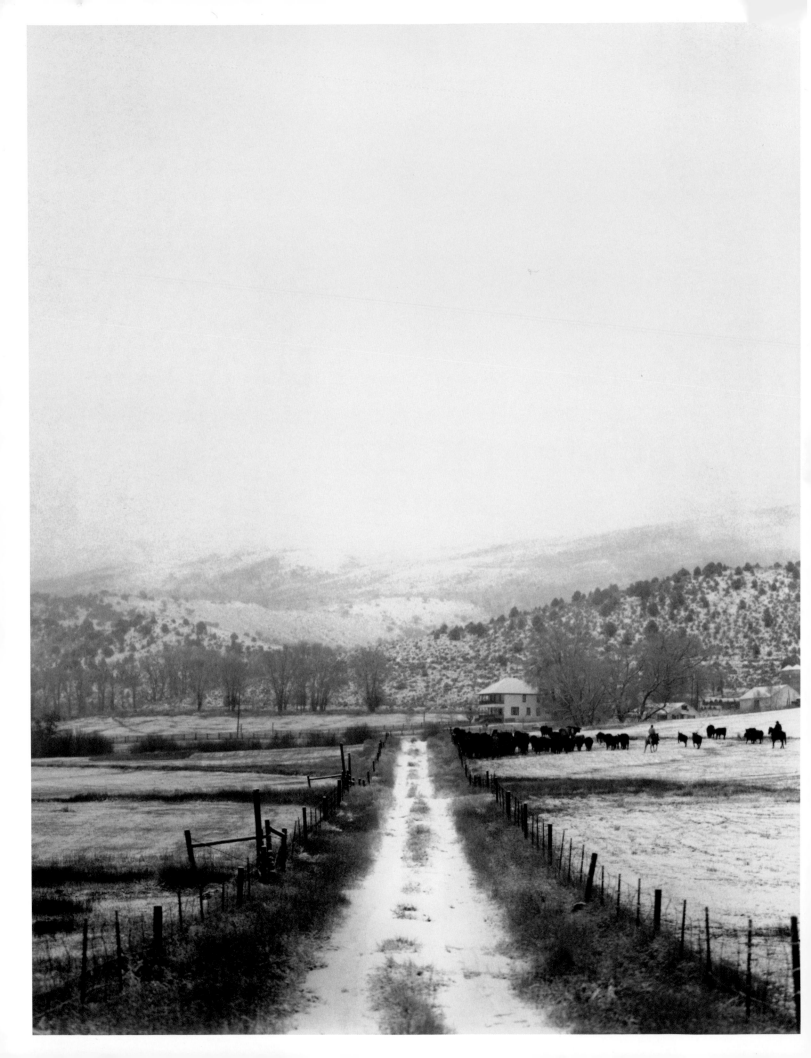

Mountain Ranch

MICHAEL CROUSER

Foreword by Gretel Ehrlich

UNIVERSITY OF TEXAS PRESS ◆ AUSTIN

Copyright © 2017 by the University of Texas Press
Photographs © 2017 by Michael Crouser
Foreword © 2017 by Gretel Ehrlich
All rights reserved
Printed in China
First edition, 2017

Requests for permission to reproduce material from this
work should be sent to:
 Permissions
 University of Texas Press
 P.O. Box 7819
 Austin, TX 78713-7819
 http://utpress.utexas.edu/index.php/rp-form

♾ The paper used in this book meets the minimum requirements
of ANSI/NISO z39.48–1992 (R1997) (Permanence of Paper).

Library of Congress Cataloging-in-Publication Data

Names: Crouser, Michael, author, photographer. |
Ehrlich, Gretel, writer of supplementary textual content.
Title: Mountain Ranch / Michael Crouser; foreword by Gretel Ehrlich.
Other titles: M. K. Brown range life series ; no. 24.
Description: First edition. | Austin : University of Texas Press, 2017. |
Series: The M. K. Brown range life series ; number twenty-four
Identifiers: LCCN 2016045433 | ISBN 978-1-4773-1293-3 (cloth : alk. paper) |
ISBN 978-1-4773-1384-8 (library e-book) | ISBN 978-1-4773-1385-5 (nonlibrary e-book)
Subjects: LCSH: Ranches—Colorado—Pictorial works. | Ranch life—Colorado—Pictorial works. |
Cowboys—Colorado—Pictorial works. | Colorado—Social life and customs—Pictorial works.
Classification: LCC F776 .C76 2017 | DDC 978.80022/2—dc23
LC record available at https://lccn.loc.gov/2016045433
doi:10.7560/312933

CONTENTS

FOREWORD // GRETEL EHRLICH

Rain mixed with snow comes like a whisper that spreads over the range. Meadows bend up into mountains where rain thickens and blows down white. Sudden quiet, then horses and riders bob up and down in threads of sun and cloud. Aspens shake: leaves and snow. This is the time of year when cattle are gathered off summer ranges and trailed home, and the whole world slows.

Michael Crouser's photographs give us these kinds of intimacies. His compendium of images in *Mountain Ranch* are an essay holding these quiet stories. A long road is littered with scudding leaves, and we enter the singular world of an isolated mountain ranch. Intimacy with a place and the beings that inhabit it takes time, and it's clear that Michael Crouser has gone through many seasons with these hard-working souls. Working dogs, using horses, calves and cows . . . generations of ranchers and the cowboys who come to do daywork, the old, the young, the married, the single, children, women, young men, girls, and boys—all are dedicated to the hard work of nurturing land and animals in the mountains of northwestern Colorado, where not much has changed over the years.

Some cold mornings mist rises from the creeks, and then sun comes on strong. That long road littered with scudding leaves brings us into the season. A man climbs onto his horse, leg half over, hoping the horse won't buck until he gets all the way on it. His working dog, a Queensland heeler, follows. The morning is quiet. He and one other rider trail in the herd. Quiet days are like a foot tapping, counting time until snow flies and stays. After "the gather" is down on the meadow near headquarters, cattle are sorted, strays are sent to their proper owners, calves are weaned and shipped, and the ranch goes loud with mother cows bellowing for their lost progeny. Soon enough, all is quiet again. Woodstoves and kerosene lamps are lit. Day after day, on nearby ranches, more cattle are gathered and trailed to sorting corrals. Snow starts and stops. Sunshine drives down out of clouds, and aspens light up with orange leaf fire. There's a hiatus before feeding and calving begin. Saddles and bridles are fixed, new reins are cut out of large hides, and a few hands go to town for fun, if there is a town nearby.

The ranches where Michael Crouser so affectionately captures these scenes tell a story of staying power, of joy in the beauty of the world, of gratitude for the working animals—the dogs and the horses—of midwifery and husbandry, of seeing the seasons through. Later in the year—sometimes February, or March or April—calving begins. Long nights are spent watching the moon shrink and glow while checking first-calf heifers, making sure all is going well. Patience is required, as is the ability to act quickly when a cow with birthing problems turns the calving barn into a triage unit. Calving is intense and goes on for a month or so. As winter comes on strong and the snow piles up, work horses are harnessed and hay is loaded and pulled across the fields. The cowboys cut the baling strings and push hay off the back of the wagon as it bumps across rough ground in long lines, to and fro. The mother cows and young calves come running.

Wet snow, hot days, frigid nights, broken fences, new calves, sick calves, dead calves . . . spring is here! Branding time means saddling horses that haven't been ridden lately. Colts buck out across the meadow; calves gambol; mother cows look on anxiously. It's branding time, and all the neighbors gather together to help. Food is laid out—meat, potato salad, green salad, fresh-baked rolls, pies, and cakes. Ropers practice their loops, cattle are moved into small corrals, and calves are roped from the herd and dragged to the fire. Afterward, the feast begins, and sometimes a baseball game, a dance, or a just an afternoon party where the stories of winter are traded, where teasing goes on, beer is passed, and laughter erupts everywhere.

As the days lengthen, meltwater comes down from the high mountains, fields are irrigated with tarp dams set in ditches, and water floods into the green fields. Miles and miles of fence are fixed. It's lots of work, but the air is filled with the scent of things growing, of cottonwoods and aspens leafing out, and the cowboy stands still for a moment, happy to have, as ranch hands say, "made it to green grass again," happy to be alive.

Spring is when ranchers saddle up every day and move "pairs"—mother cows and calves—out on spring range. As the weeks go on, they take the cattle into ever-higher terrain, entering the cathedrals of aspen as torrents of snowmelt race by. Cold-weather grasses, such as June grass and alpine fescue, come up first, and then the warm-season bunch grasses grow tall. The sun is hot. The last high cornices of mountain snow begin to melt, and there's a vitality in the way the horses buck on frosty mornings. By summer, the cows, calves, young horses, and working dogs have settled into the long days when first light comes at four thirty in the morning and stays until ten at night. Meteor showers punctuate loneliness, and on one cold night as early as July, northern lights unspool and pulse. Pendleton blankets are piled on at line camp. Long before the autumnal equinox, winter is on its way.

Mountain Ranch is a quiet book of brief histories and richly detailed images: a horse's hind legs kicking, two cow dogs jumping off the feed wagon, a draft horse being shod, a calf book being checked, a bronc being ridden, and cattle and riders moving through narrow lanes of sunlight, snow, and the white trunks of a tree-glutted mountainside. A rancher's life is all about maternity—bringing newborns into the world, feeding and nurturing them—and about harvesting sunlight and grass. To live this life is to be swept into the loose symphony of long seasons, of fading and brightening light, of difficult weather smoothing out into long summer days.

An essayist, a historian, and a witness, Michael Crouser shows us how to see. It is a pleasure to be brought into this out-of-the-way part of the world with such understated passion.

Mountain Ranch

// THE PHOTOGRAPHS

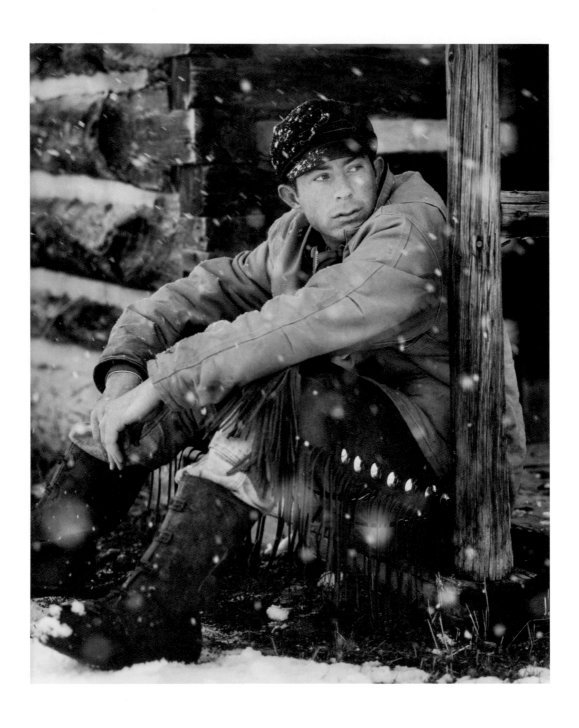

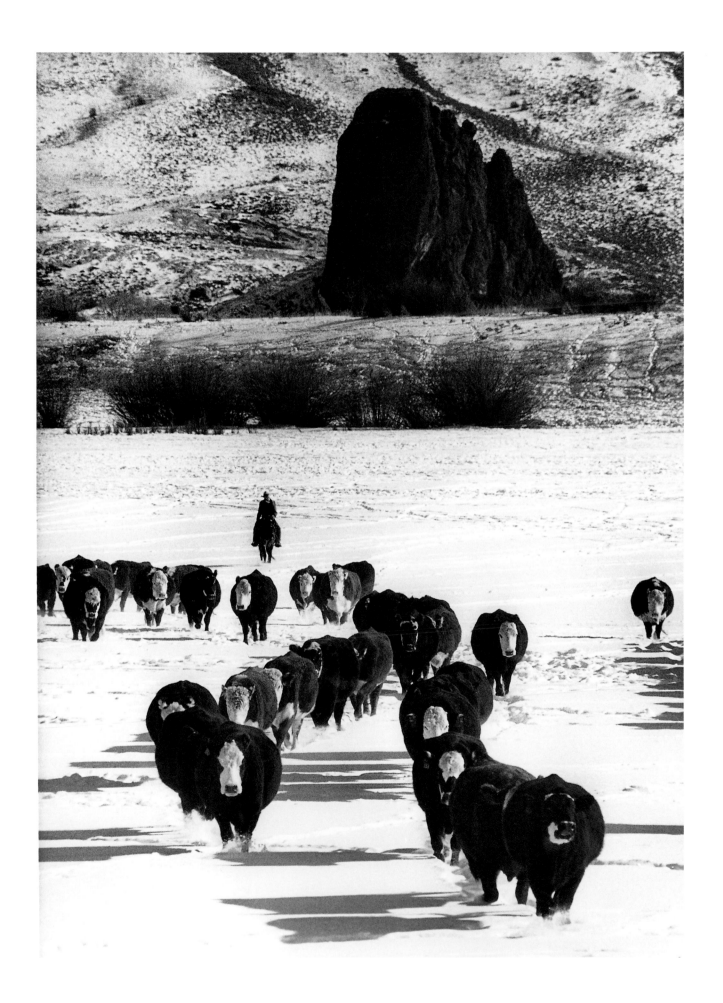

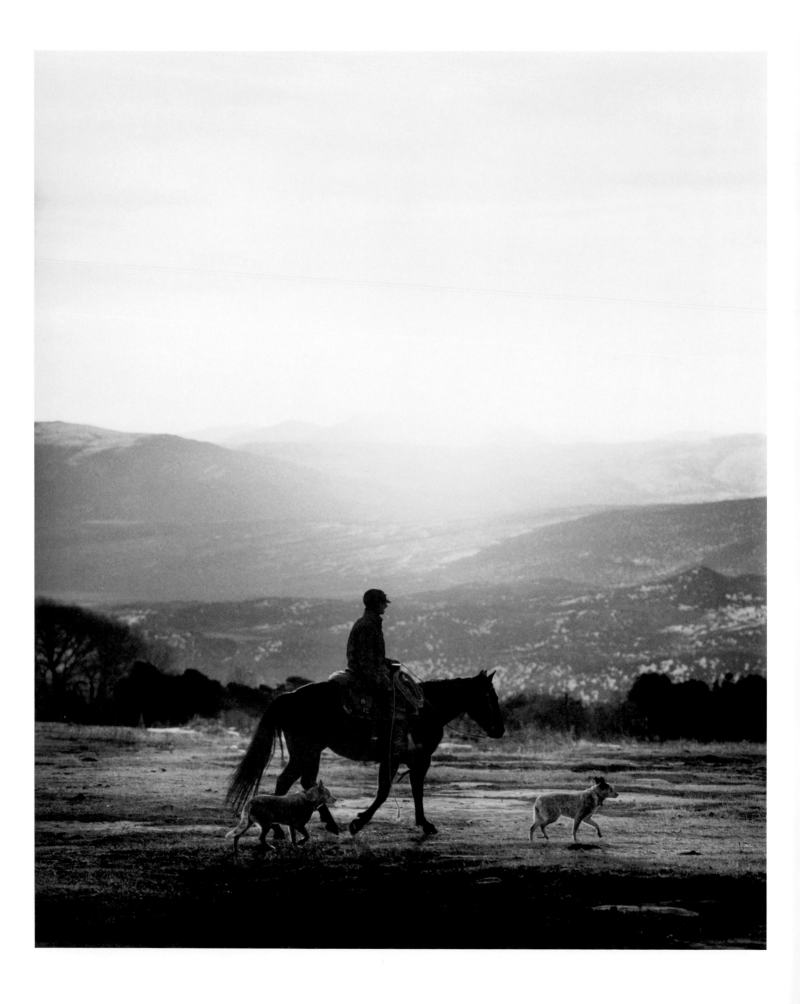

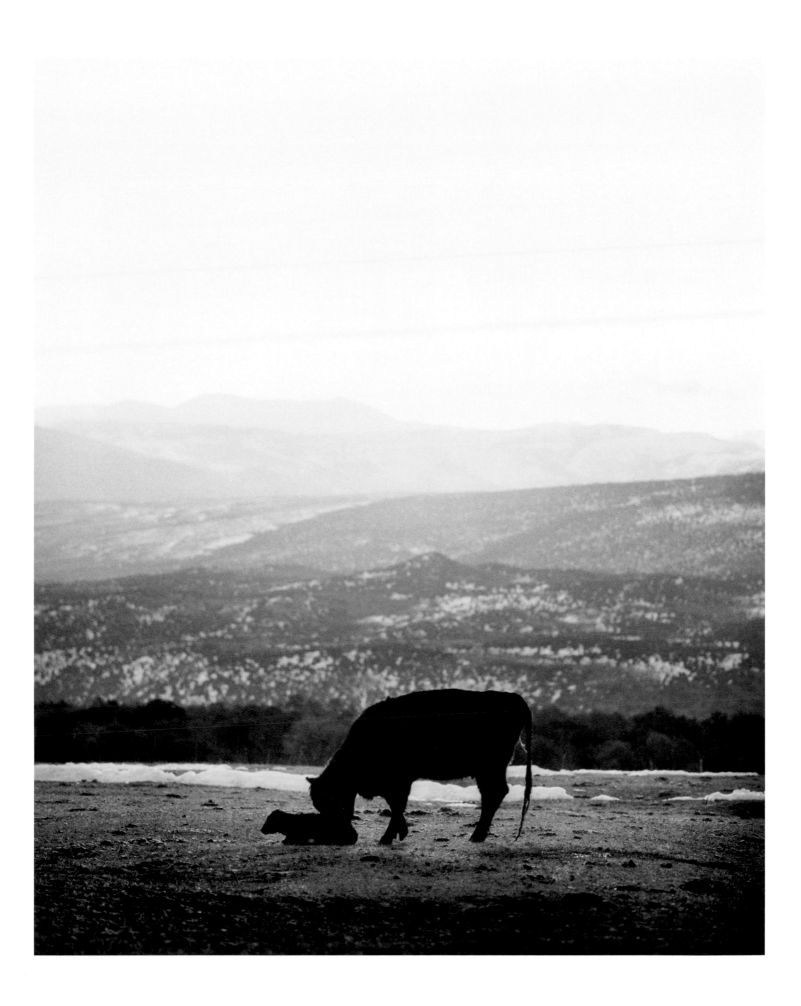

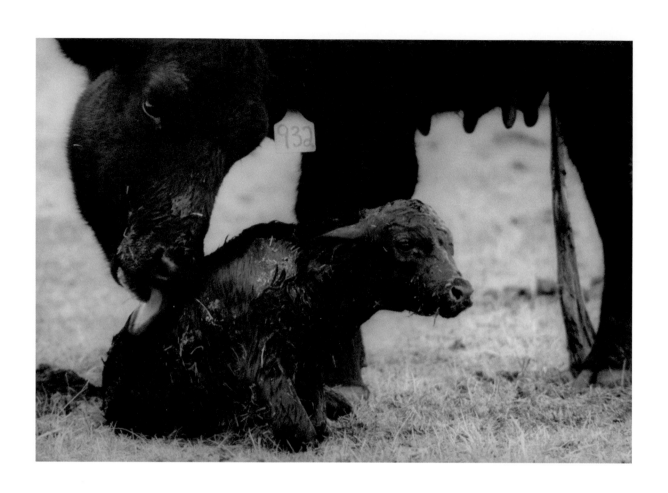

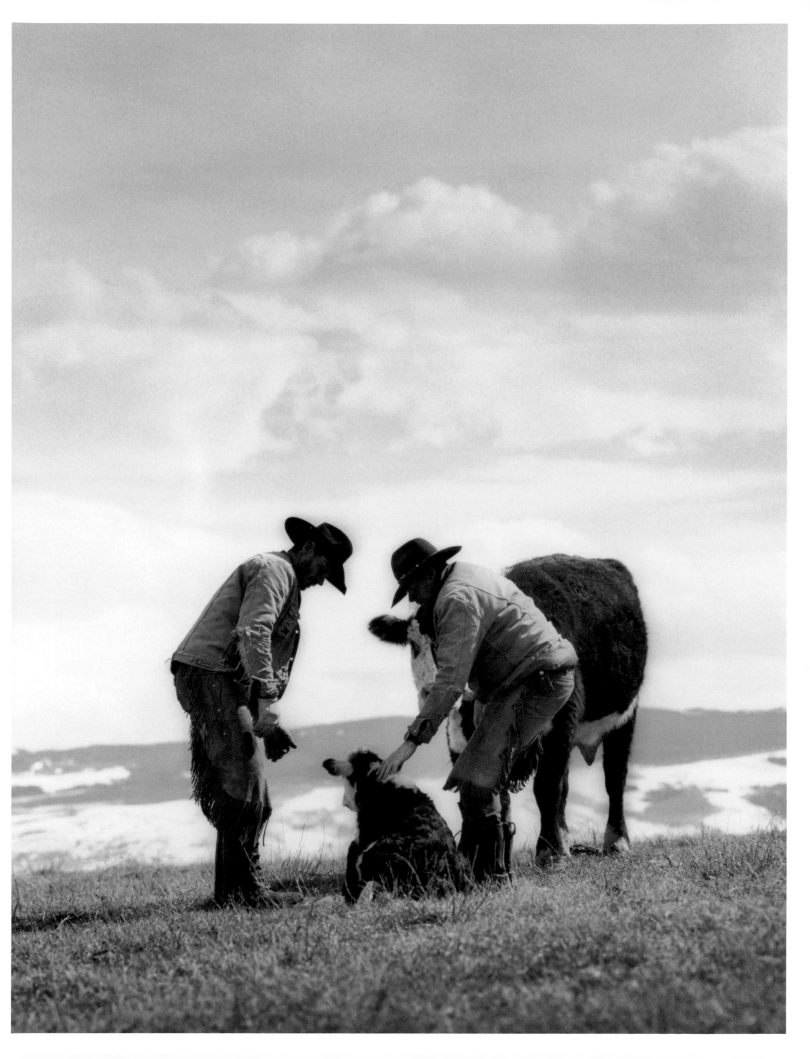

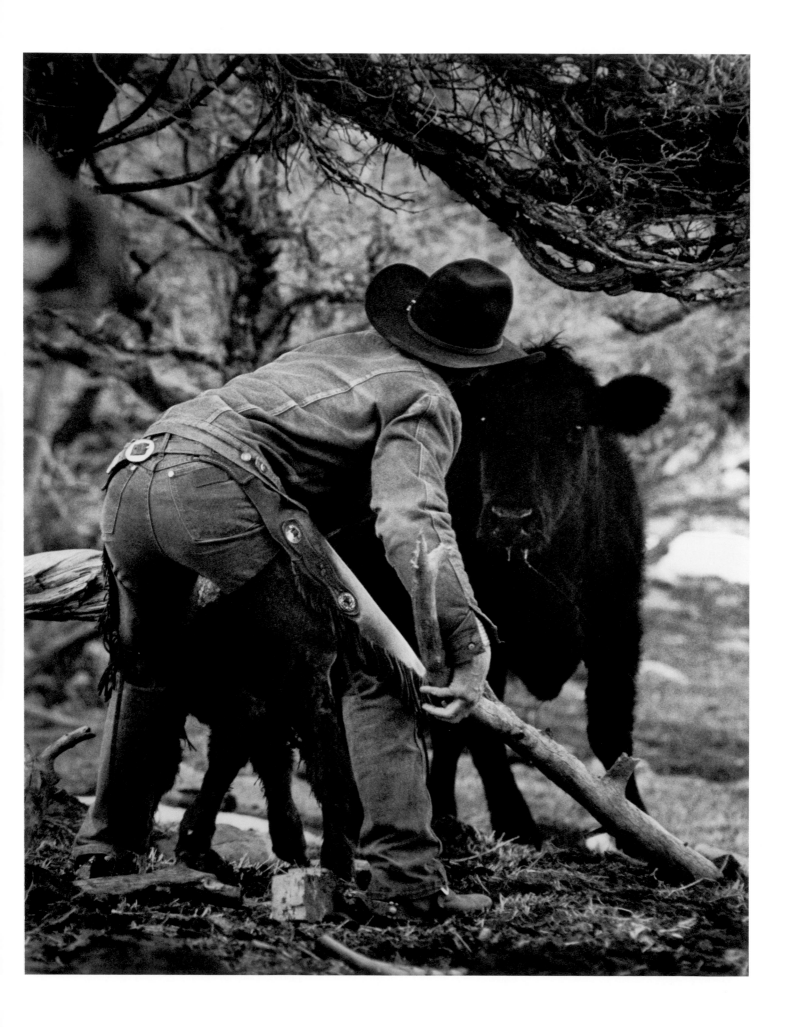

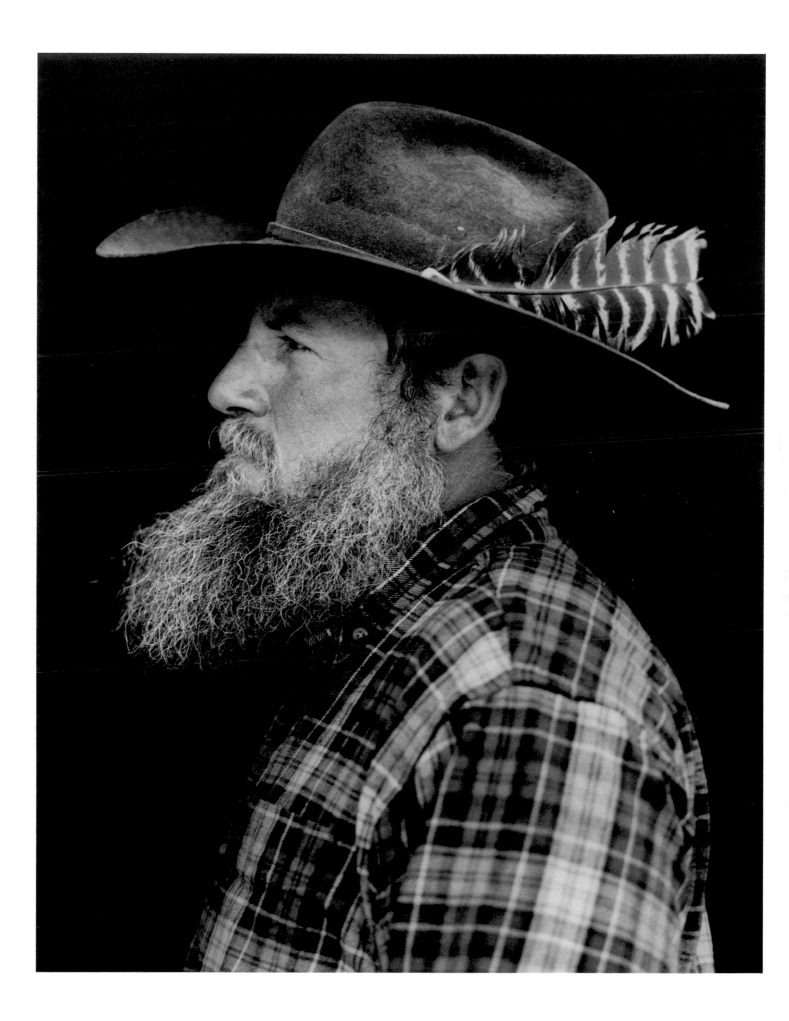

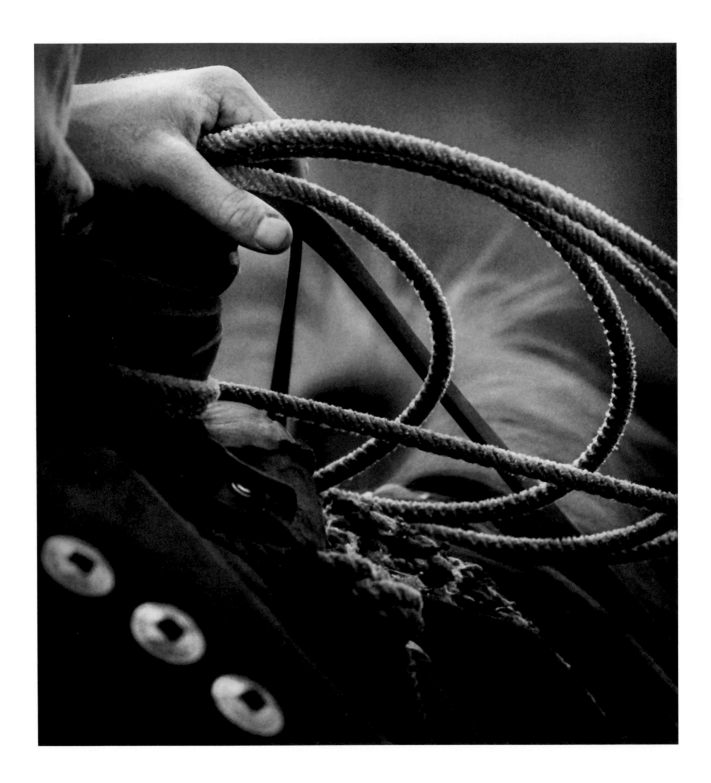

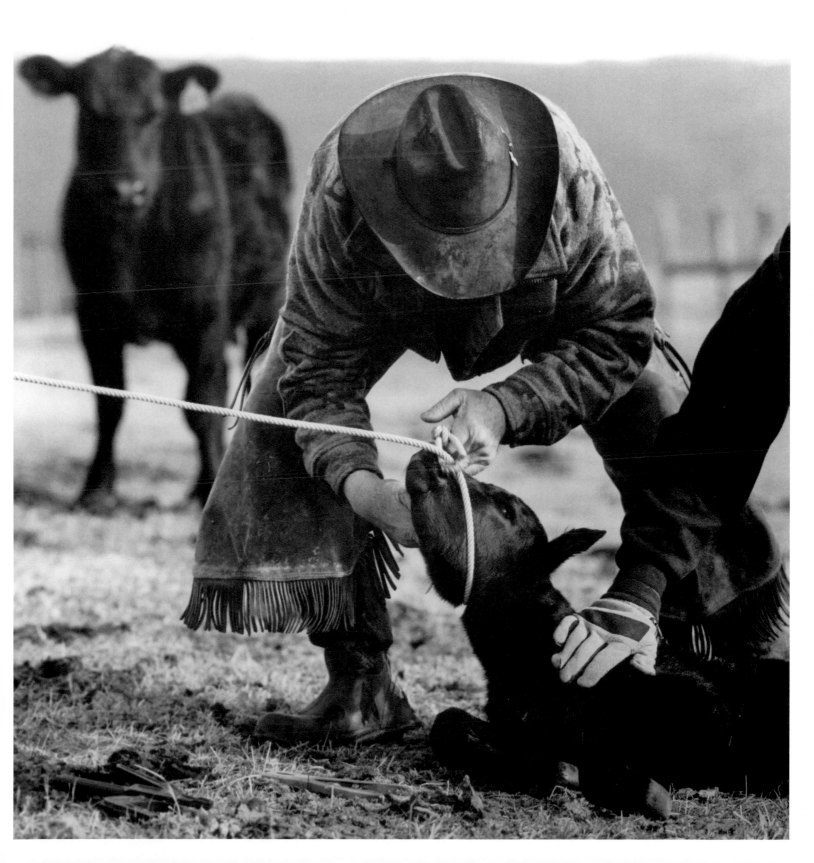

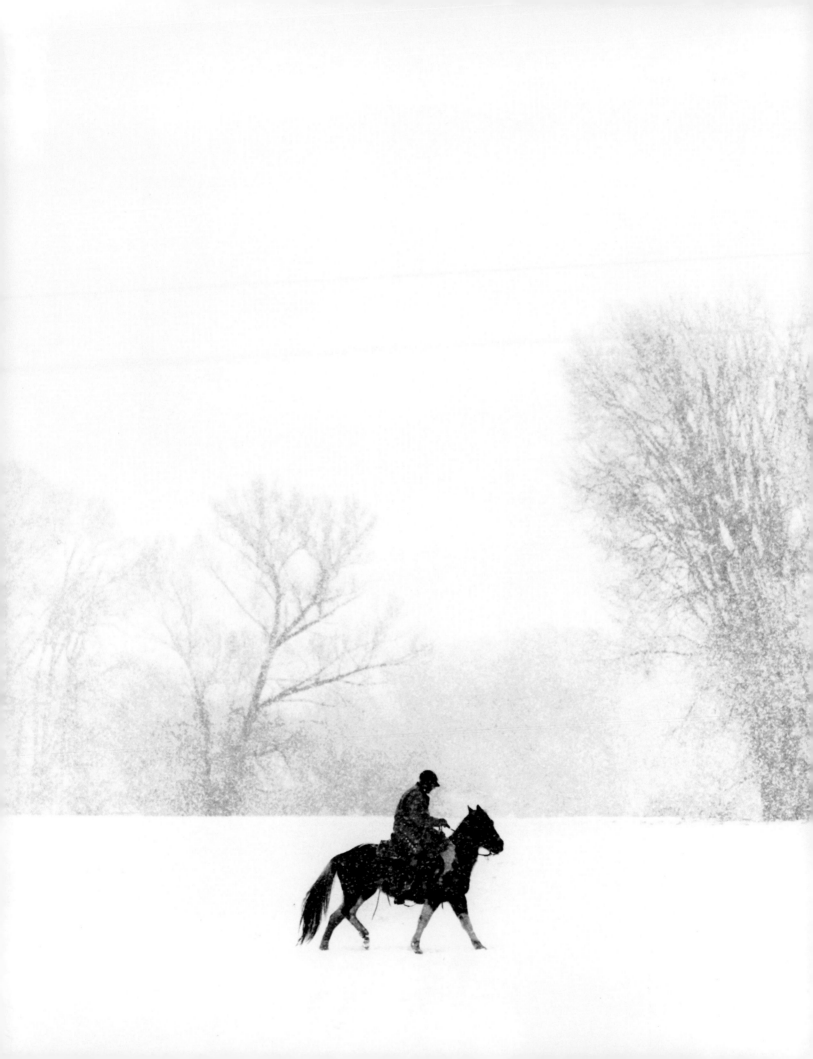

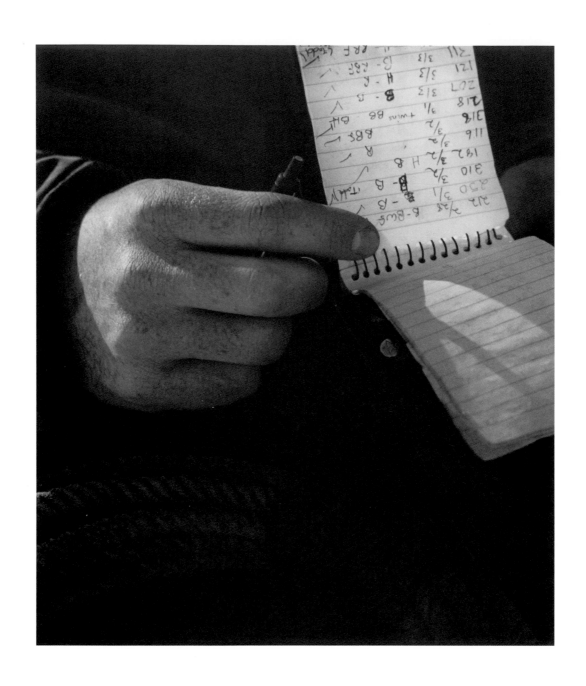

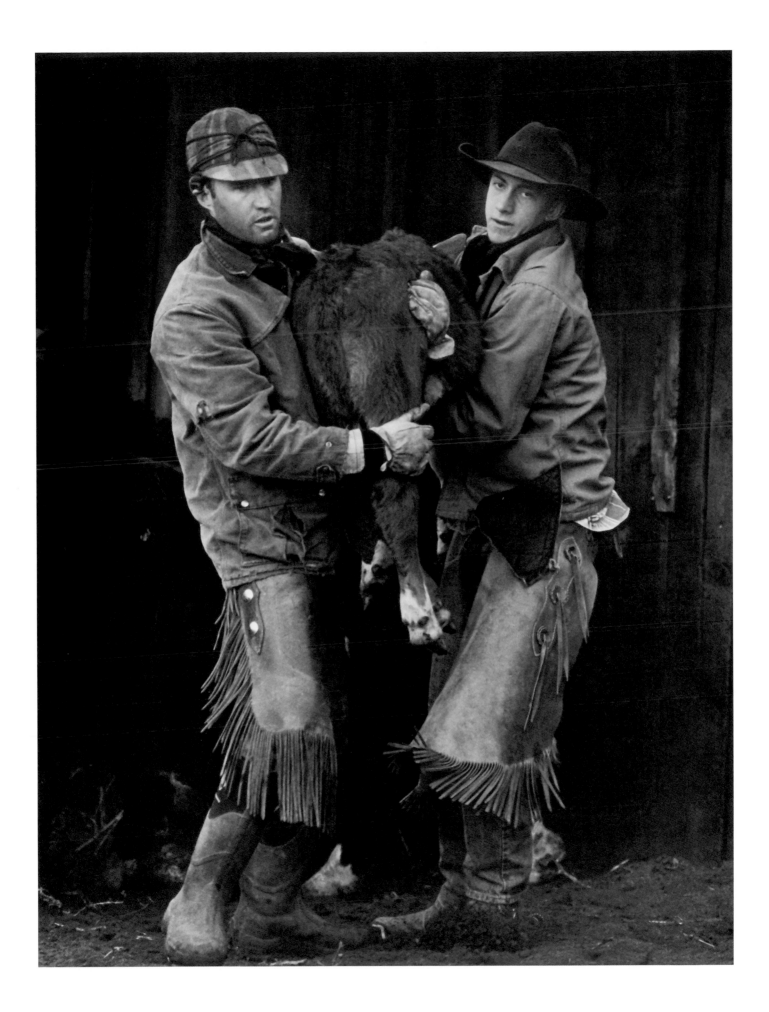

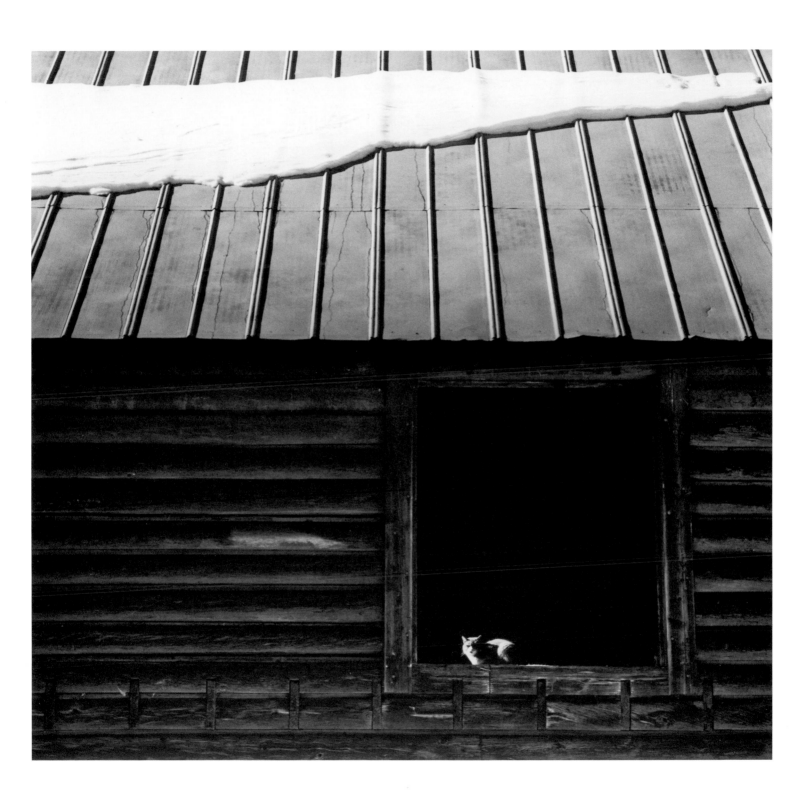

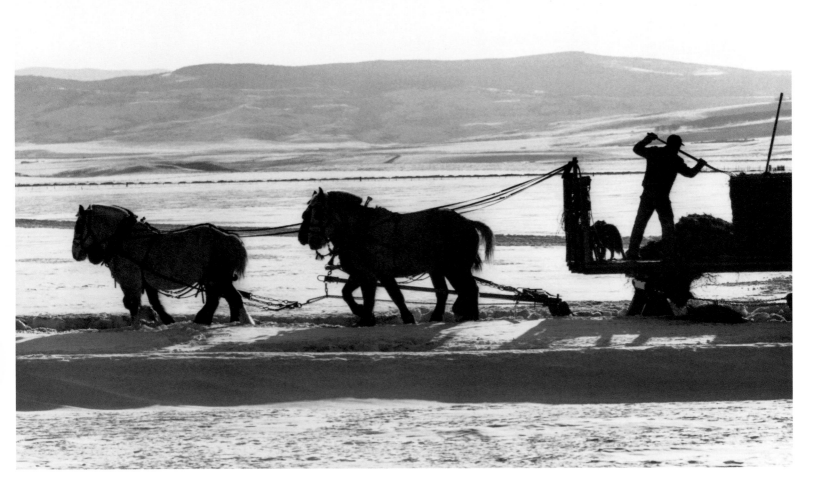

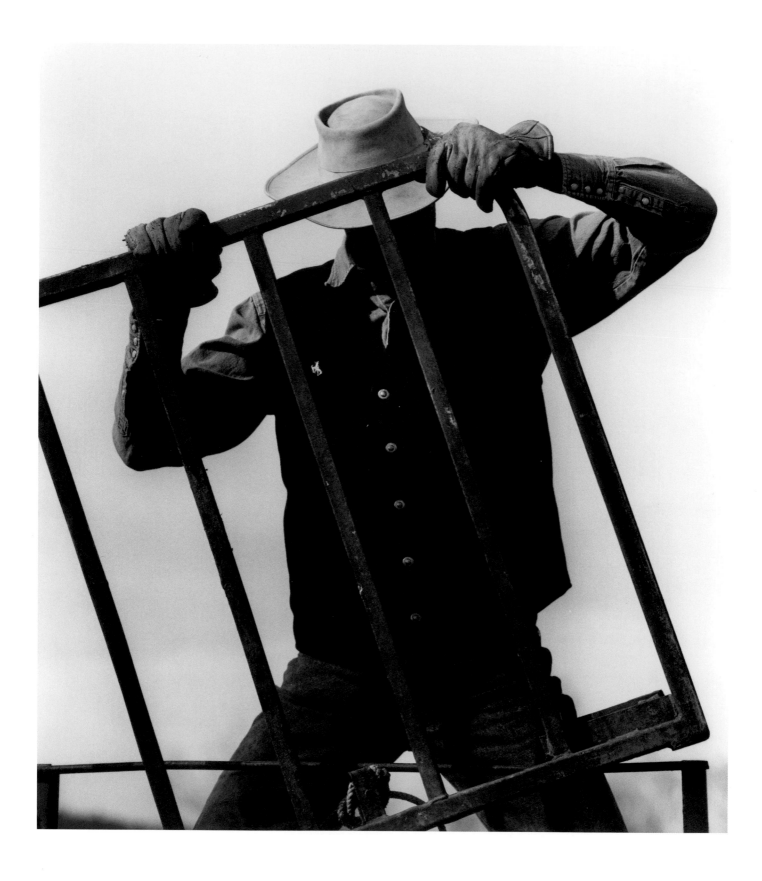

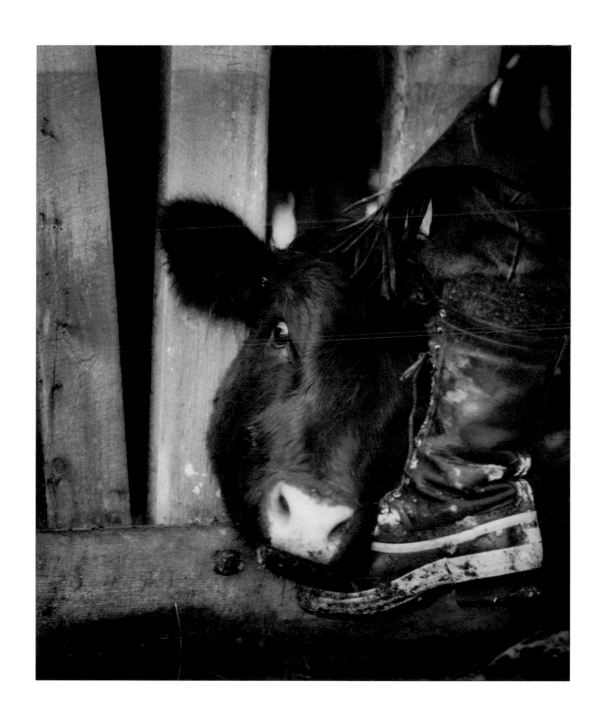

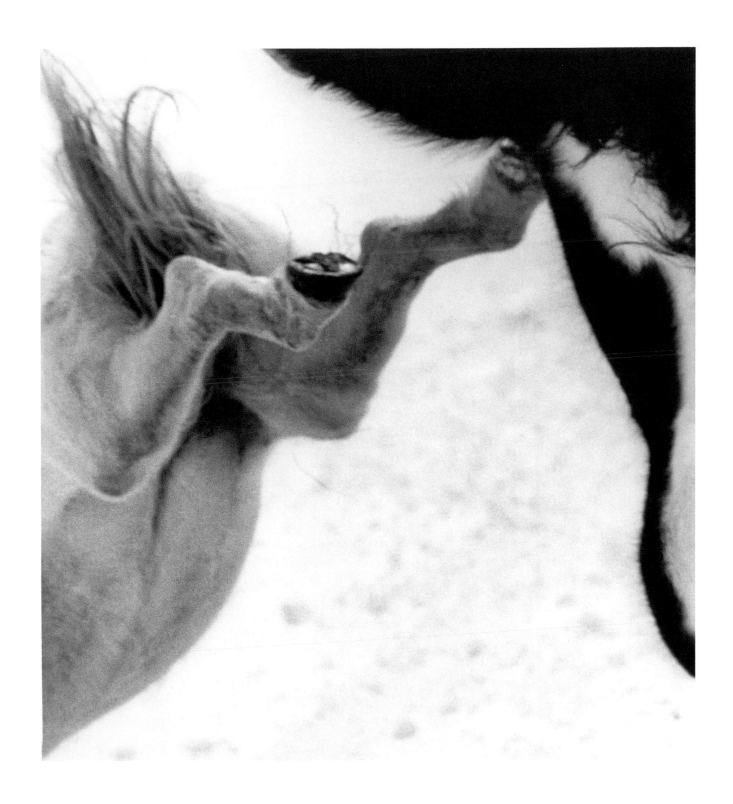

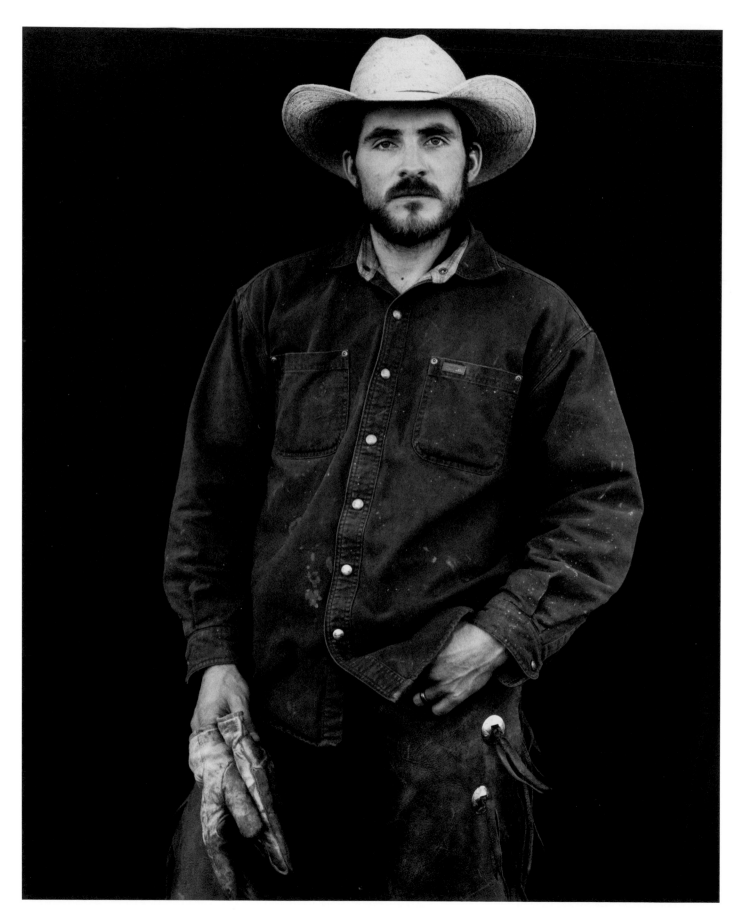

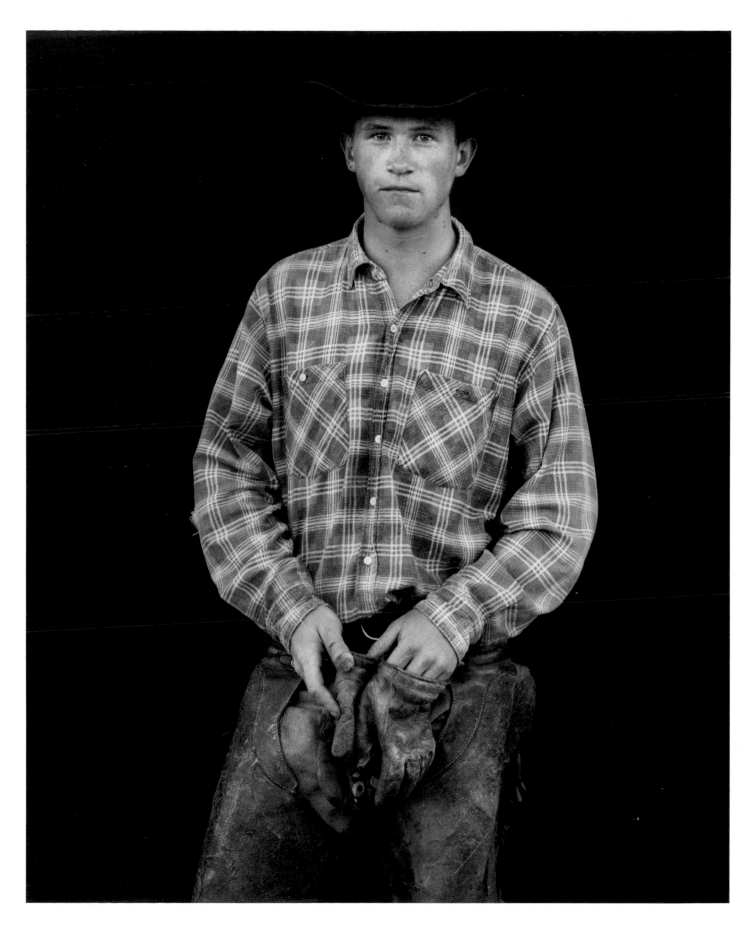

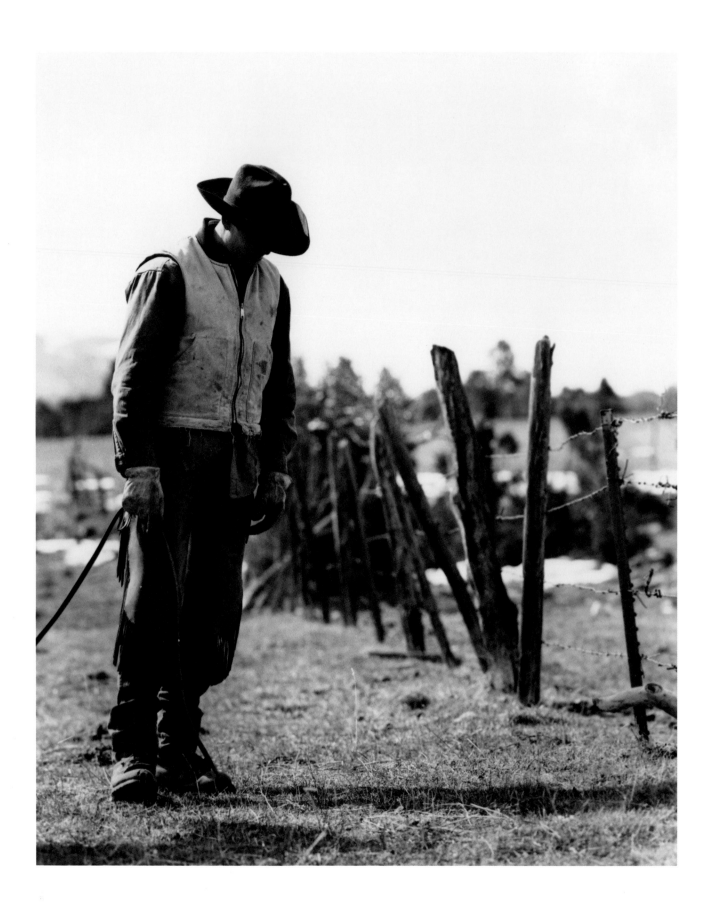

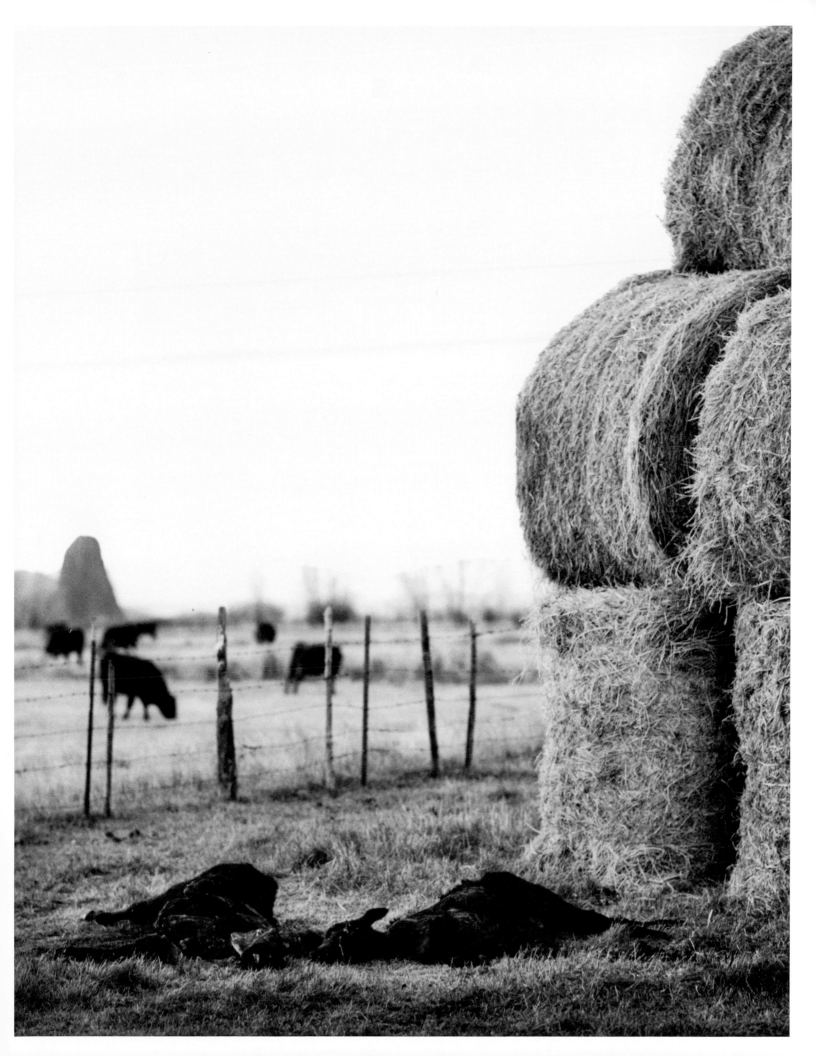

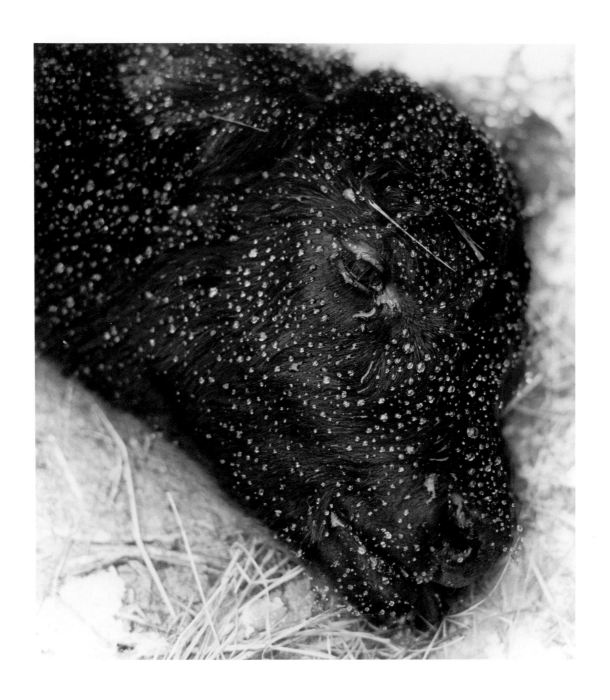

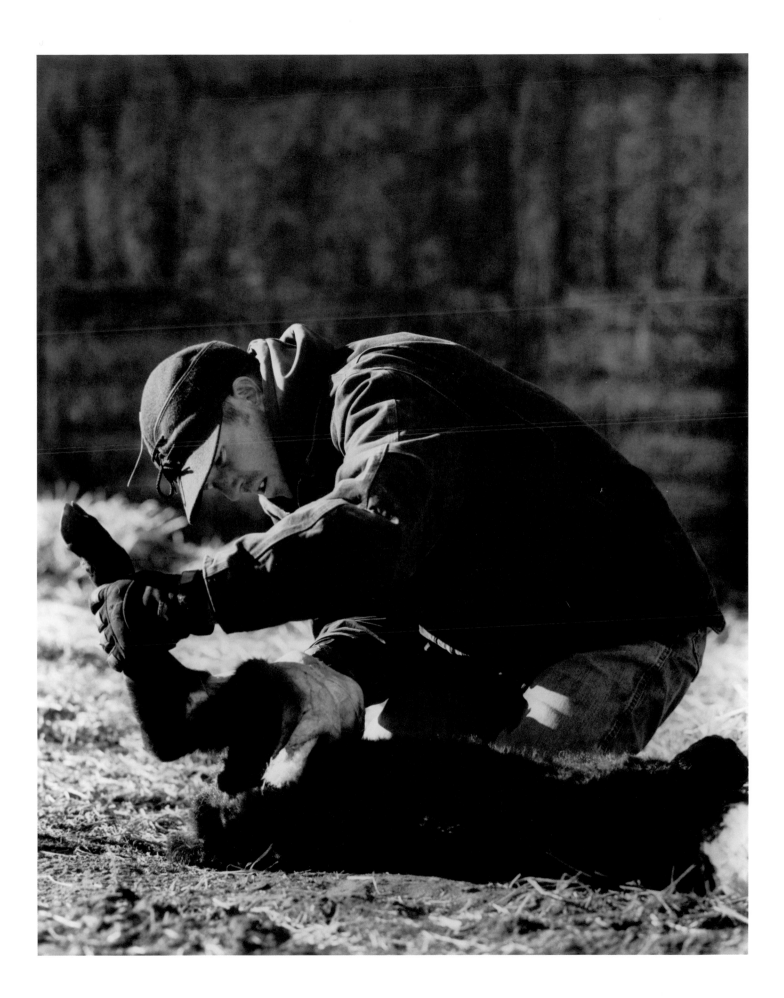

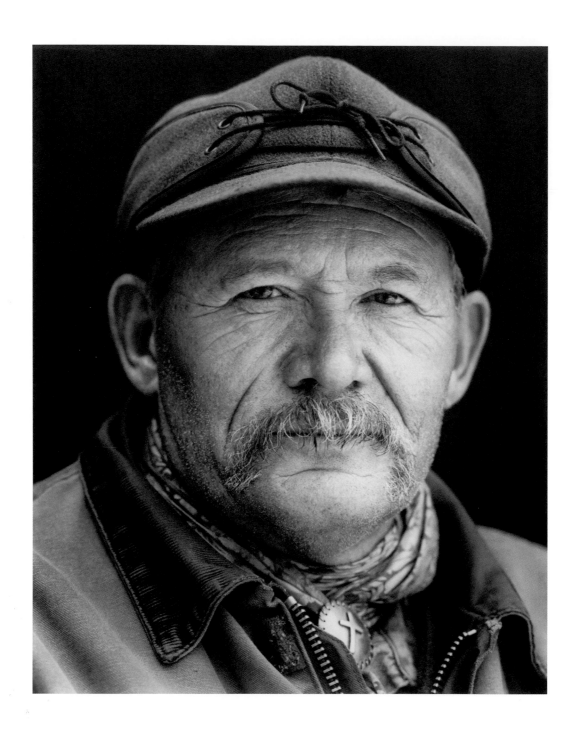

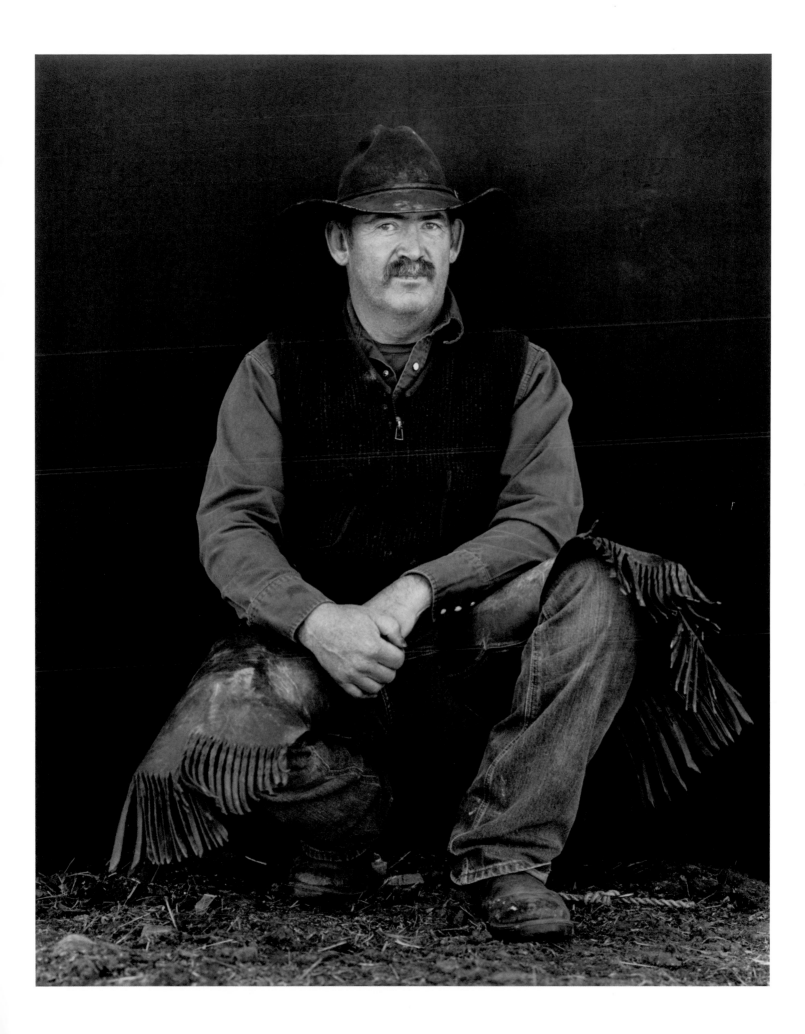

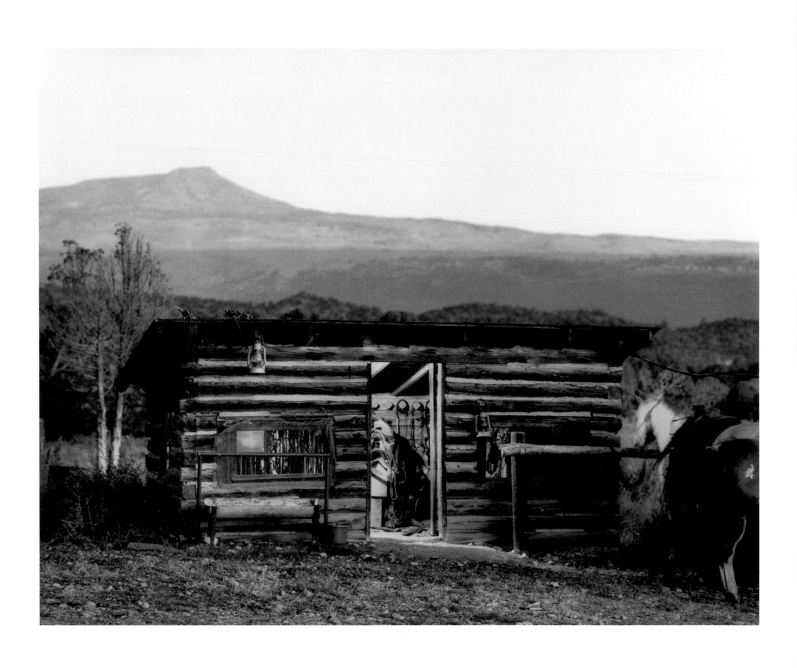

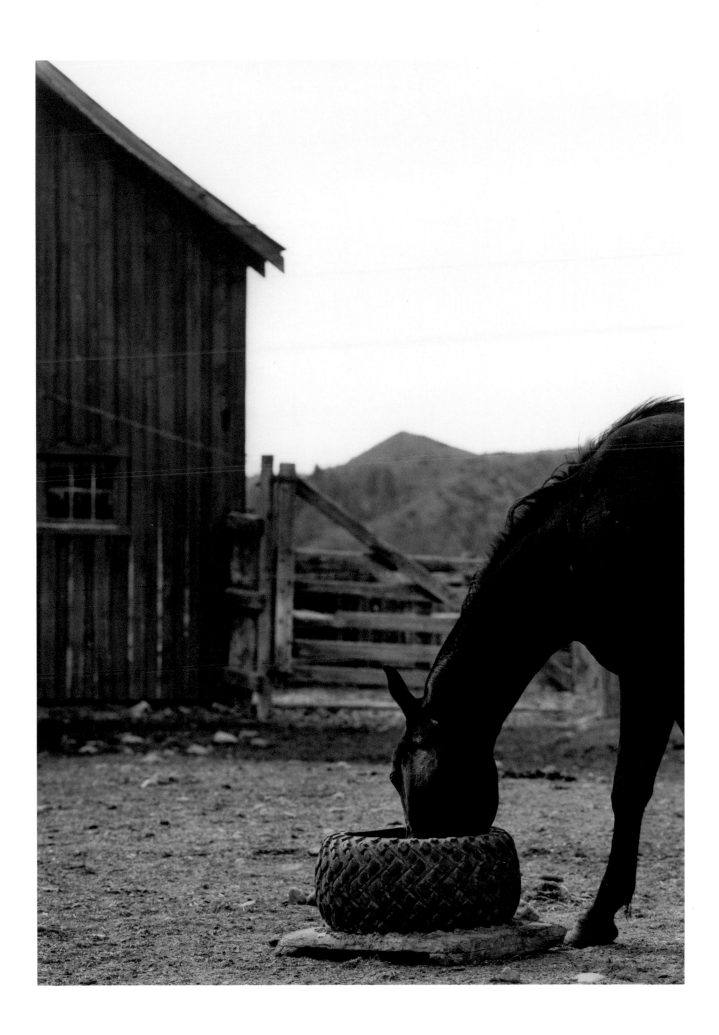

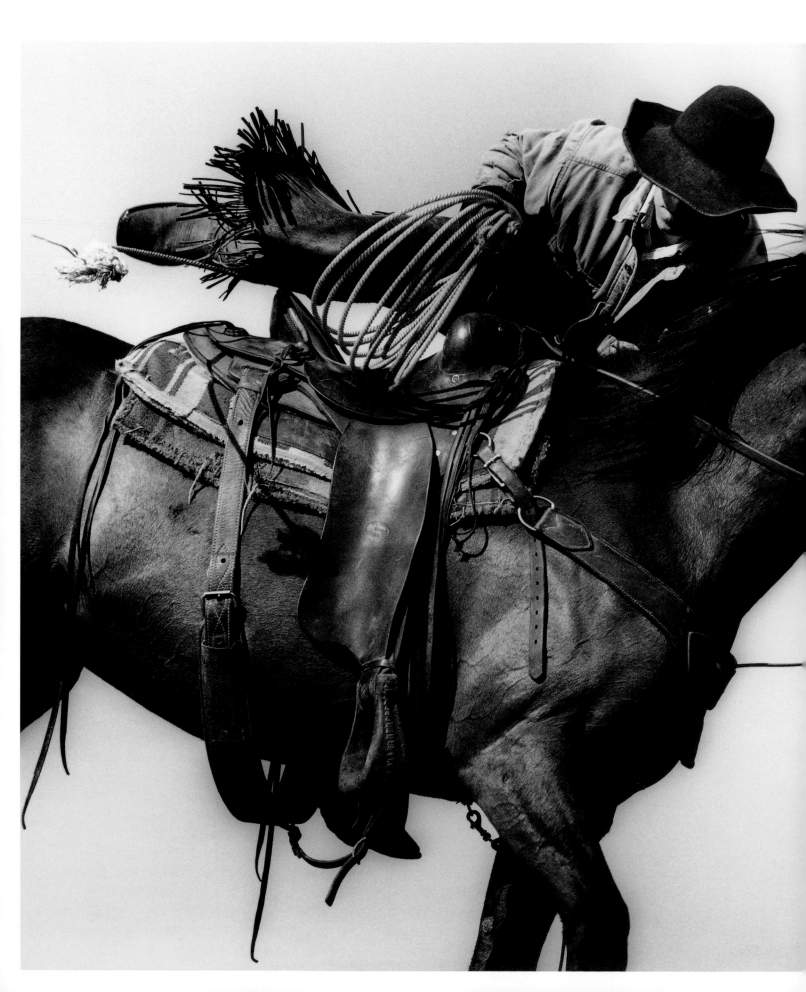

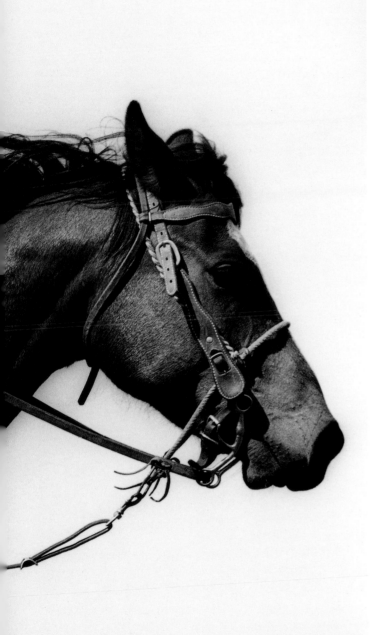

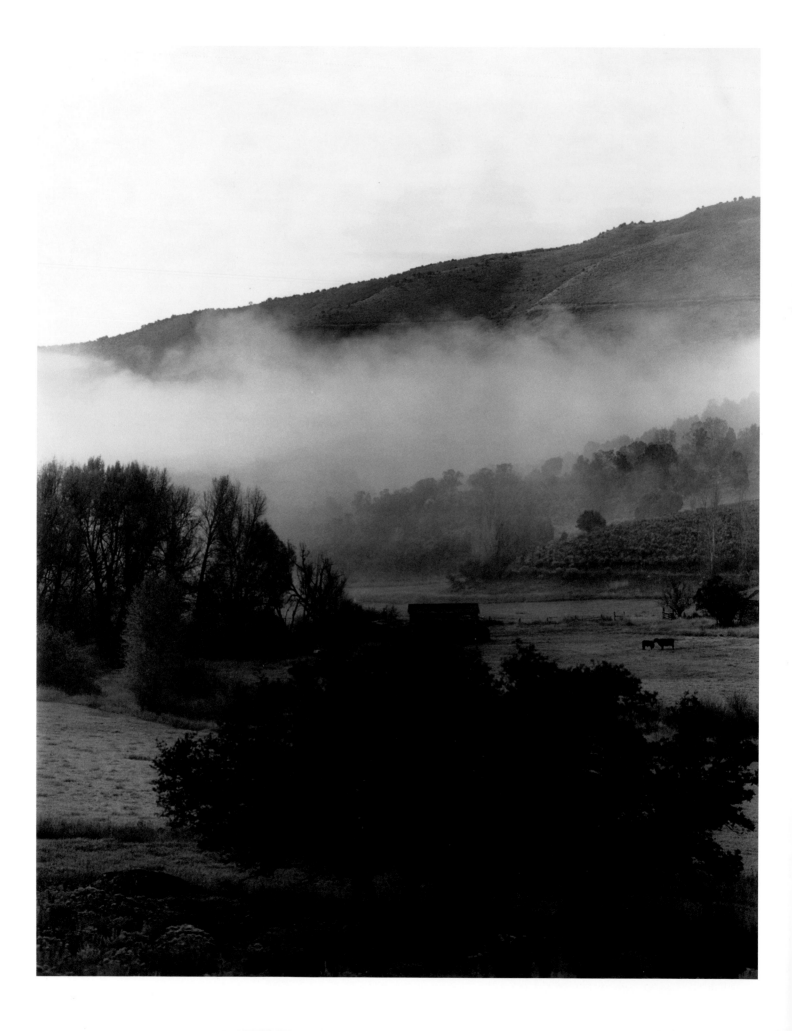

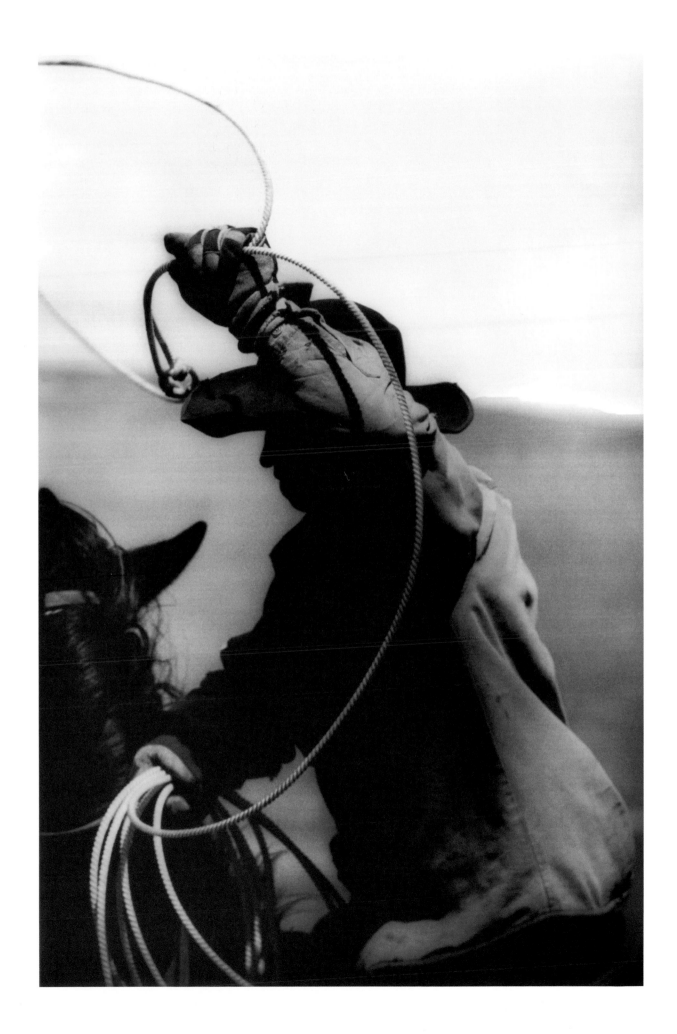

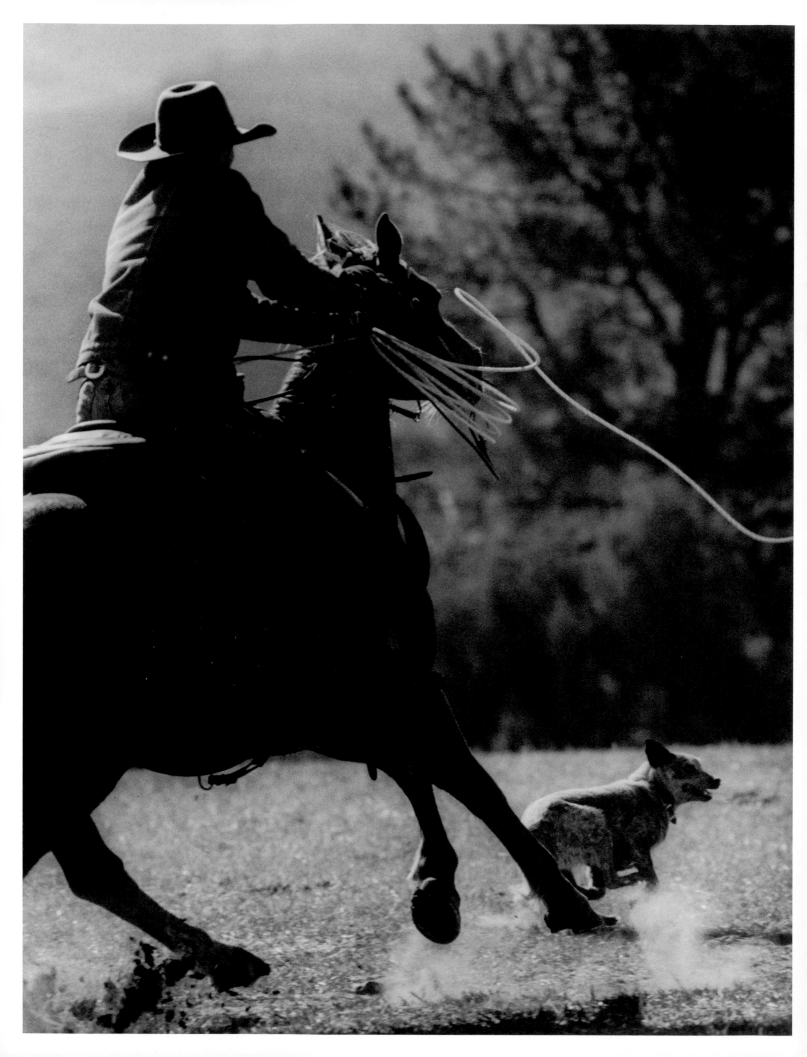

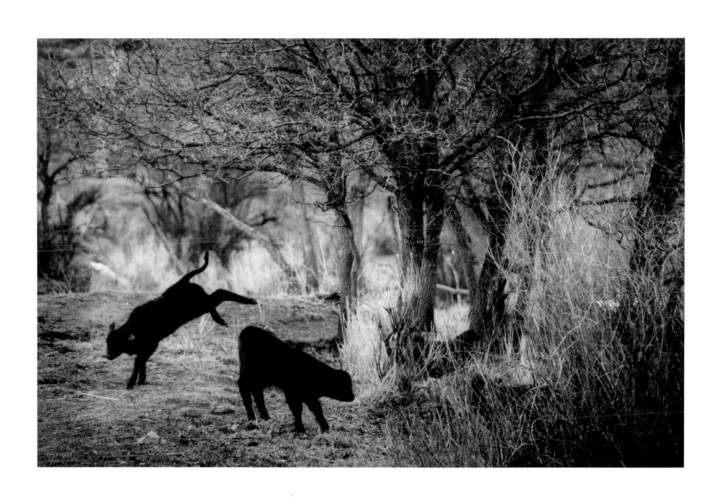

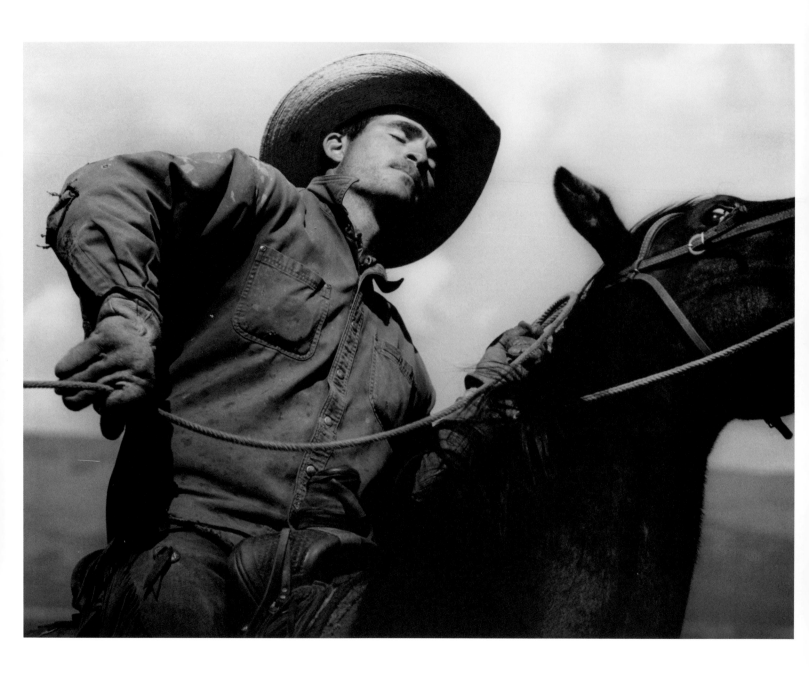

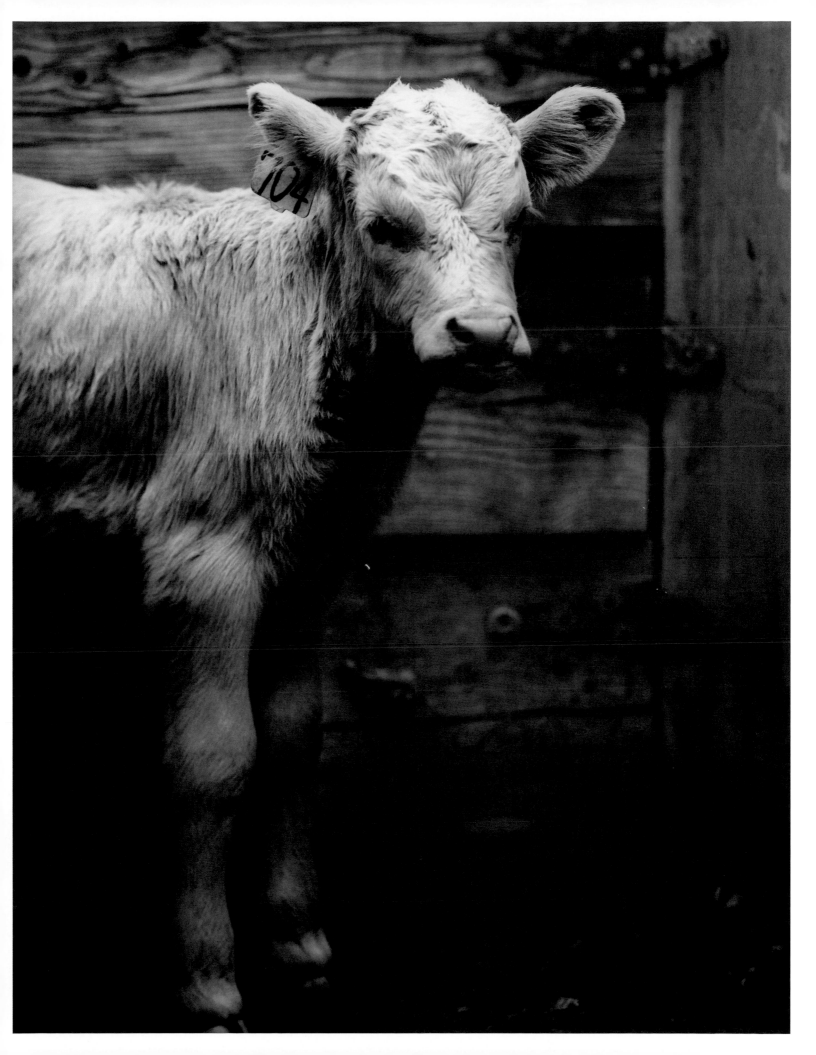

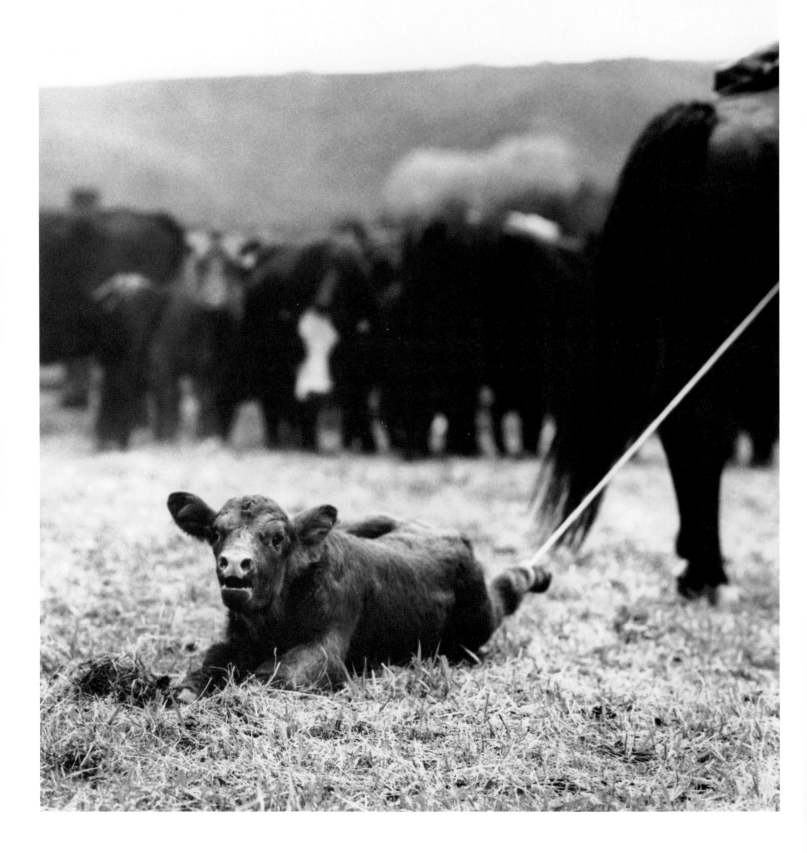

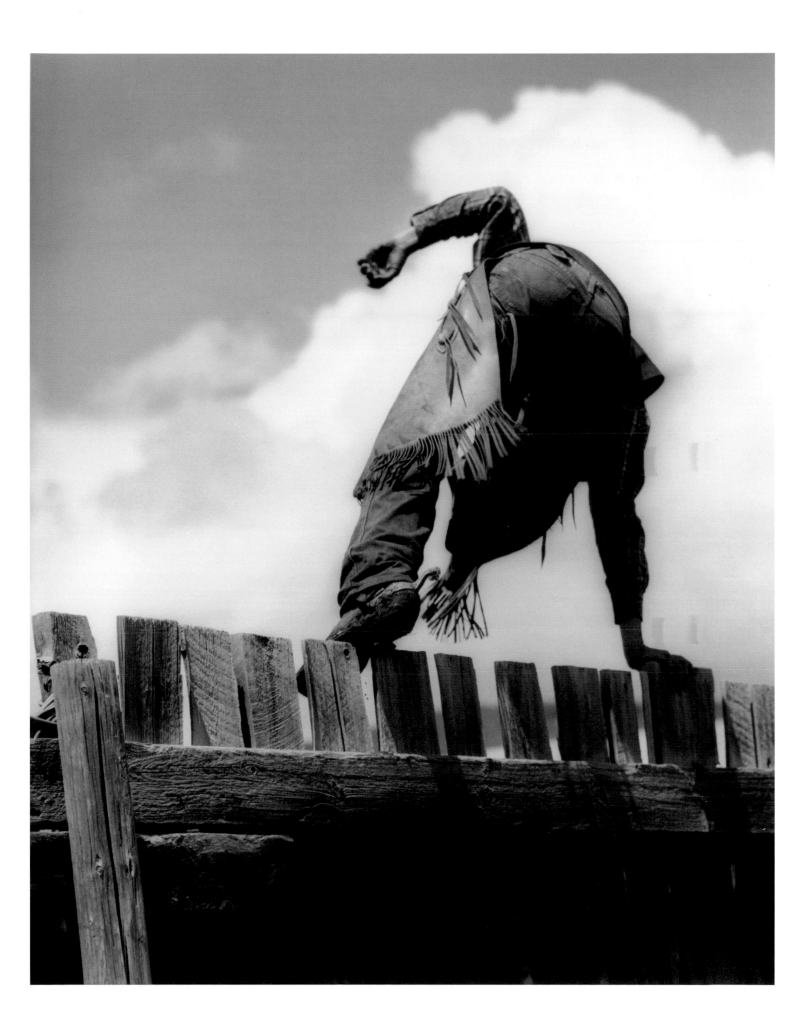

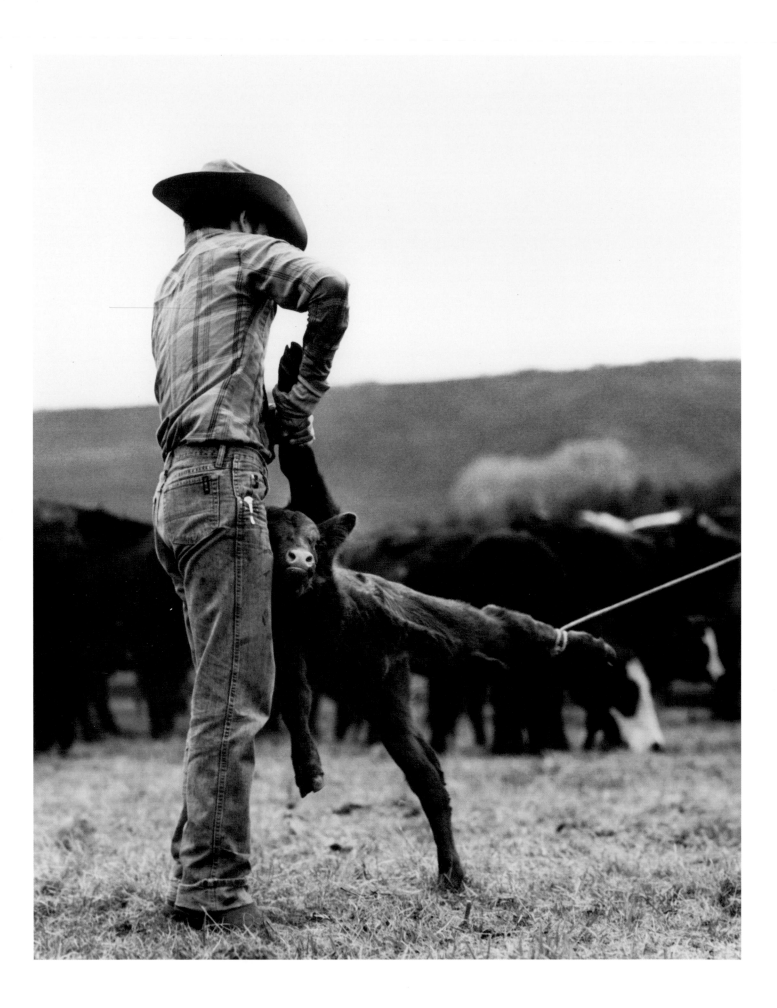

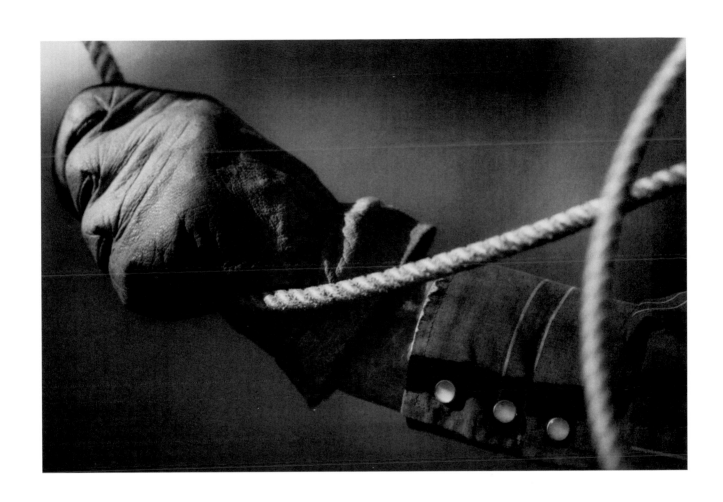

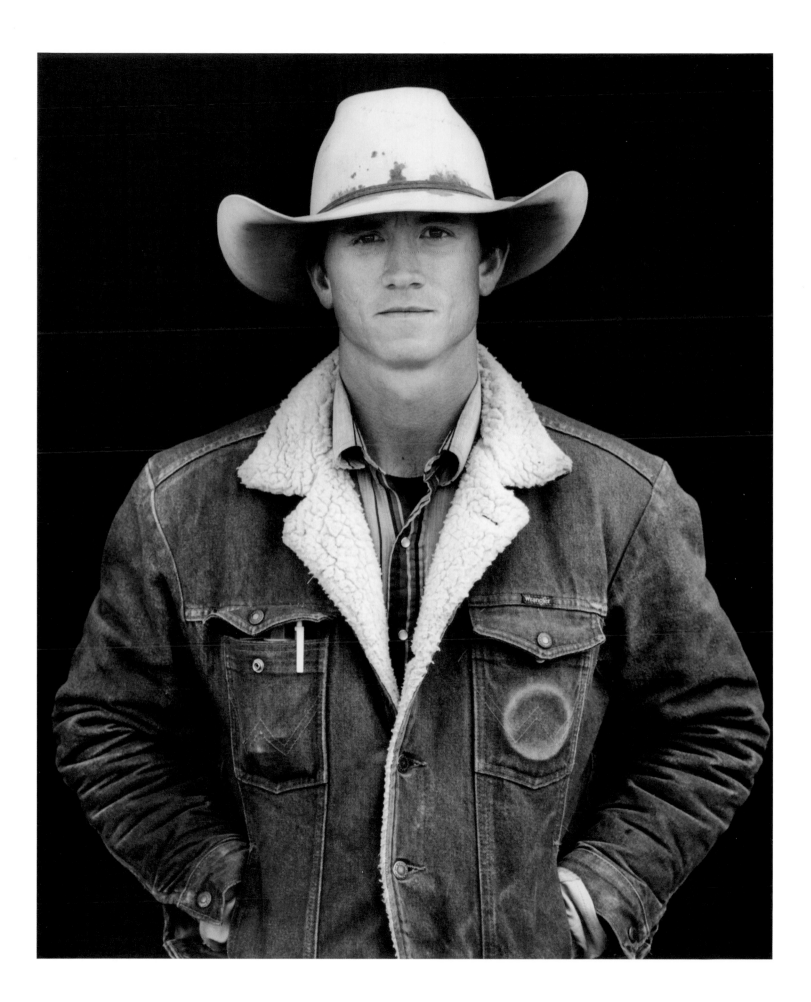

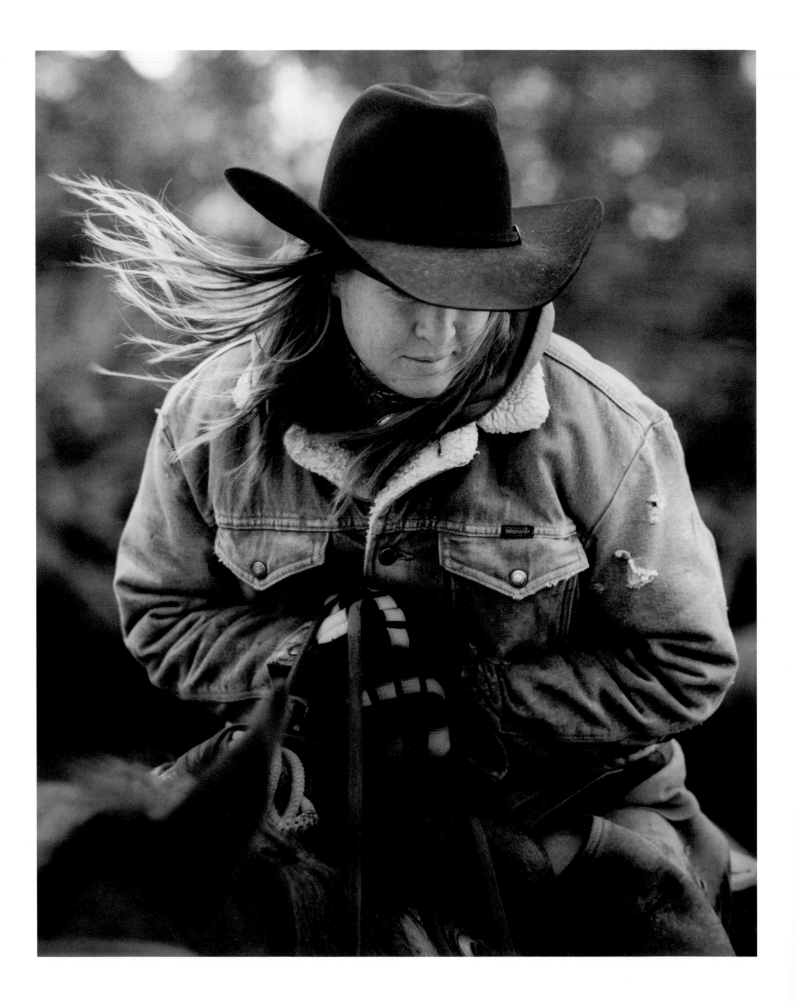

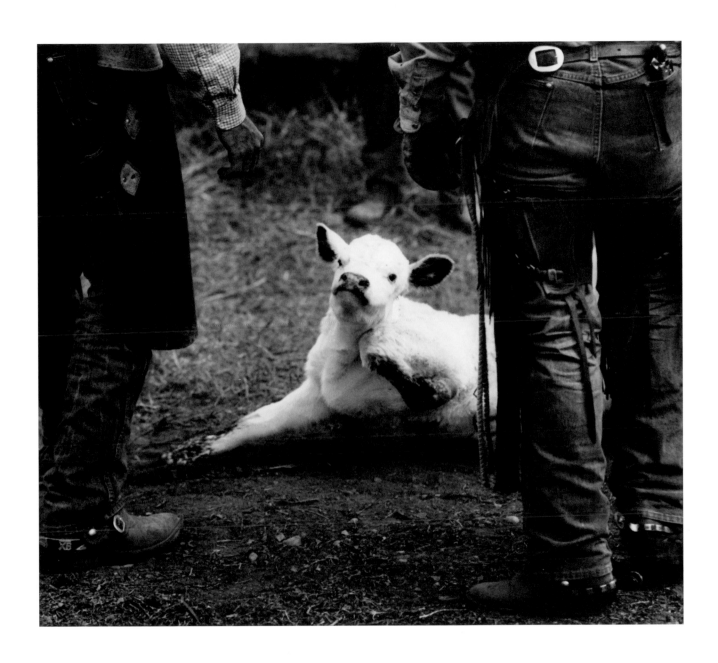

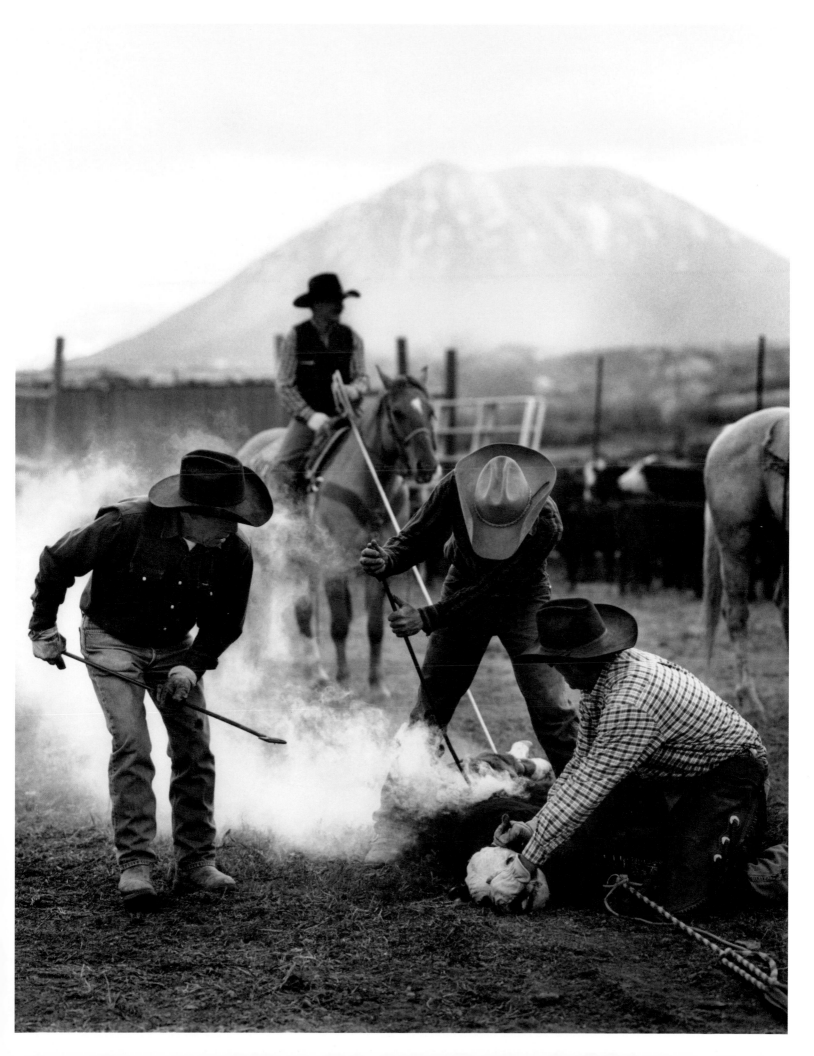

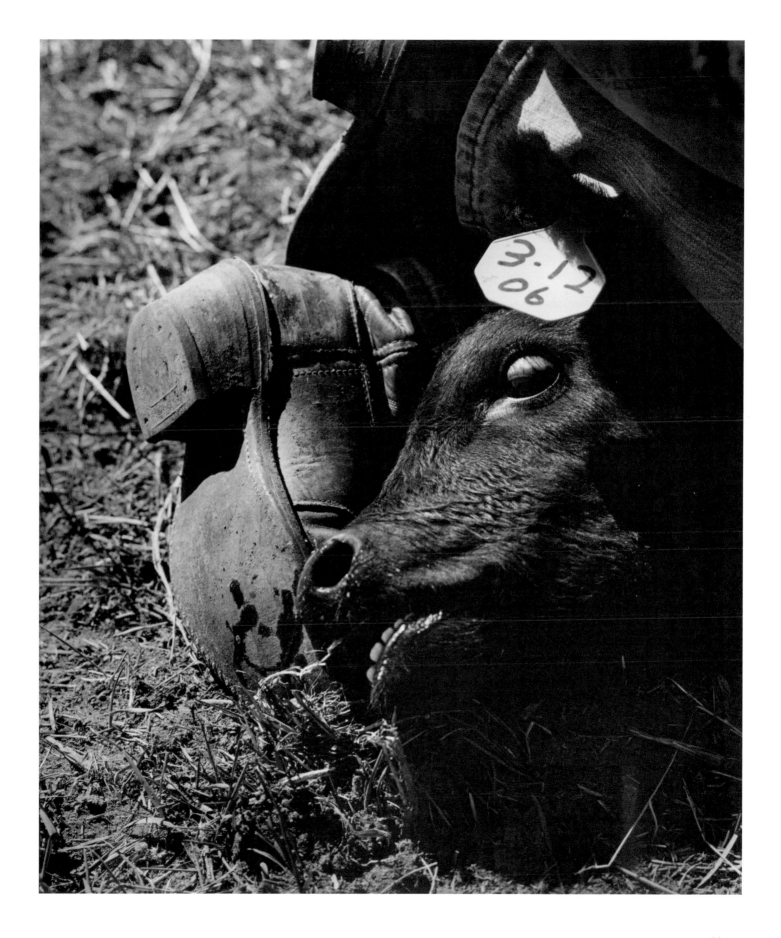

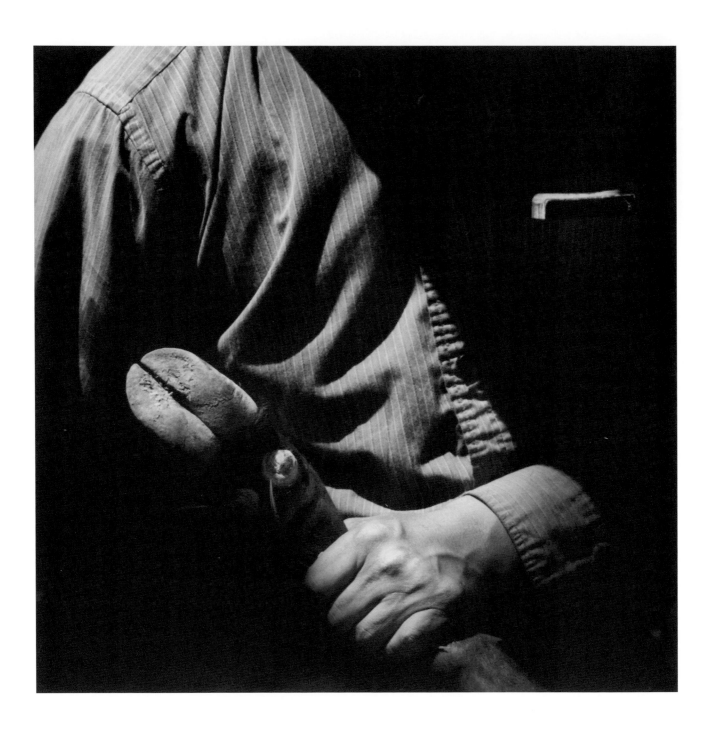

56

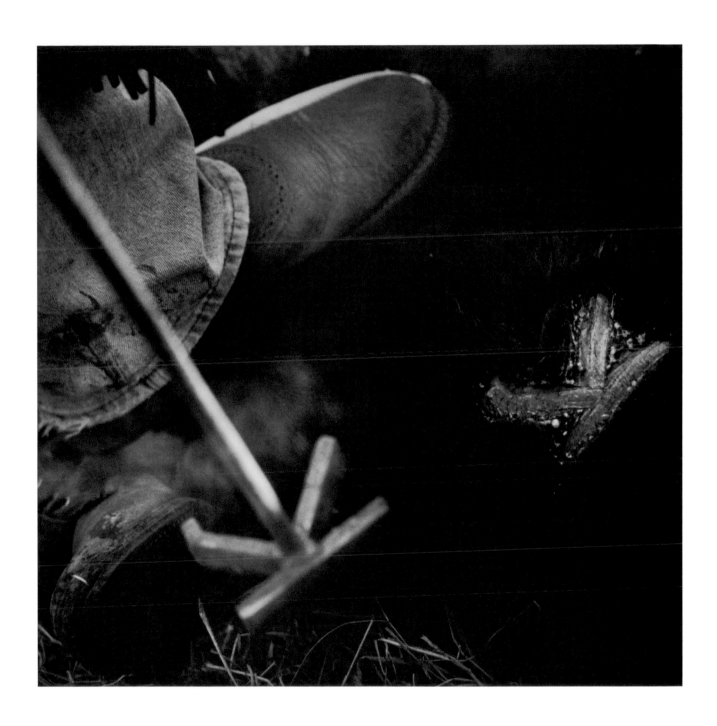

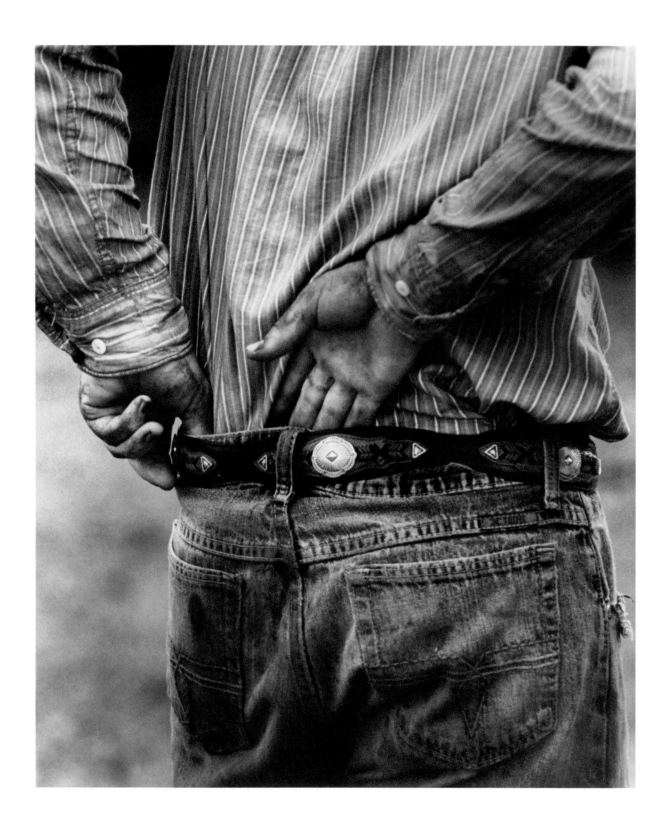

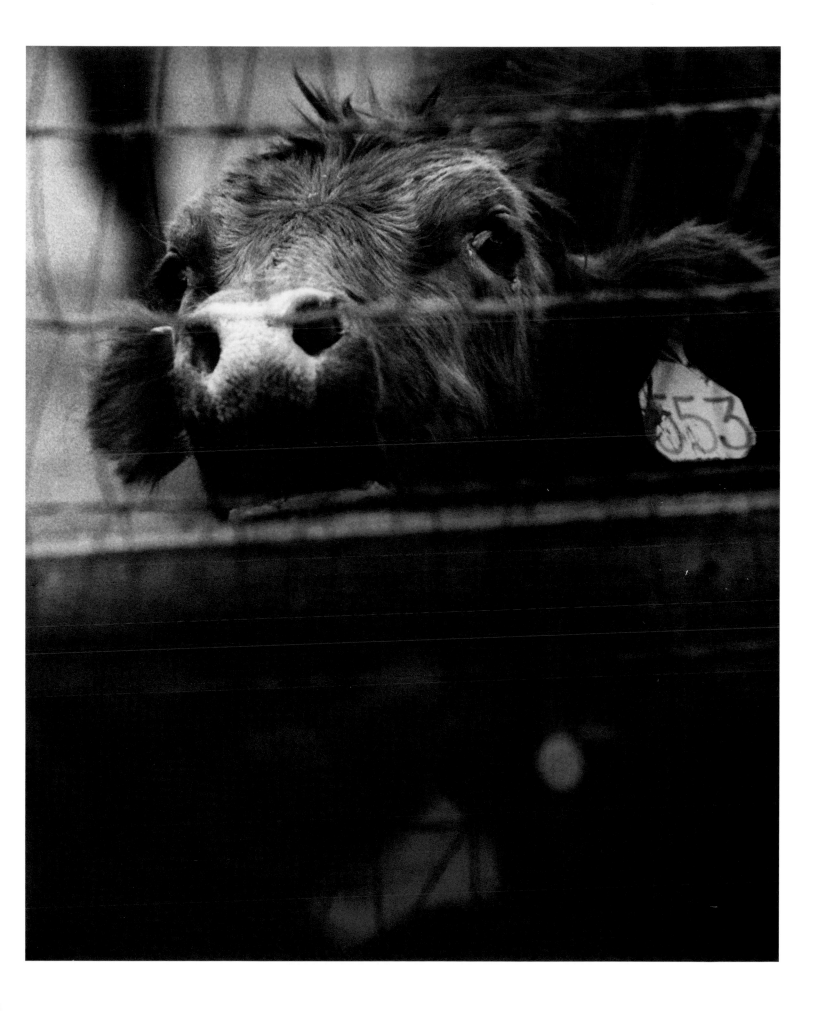

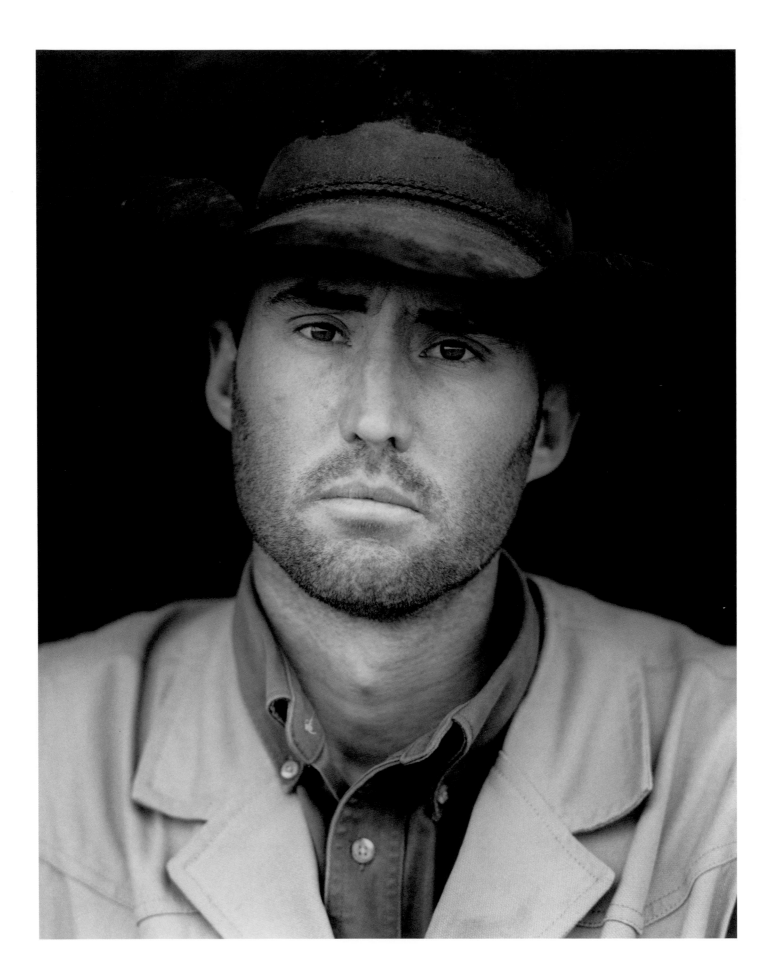

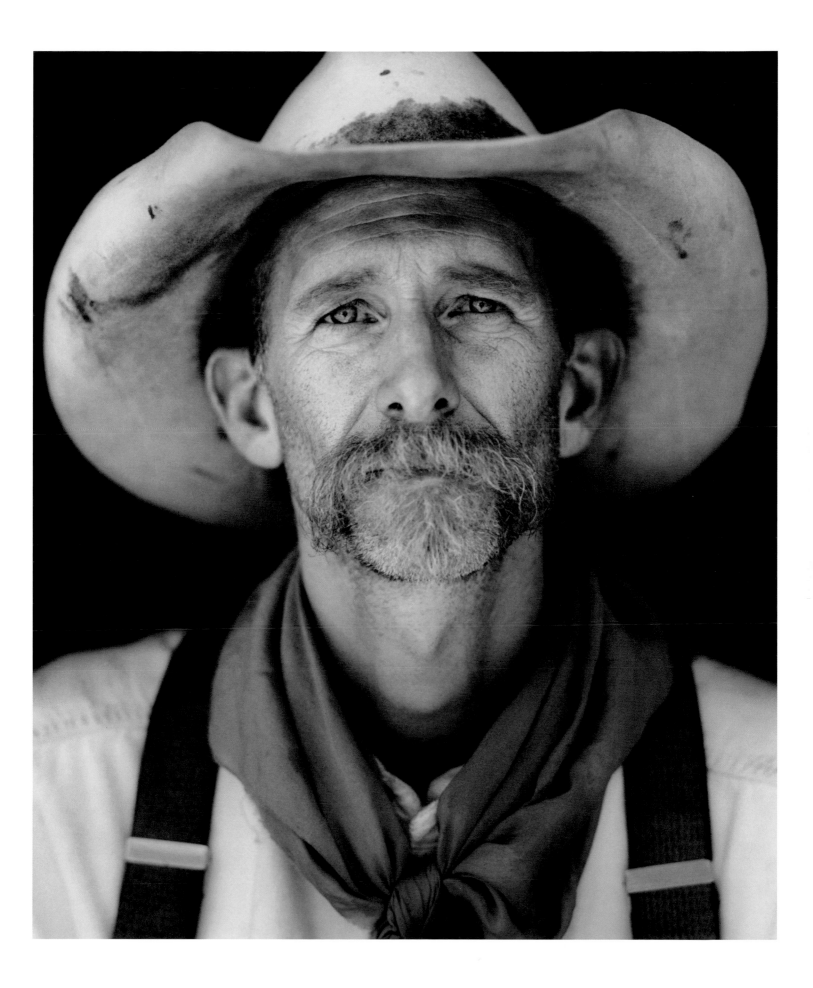

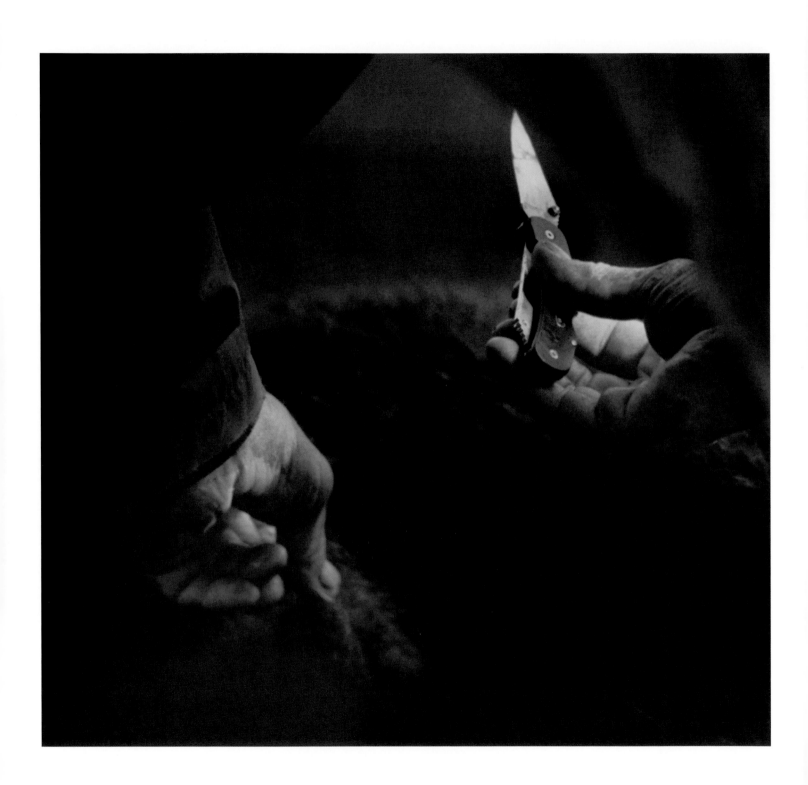

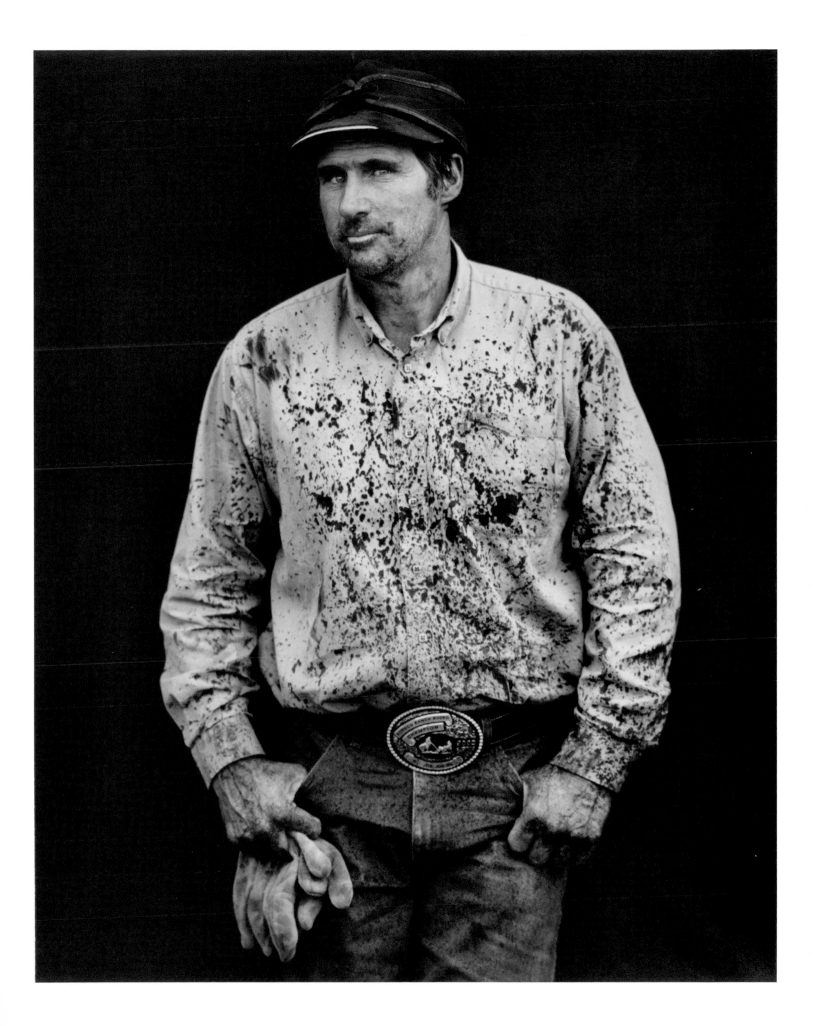

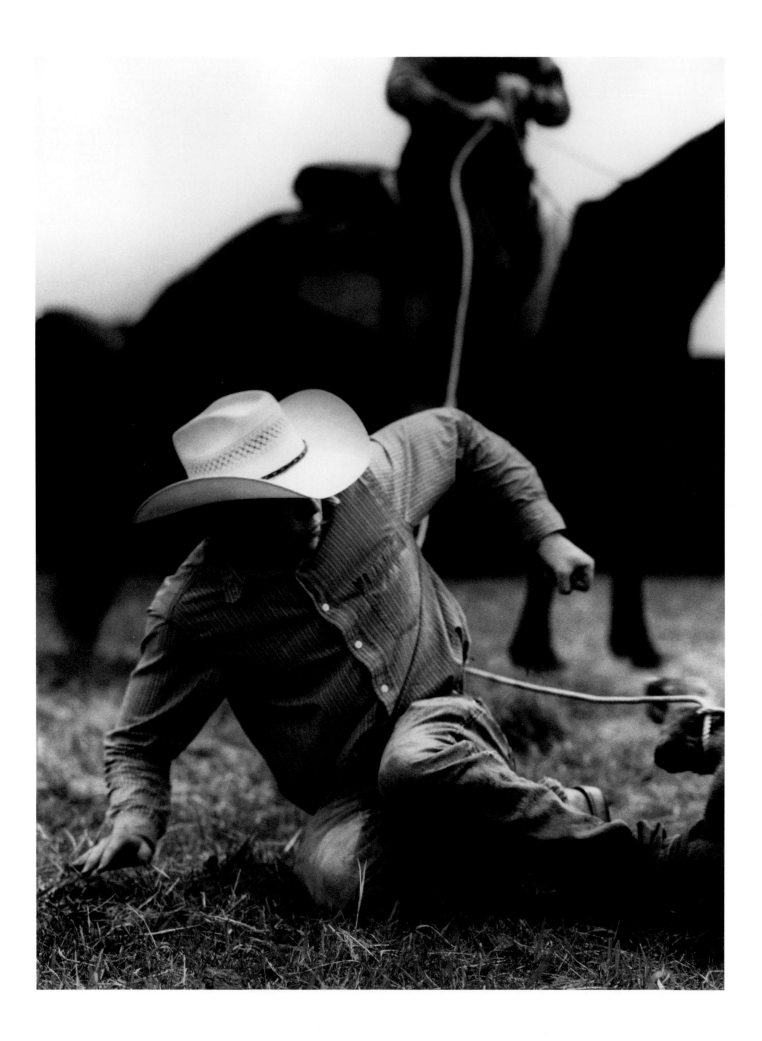

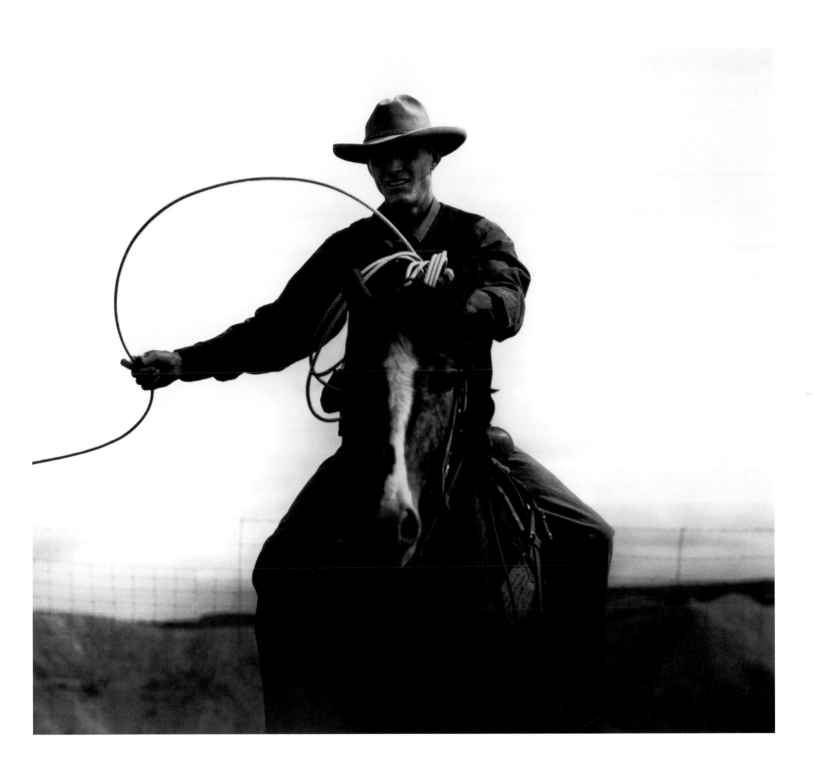

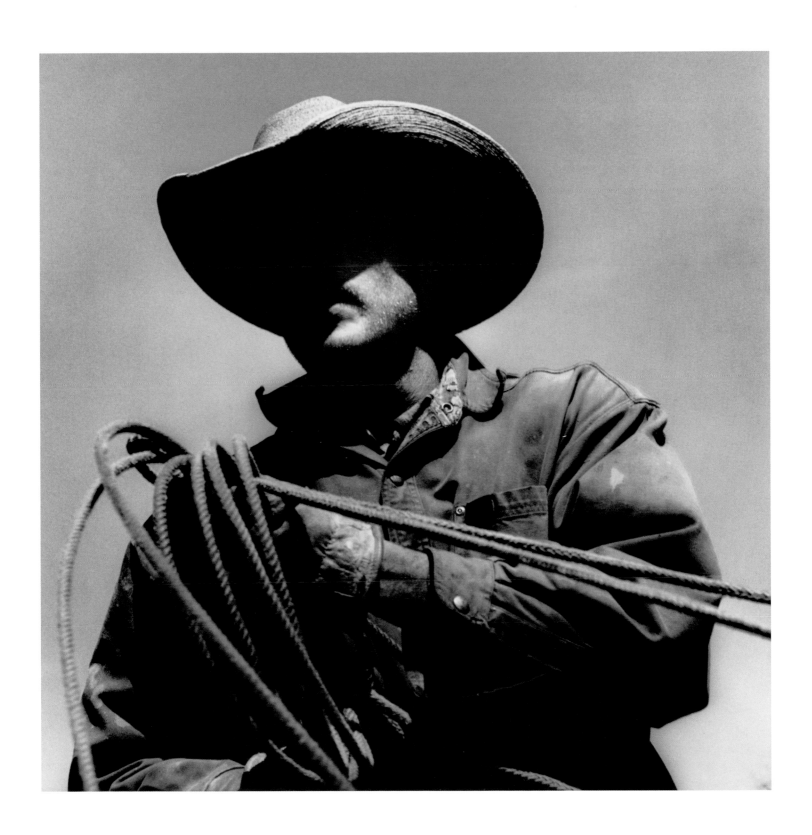

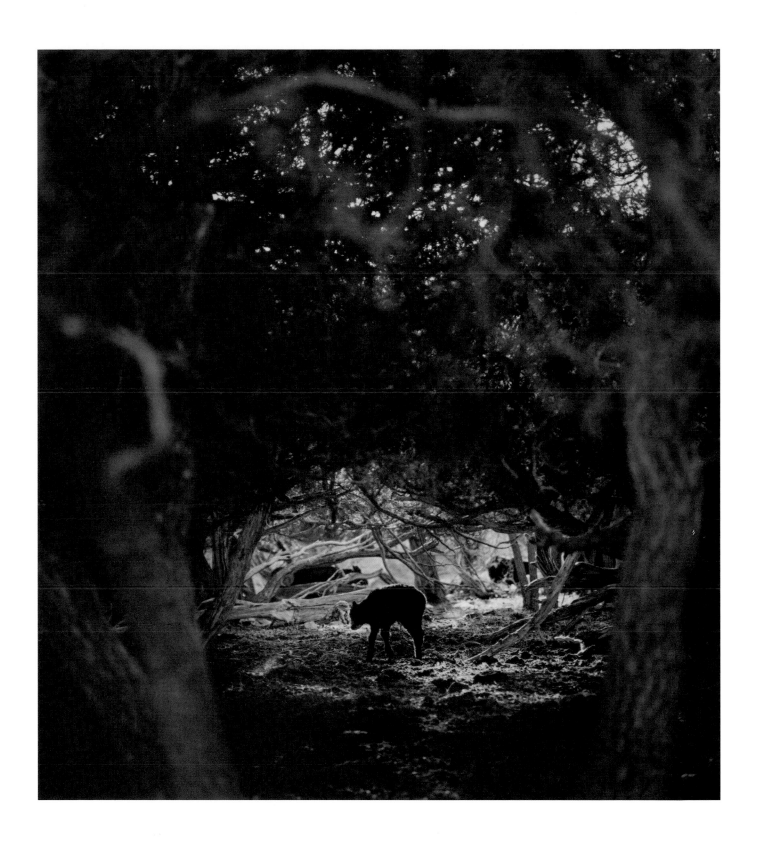

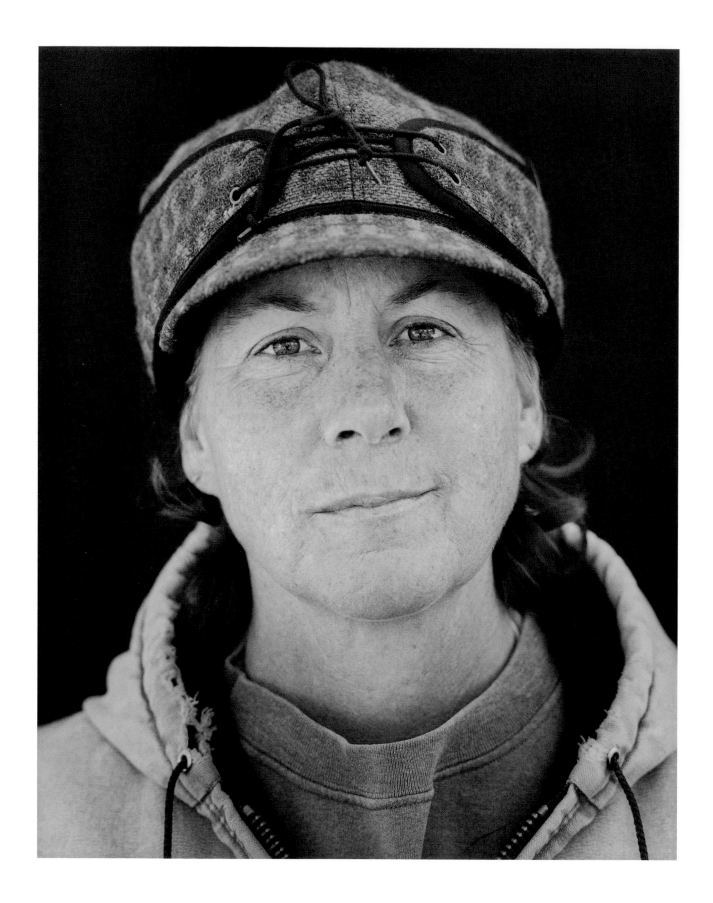

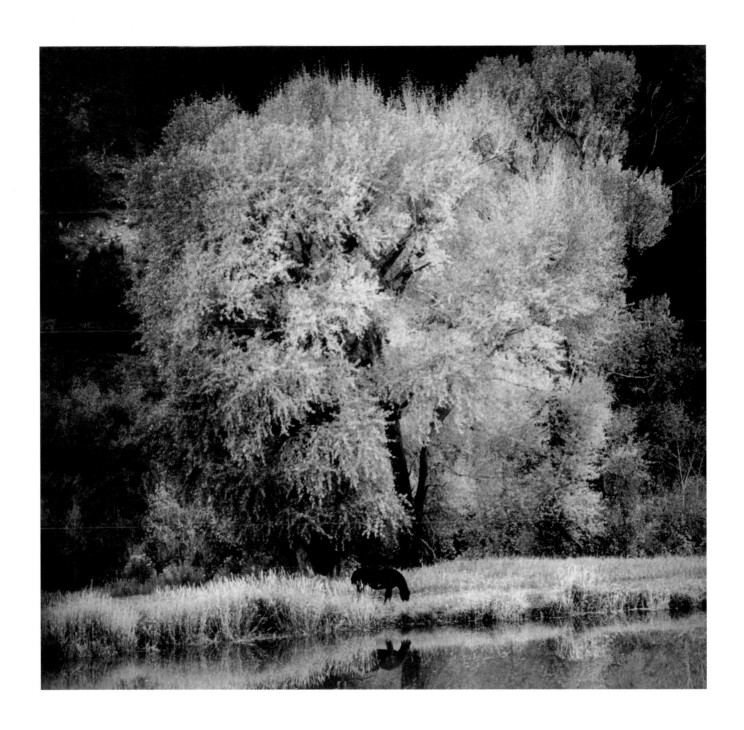

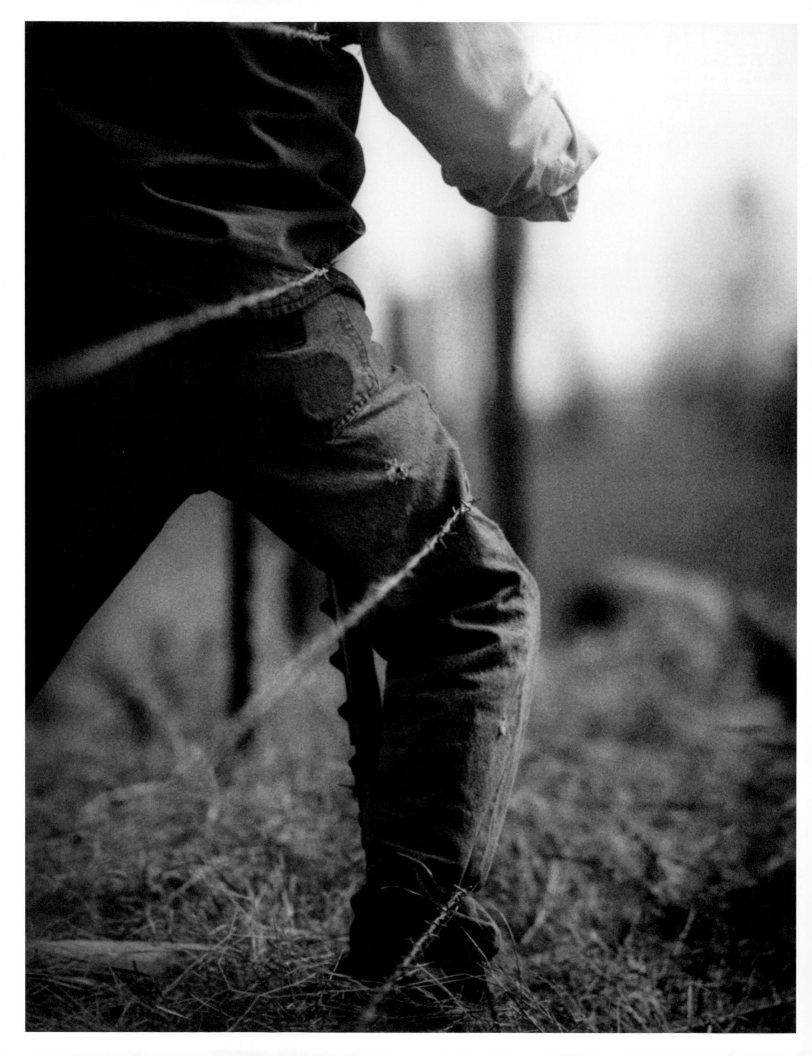

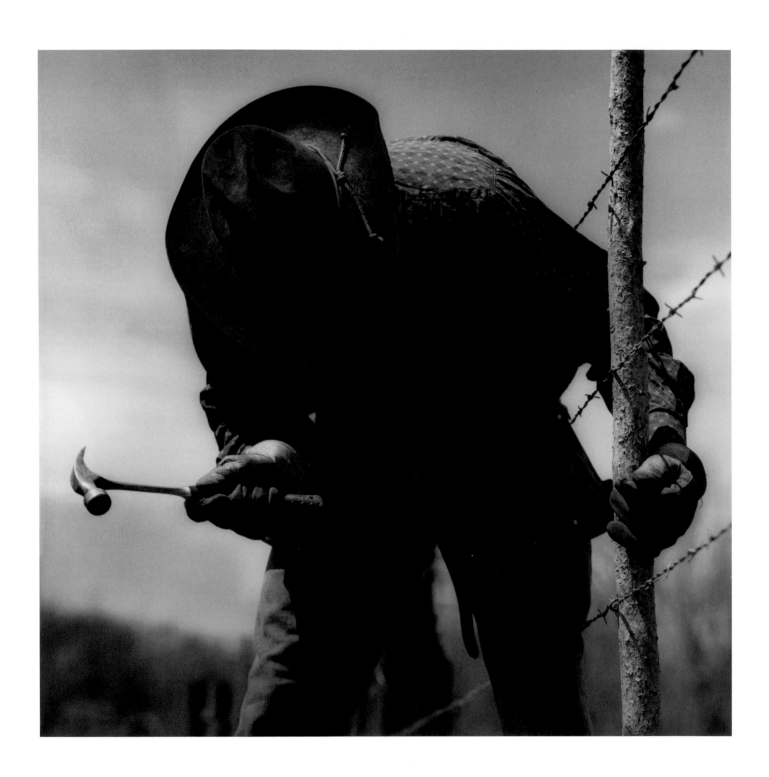

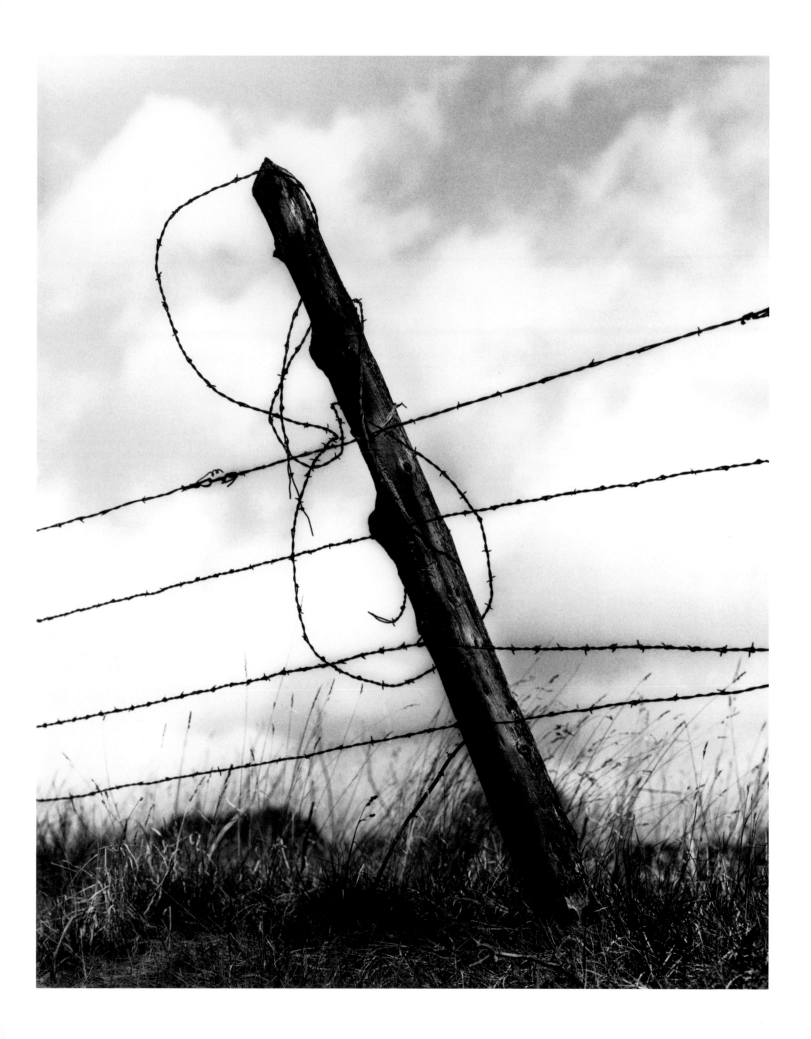

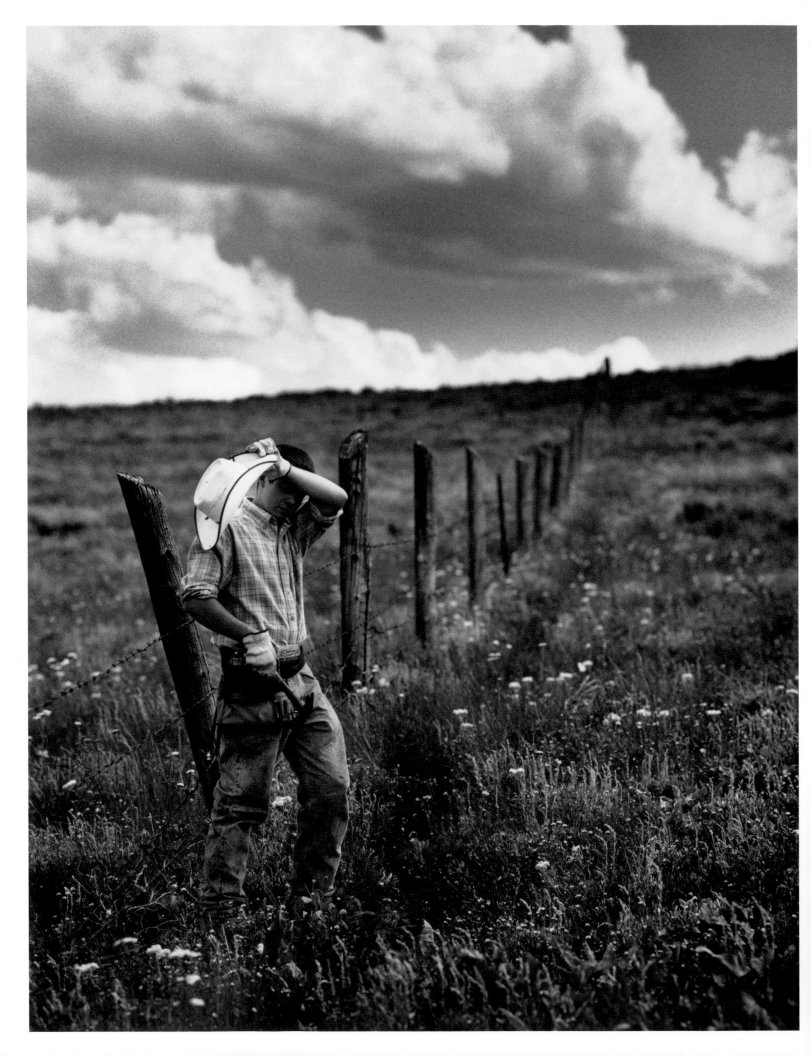

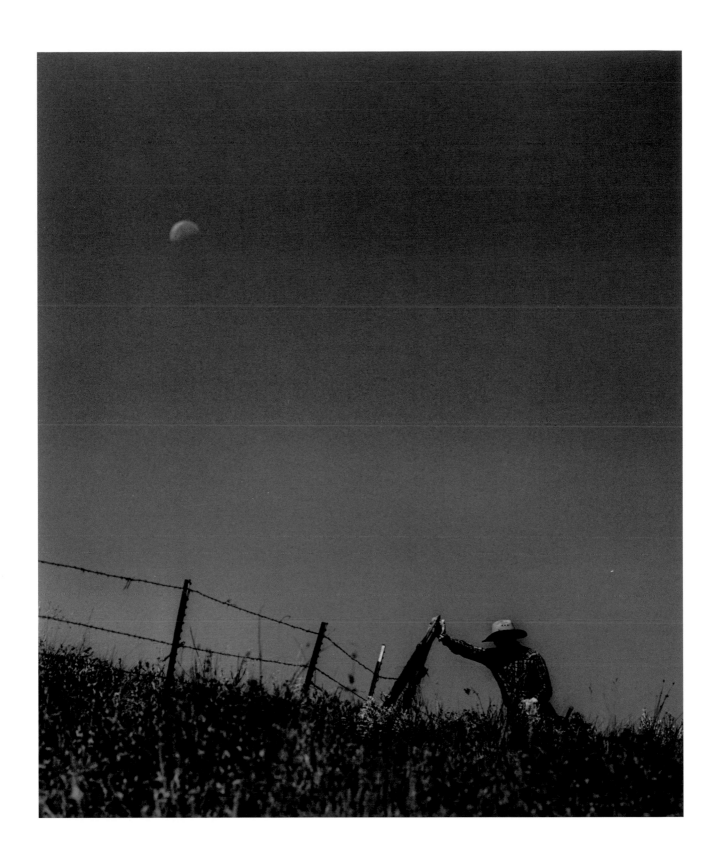

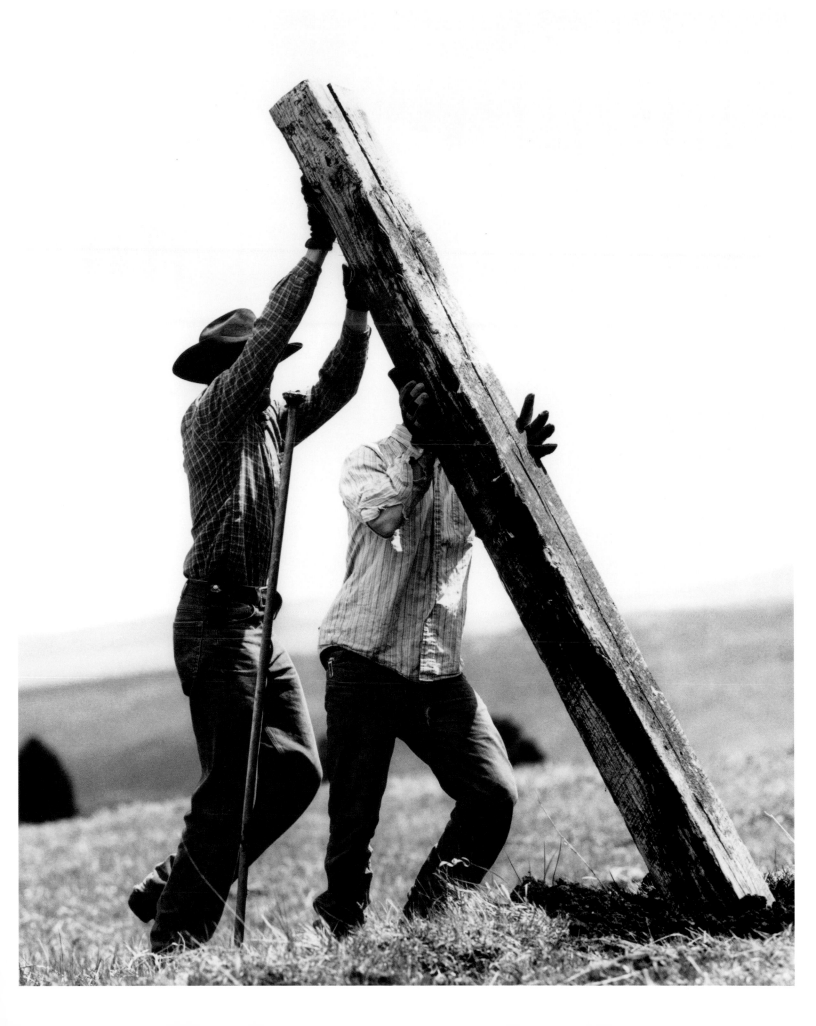

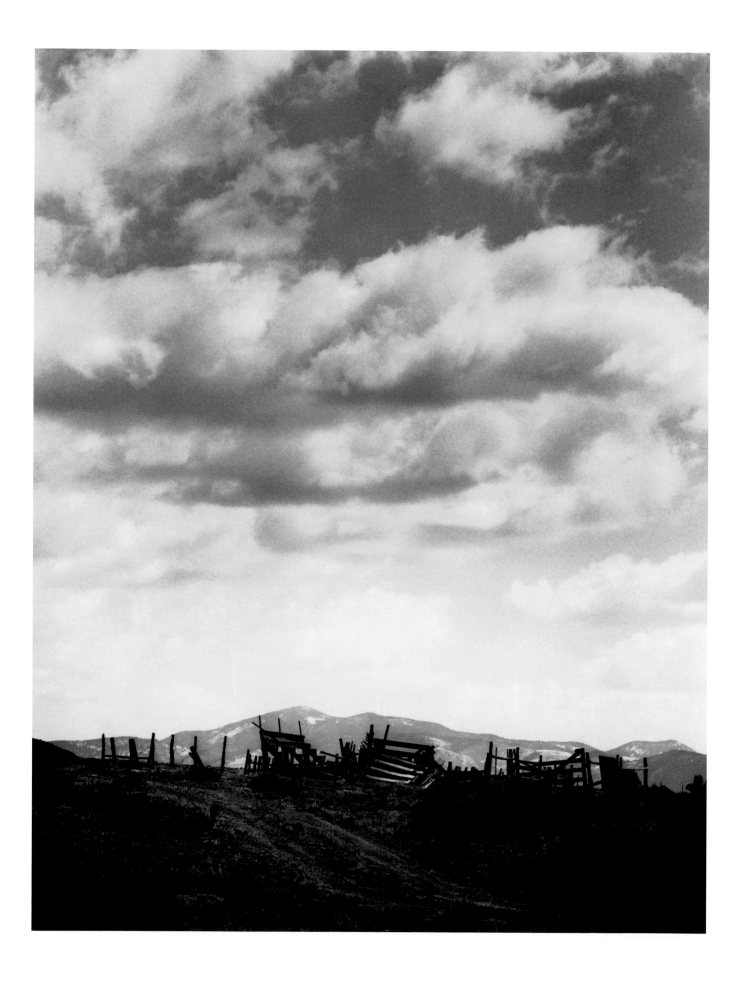

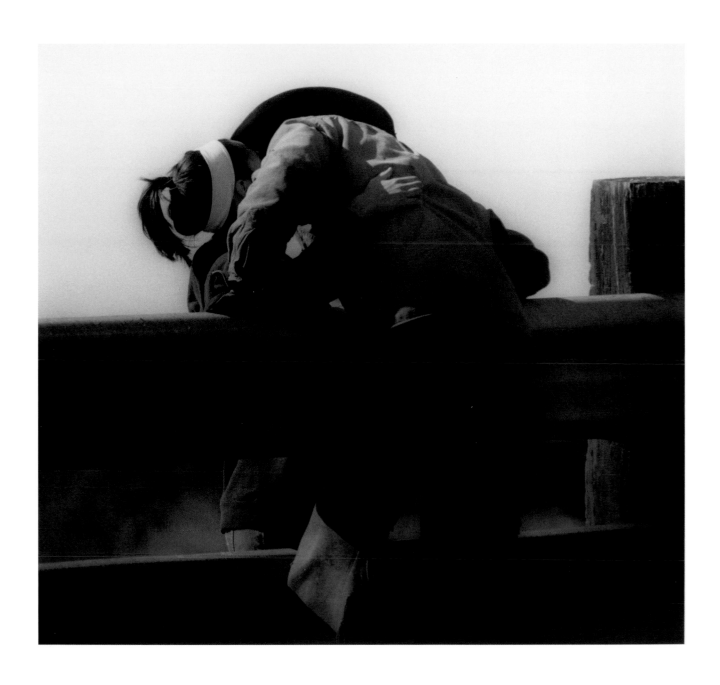

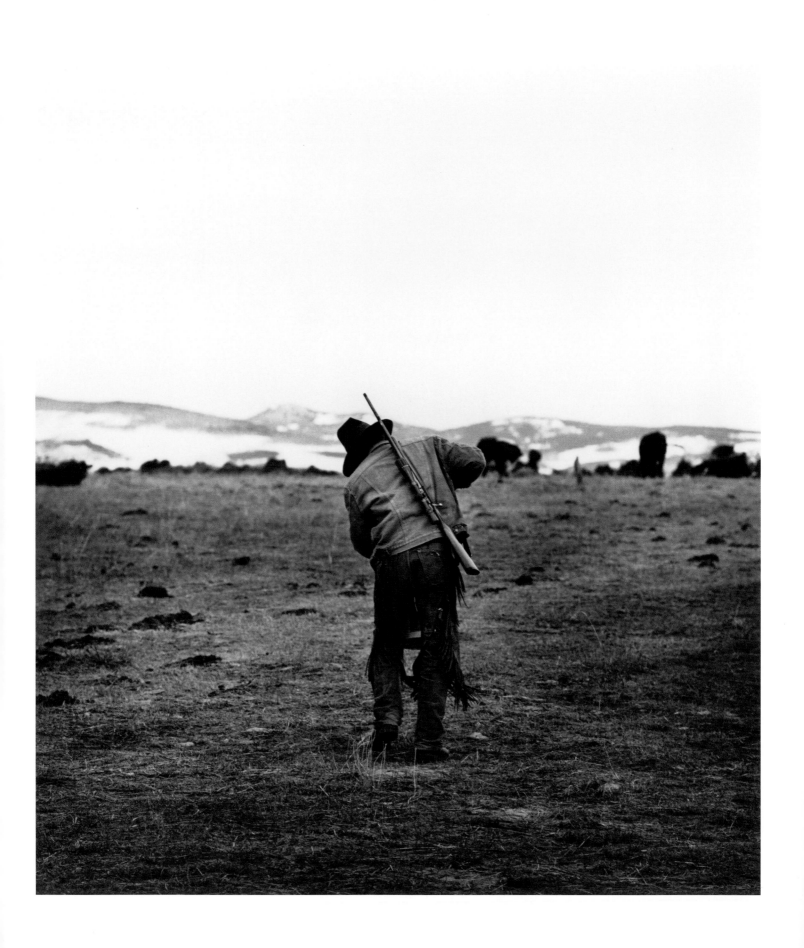

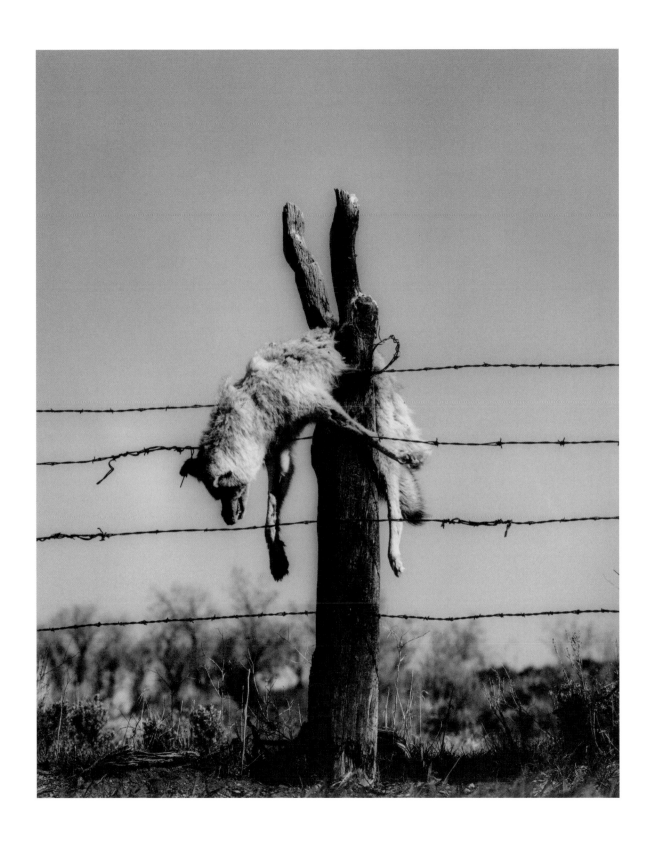

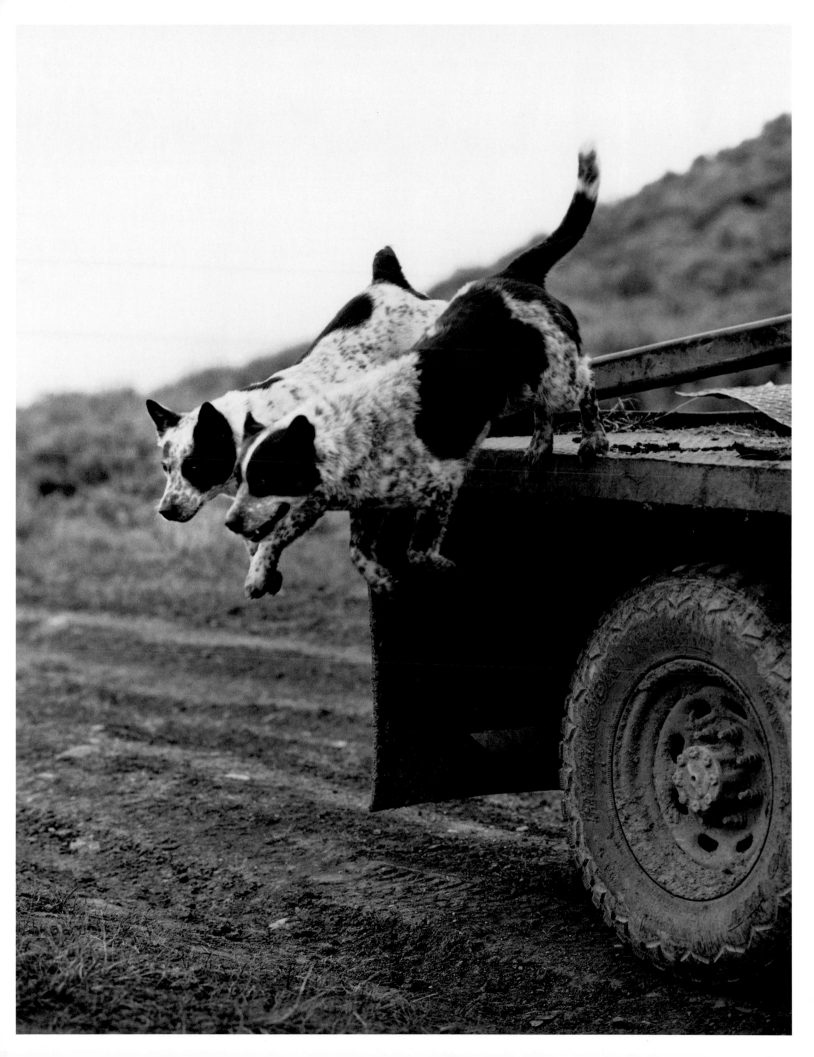

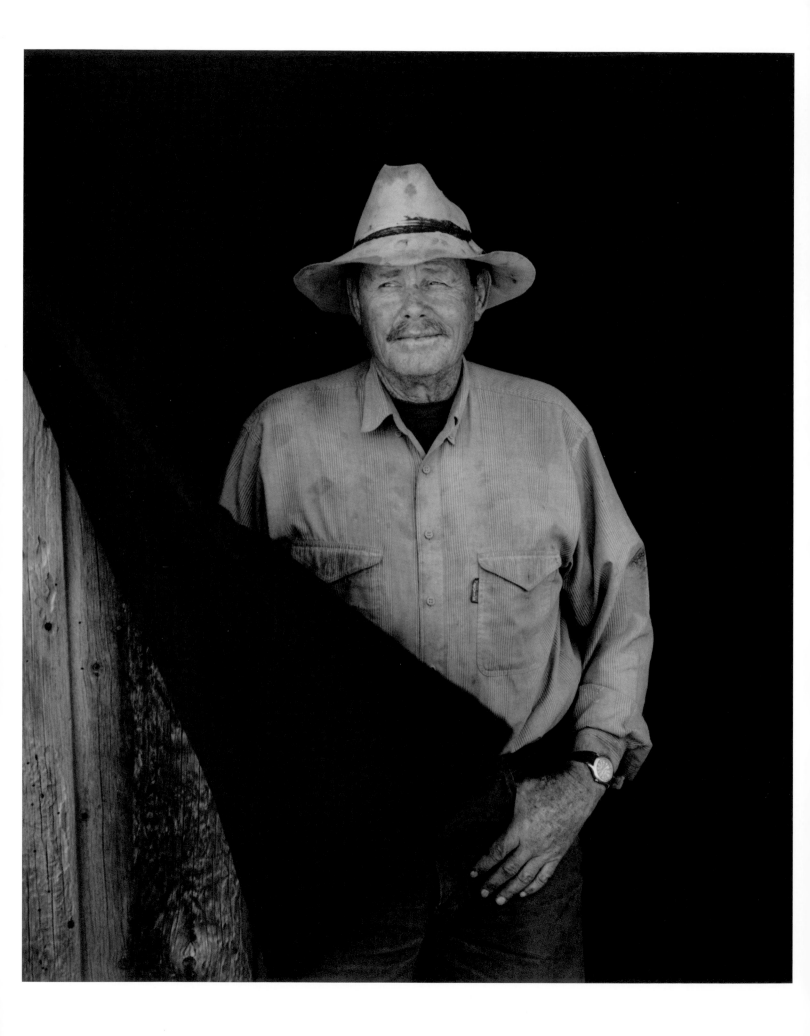

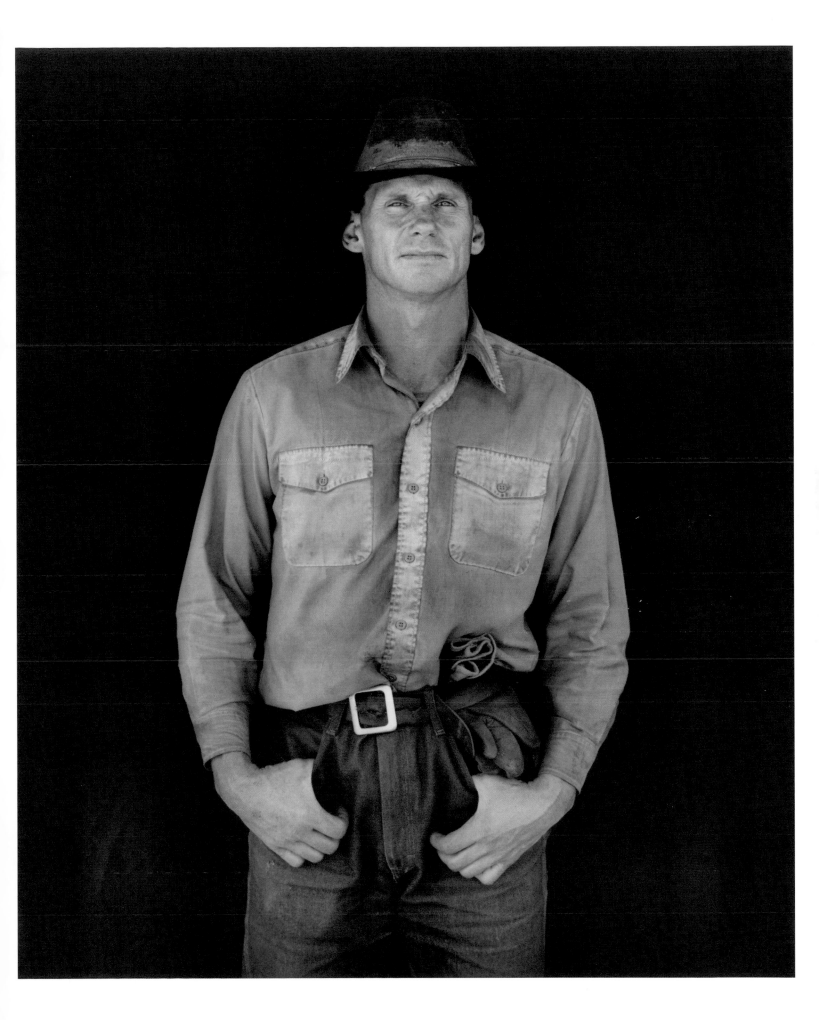

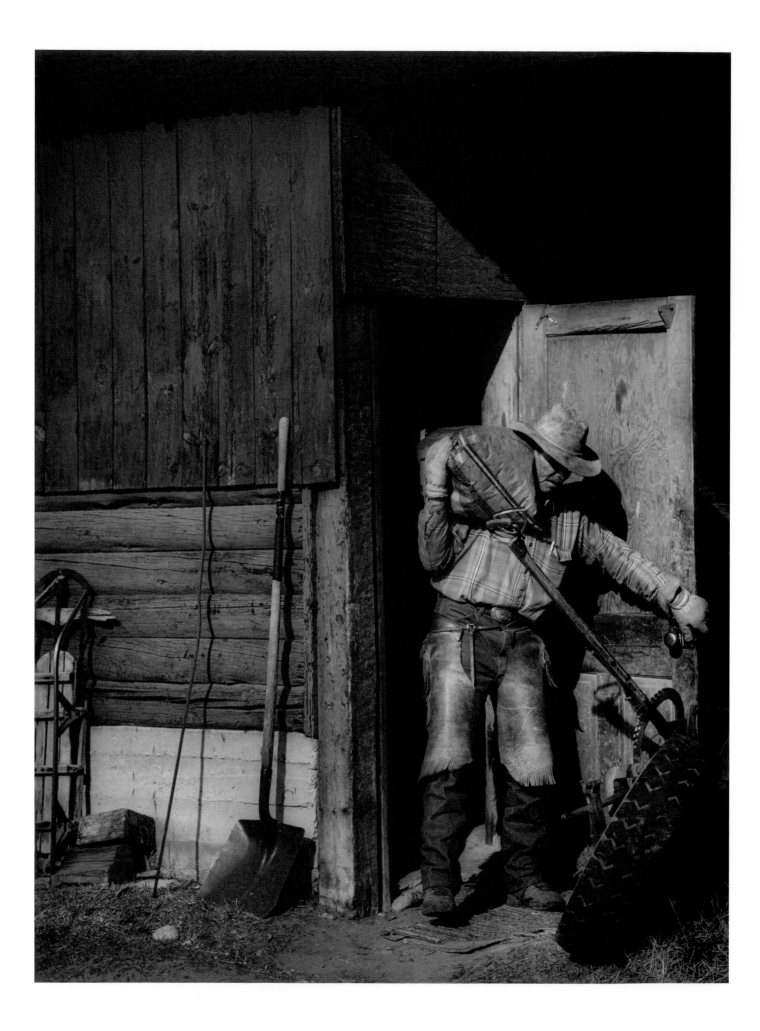

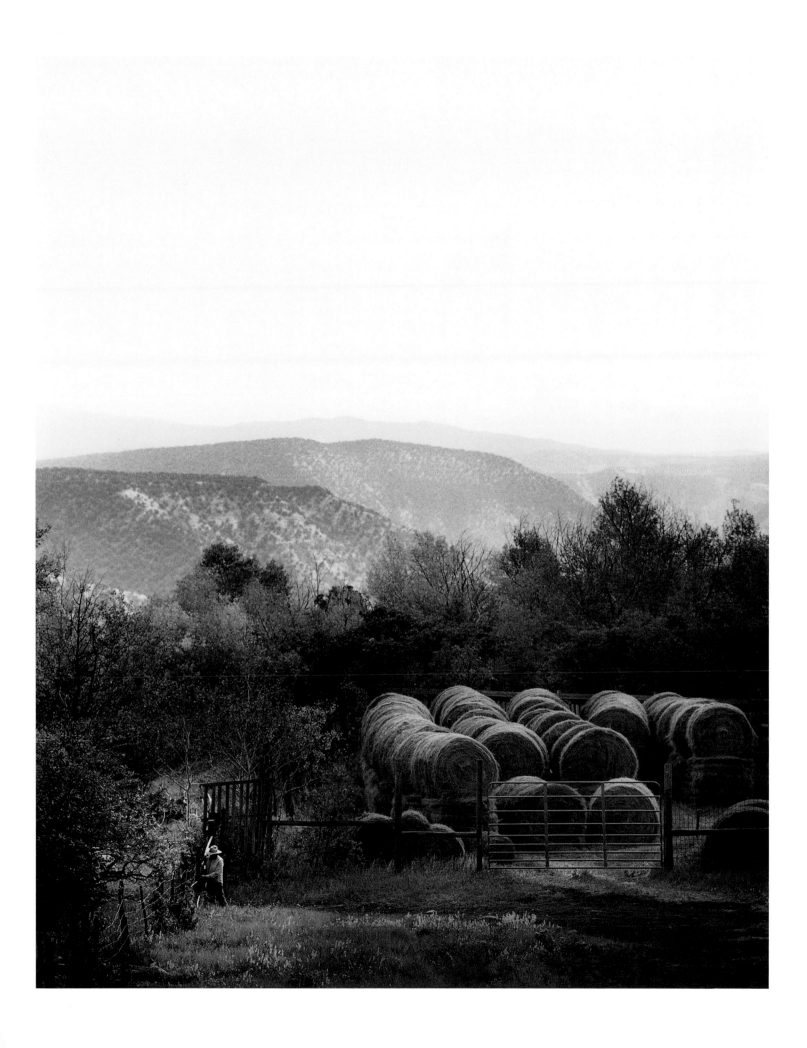

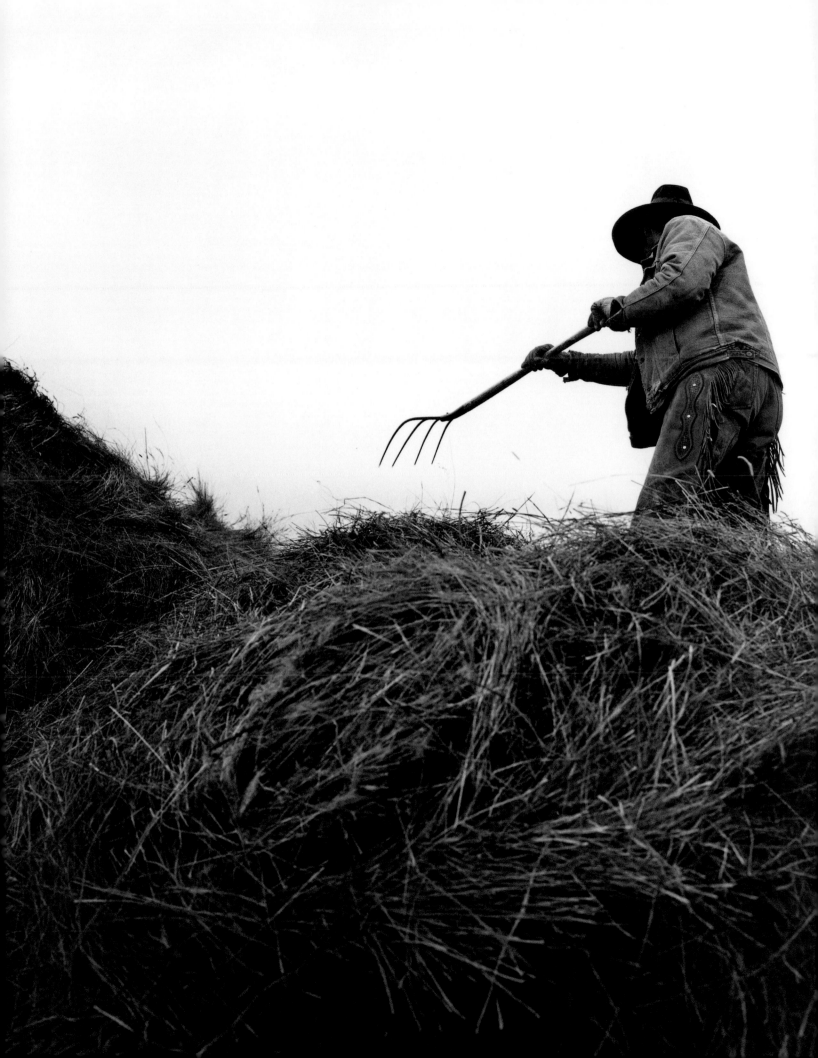

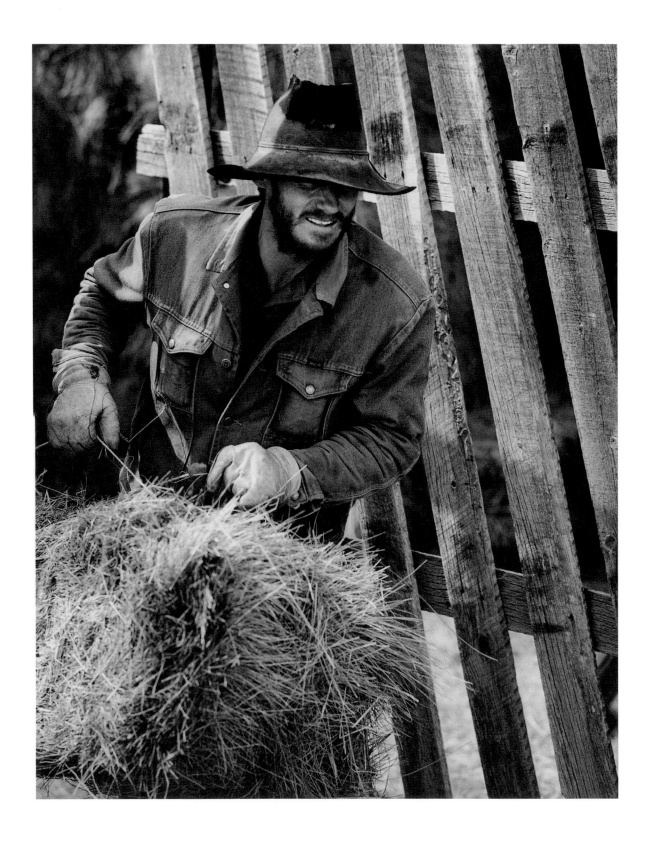

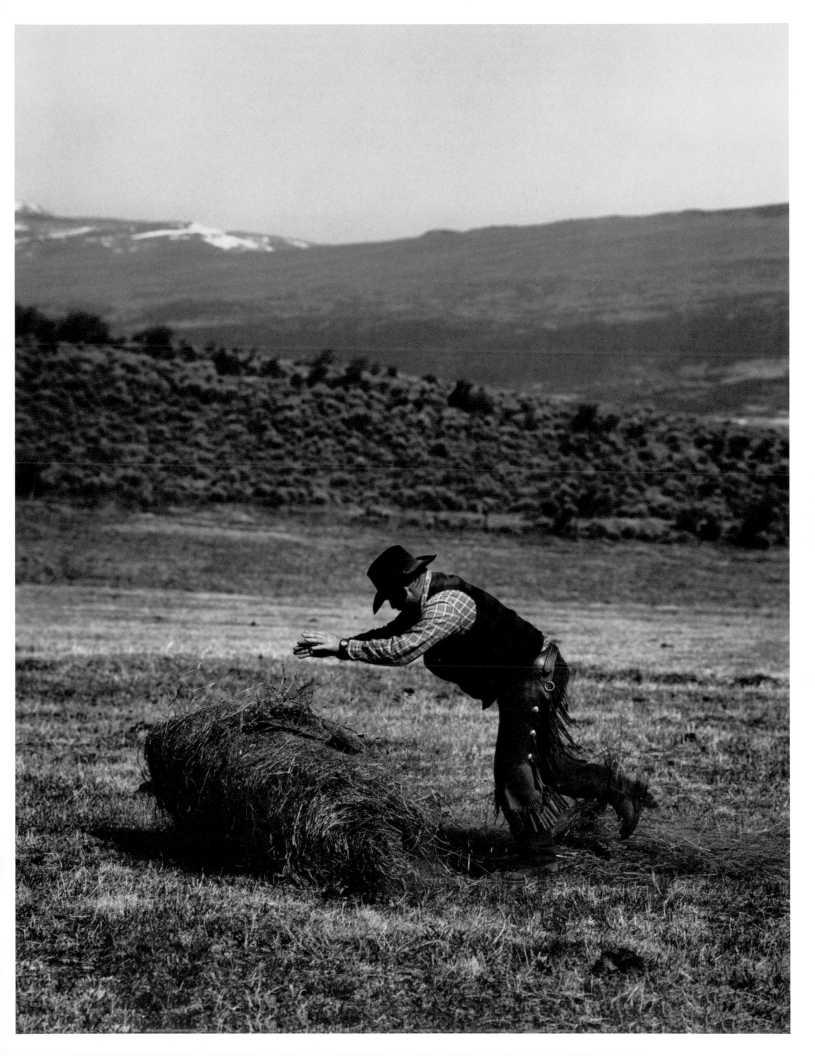

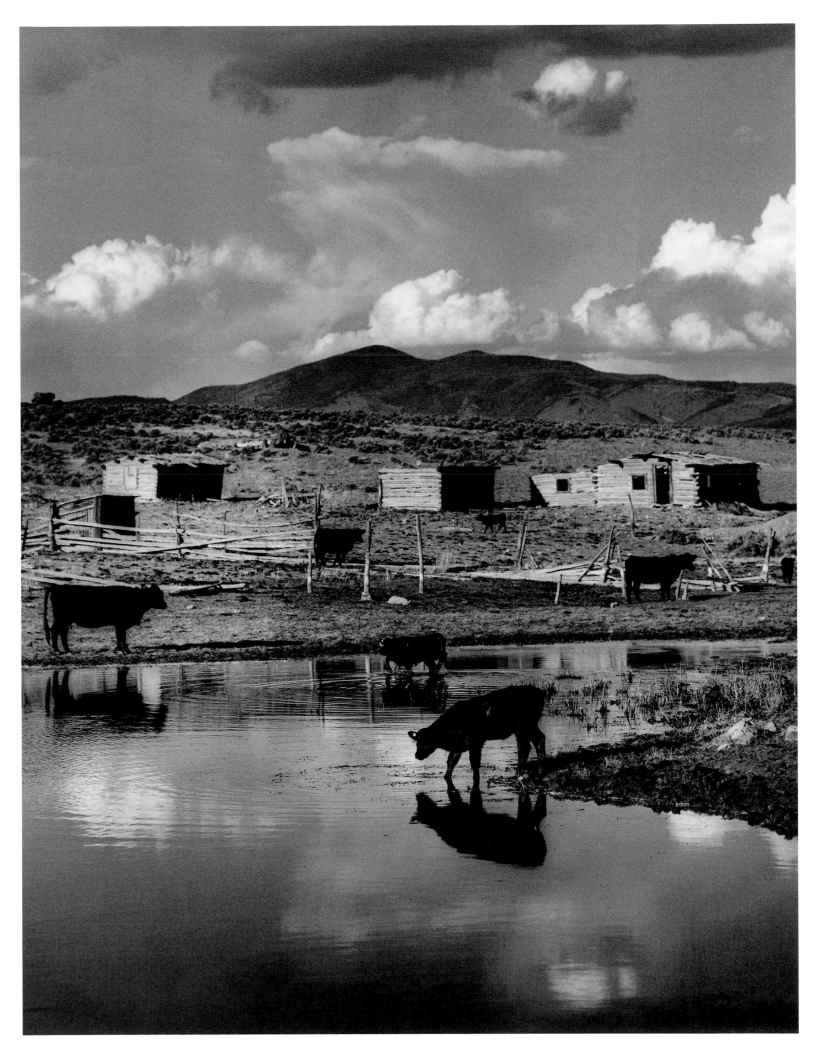

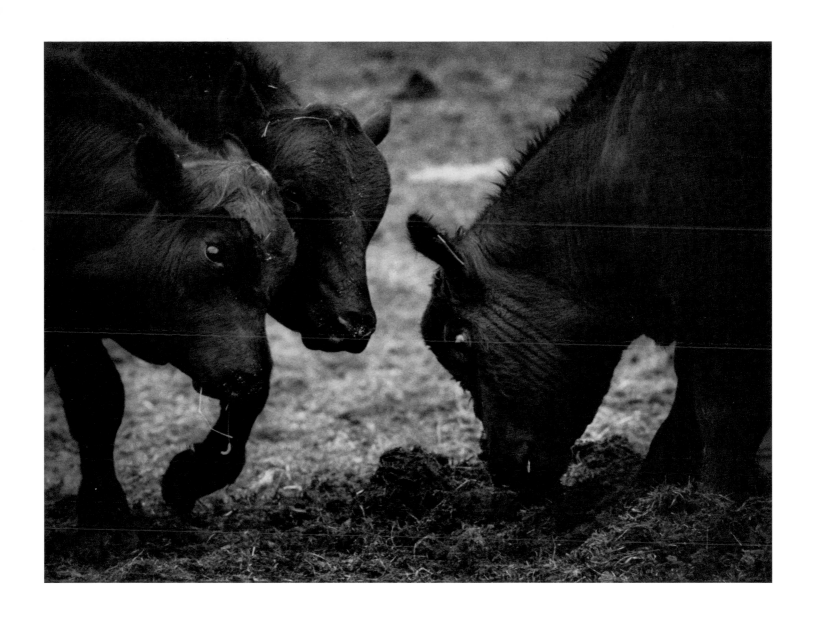

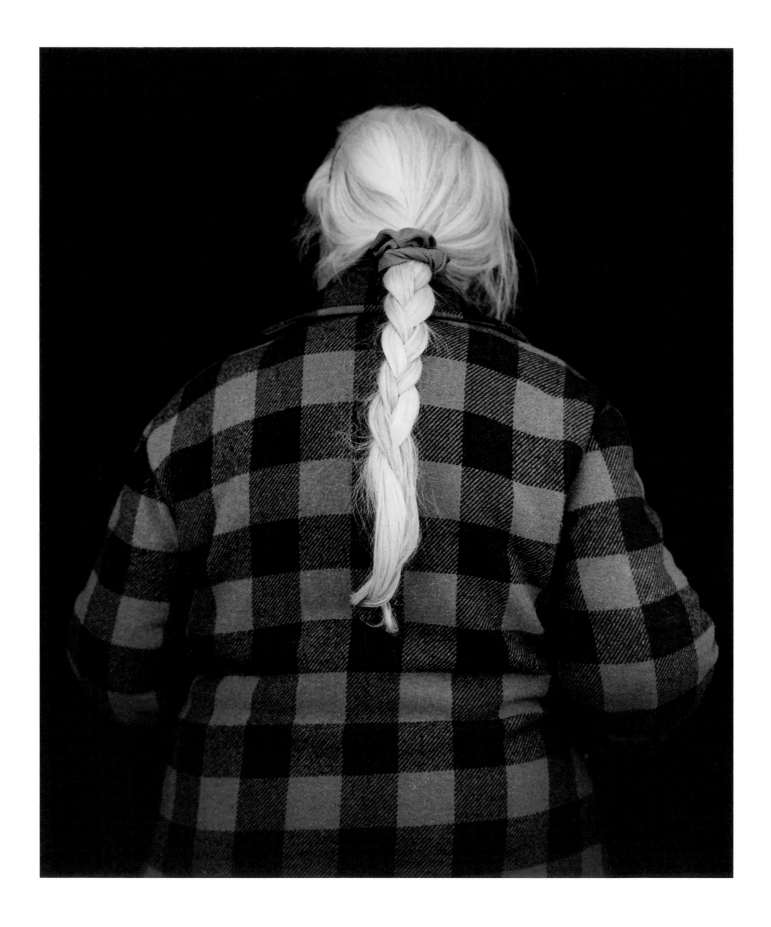

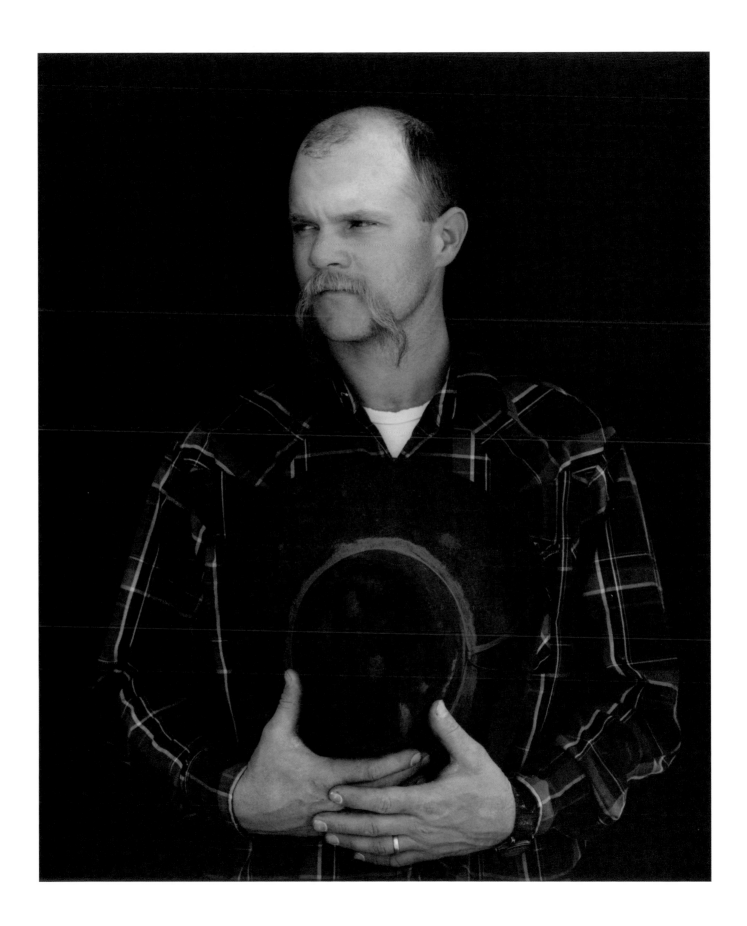

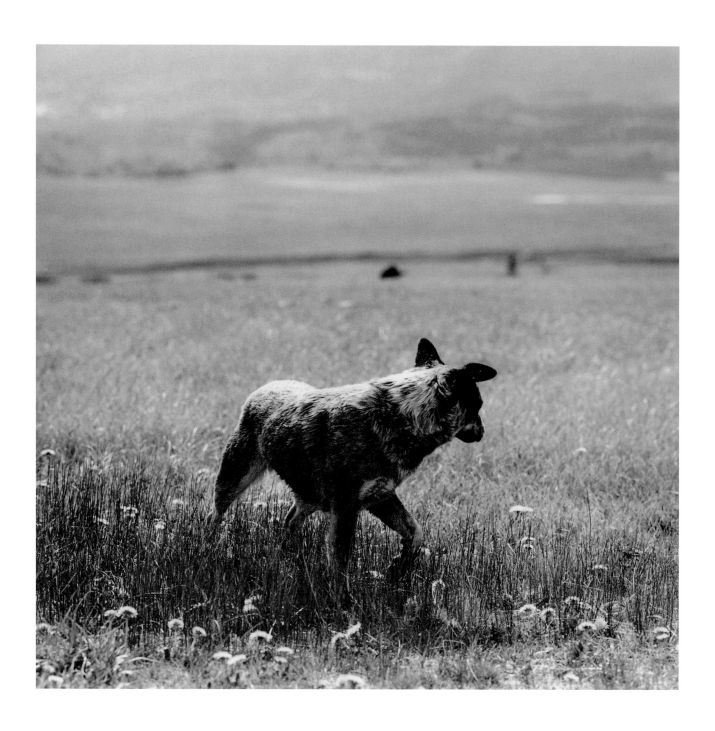

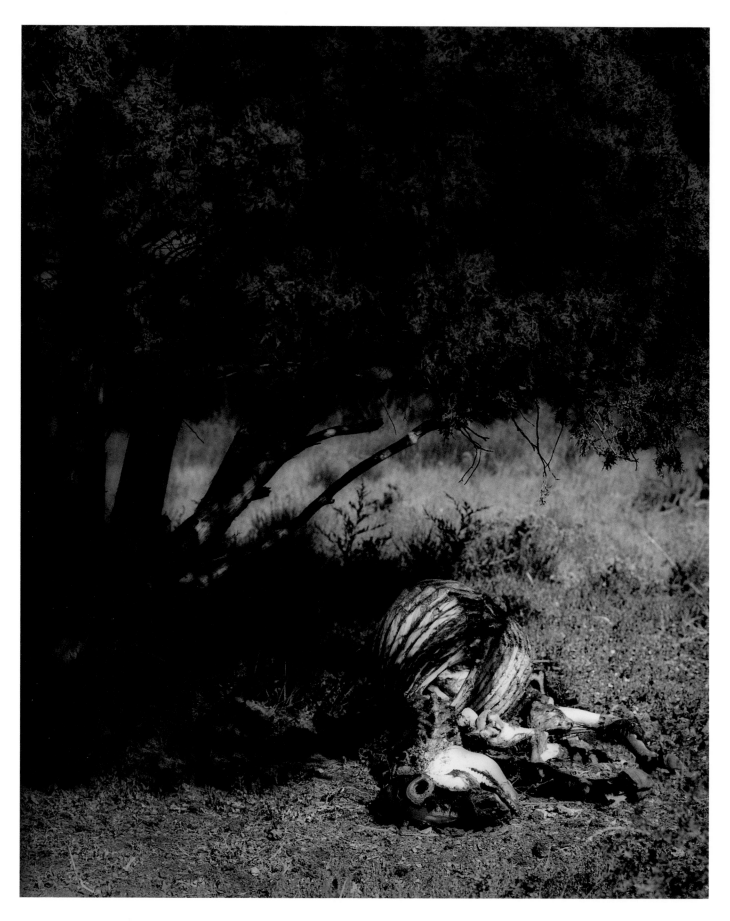

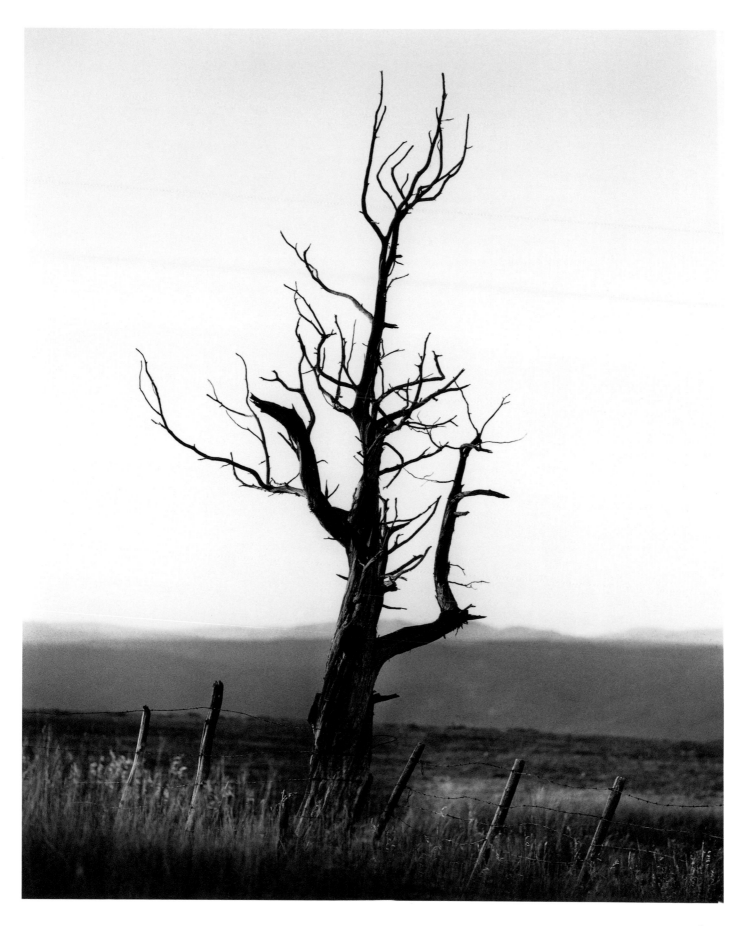

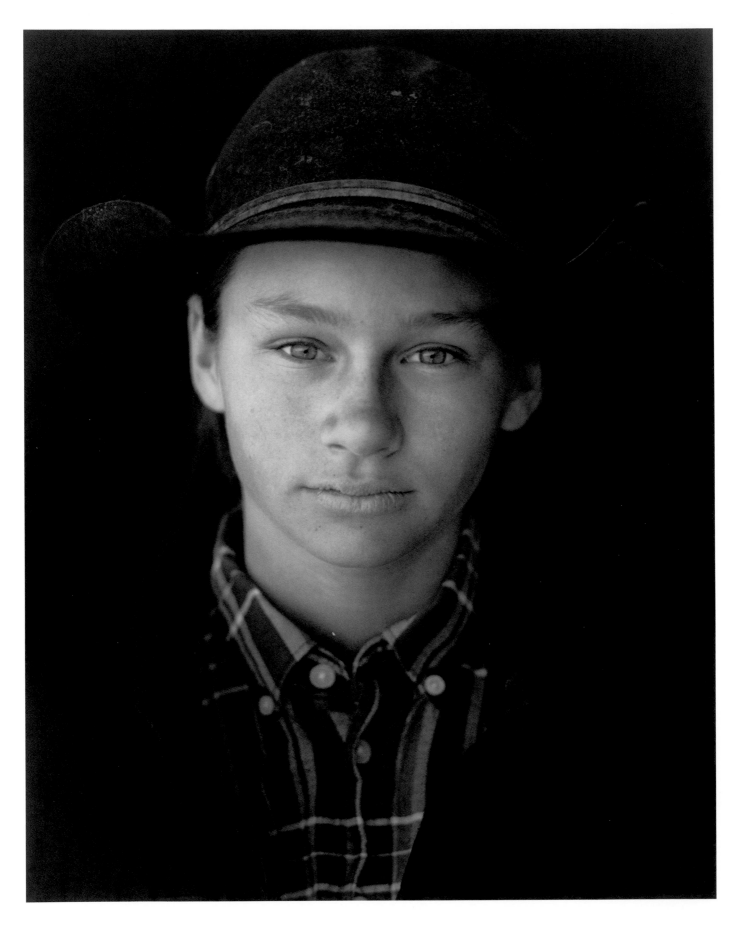

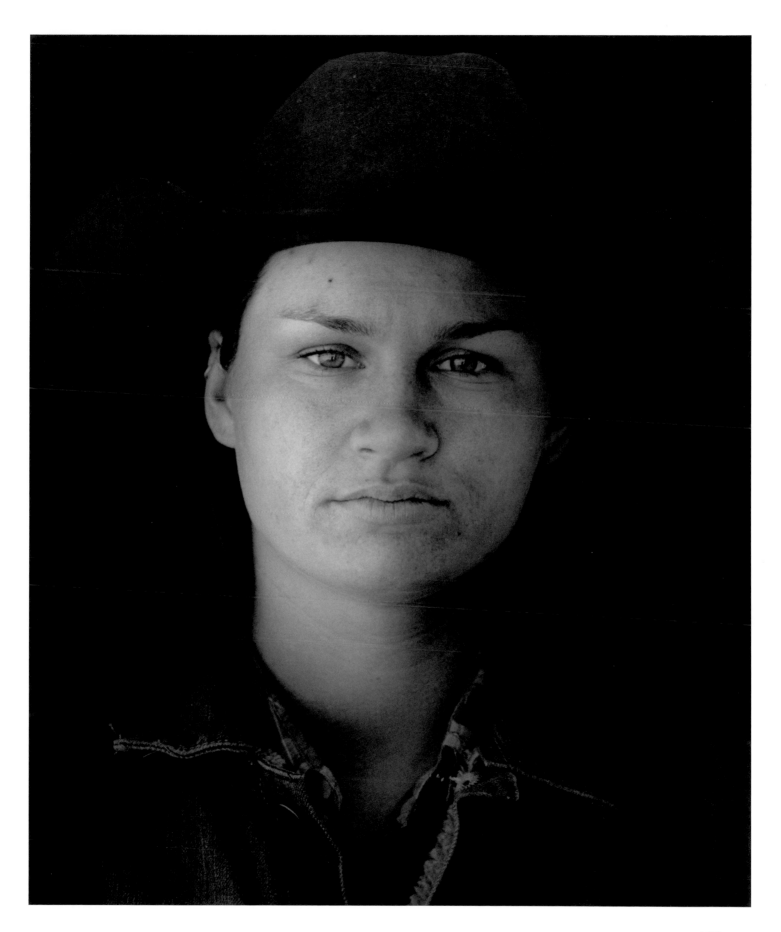

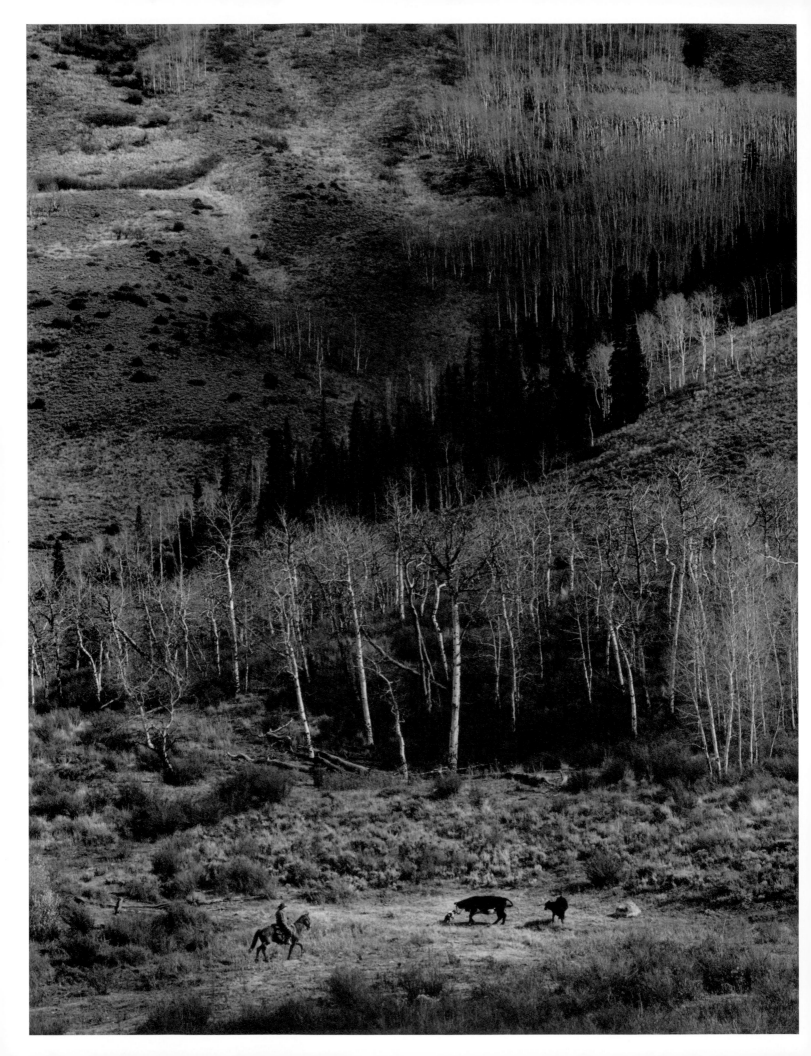

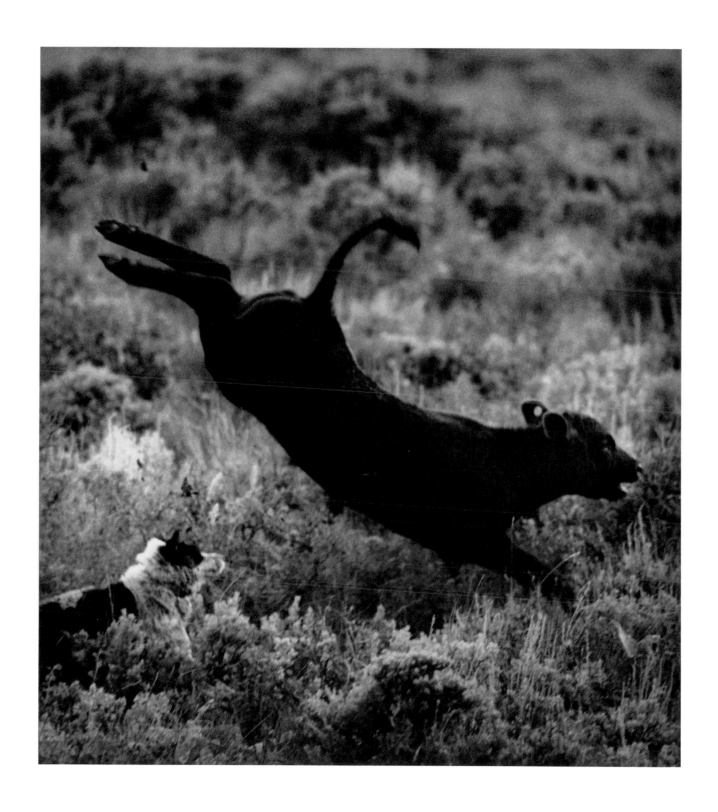

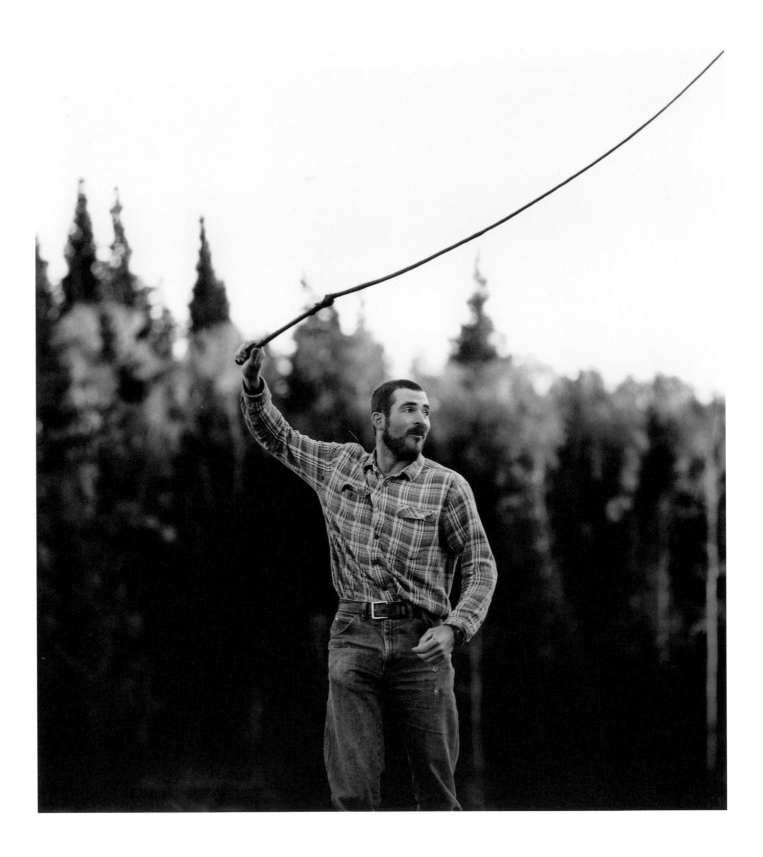

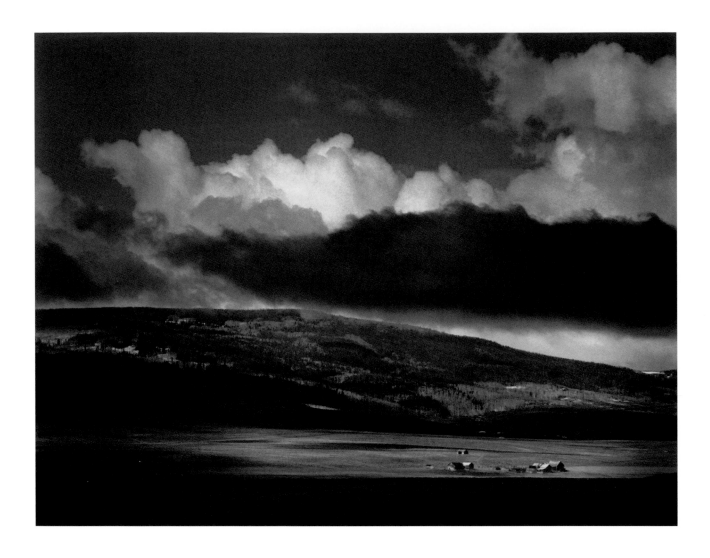

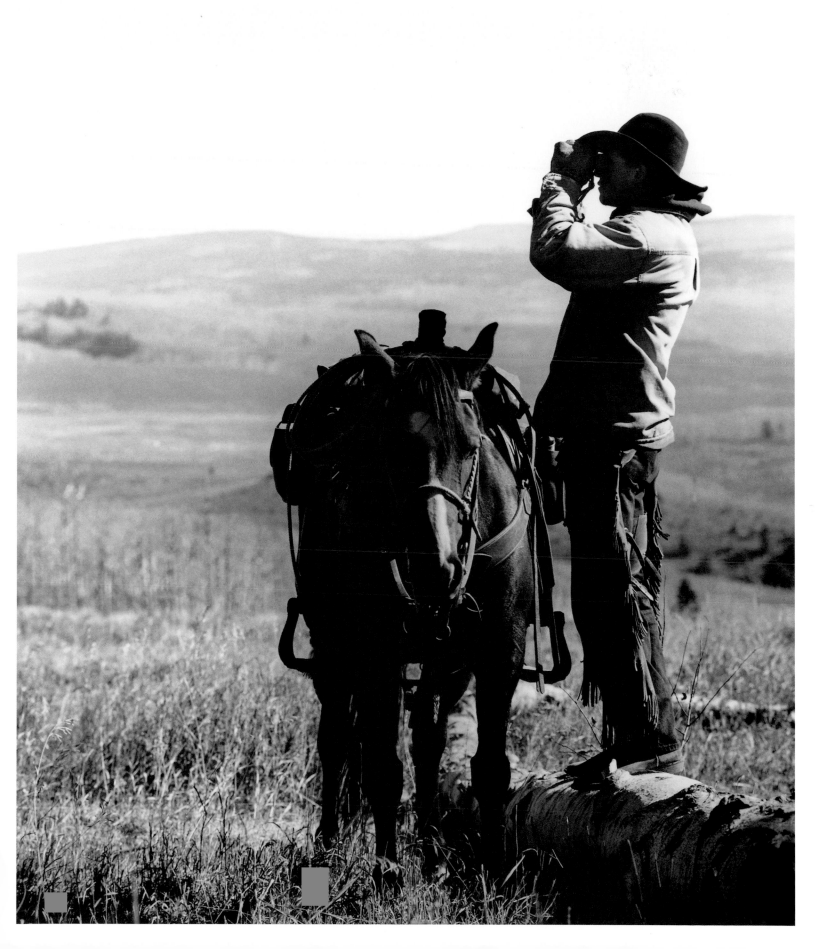

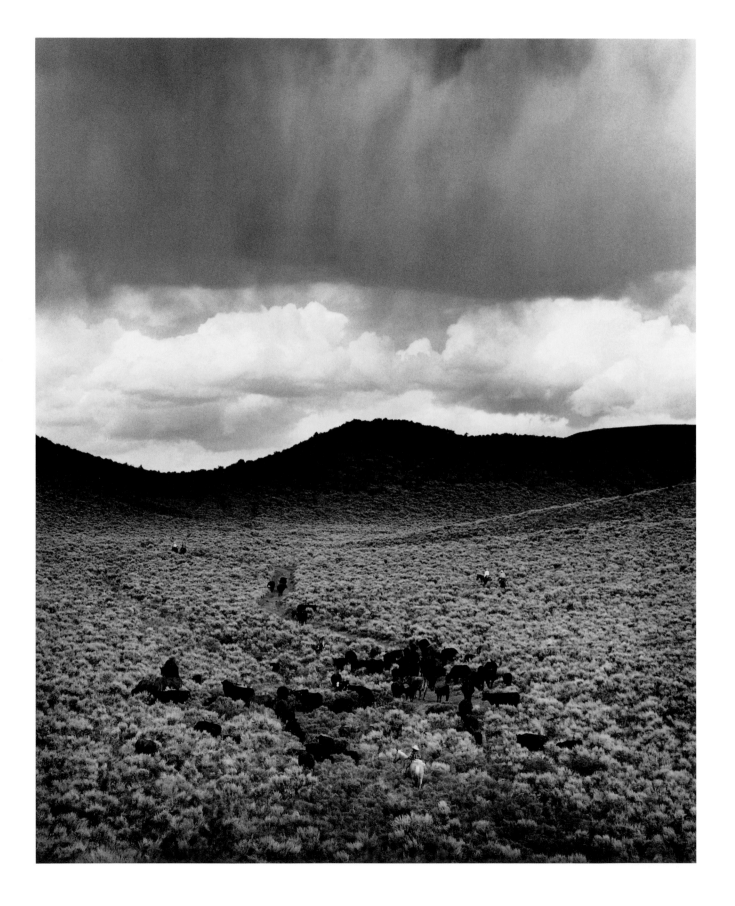

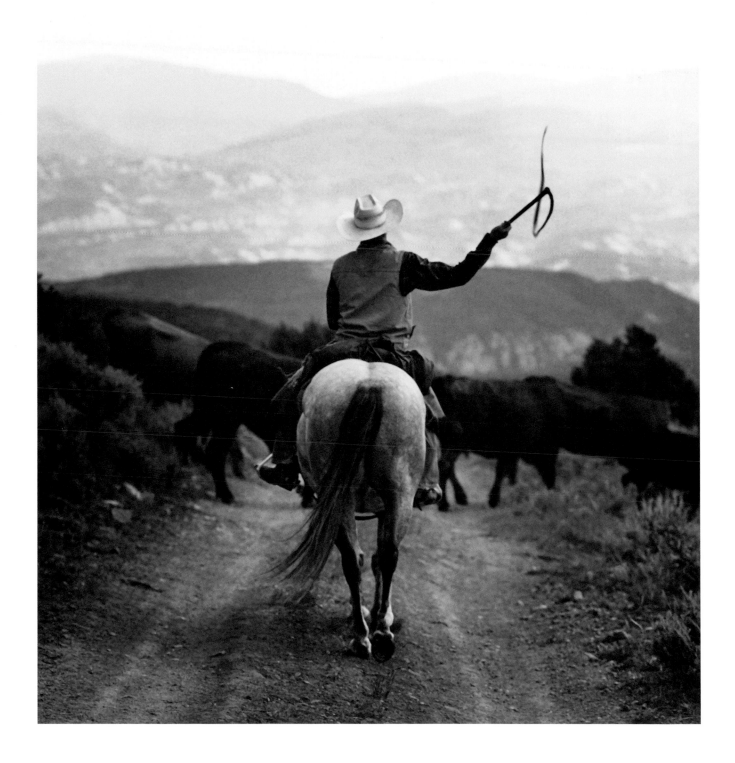

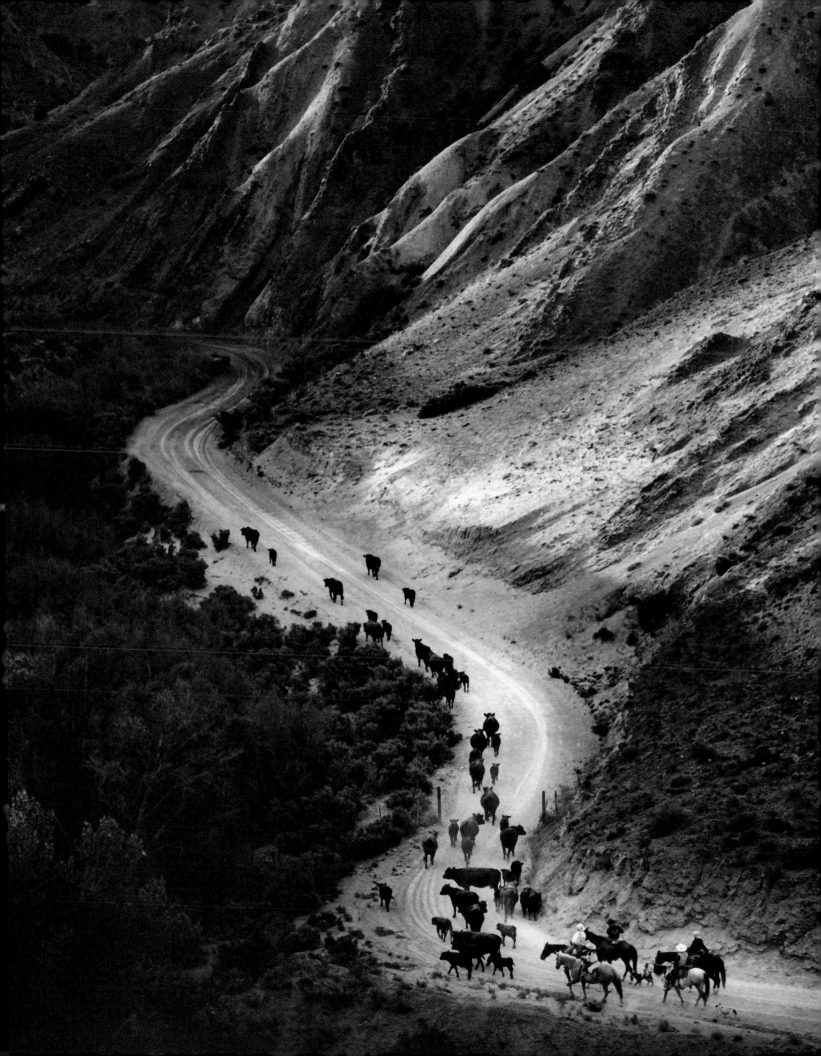

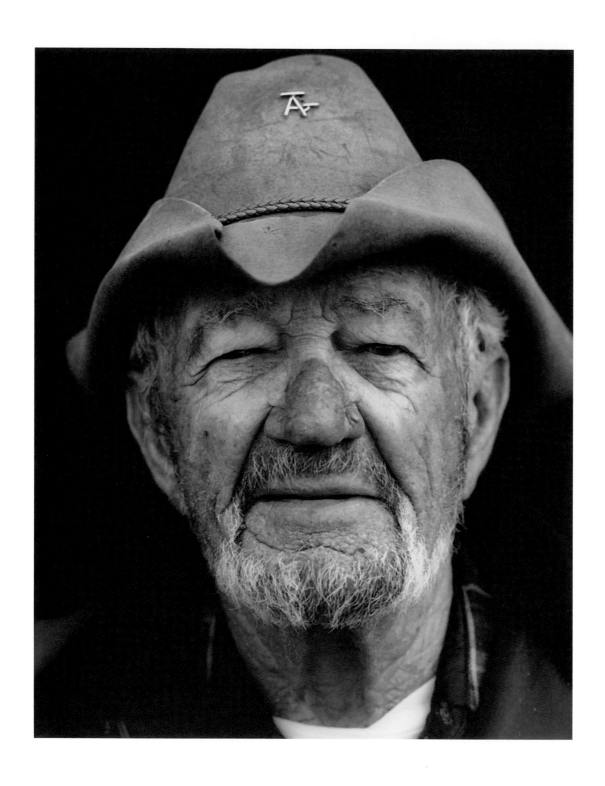

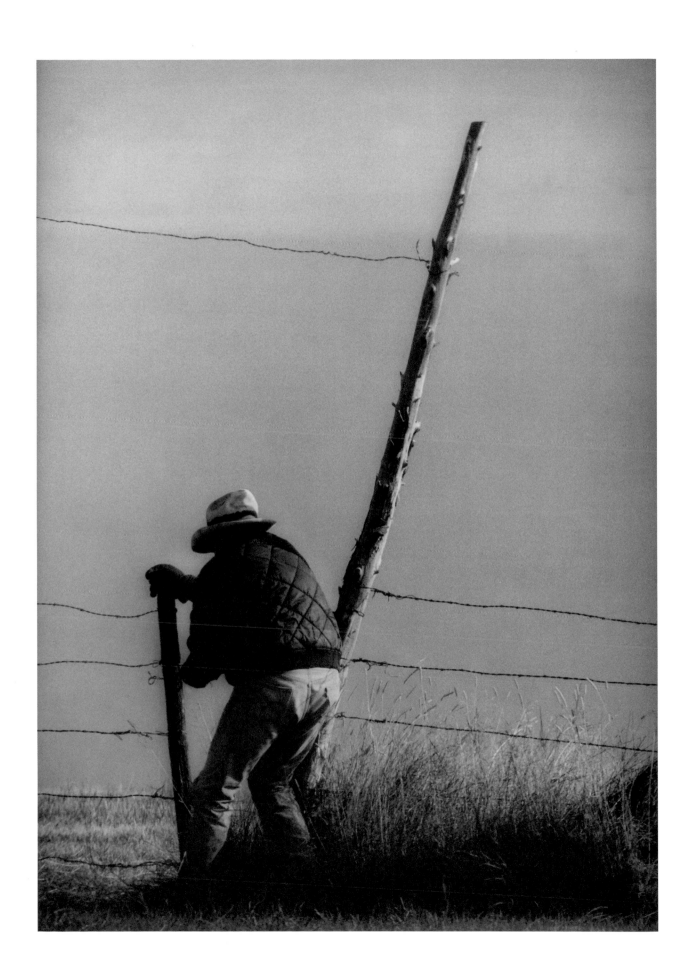

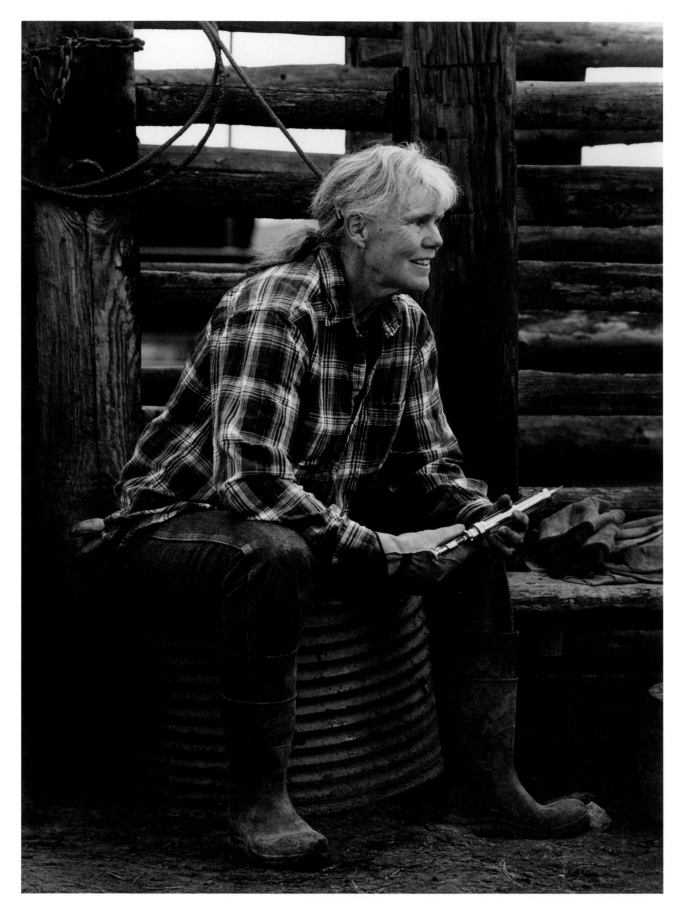

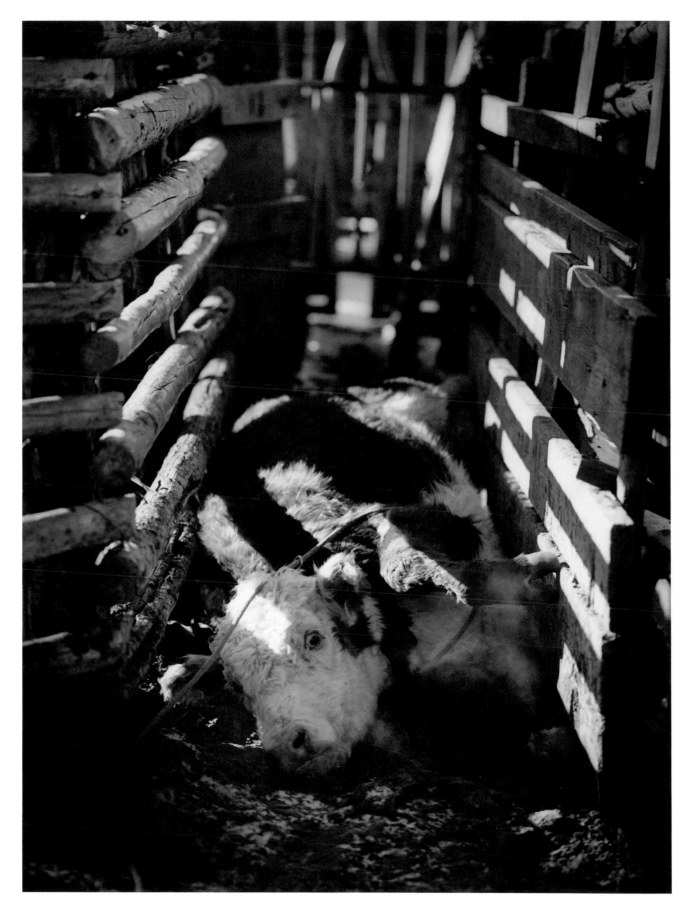

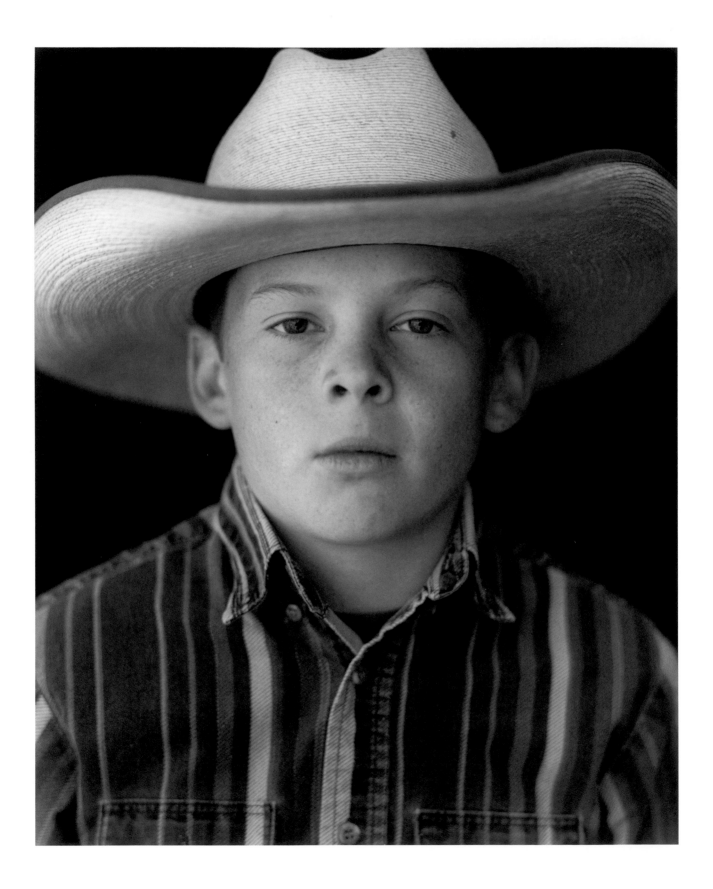

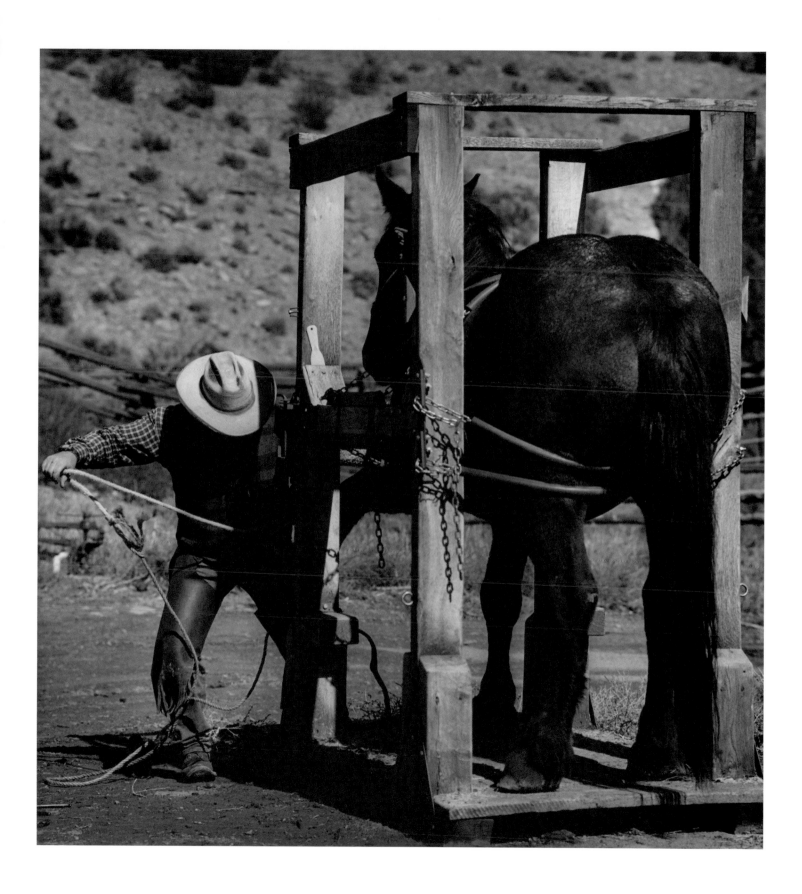

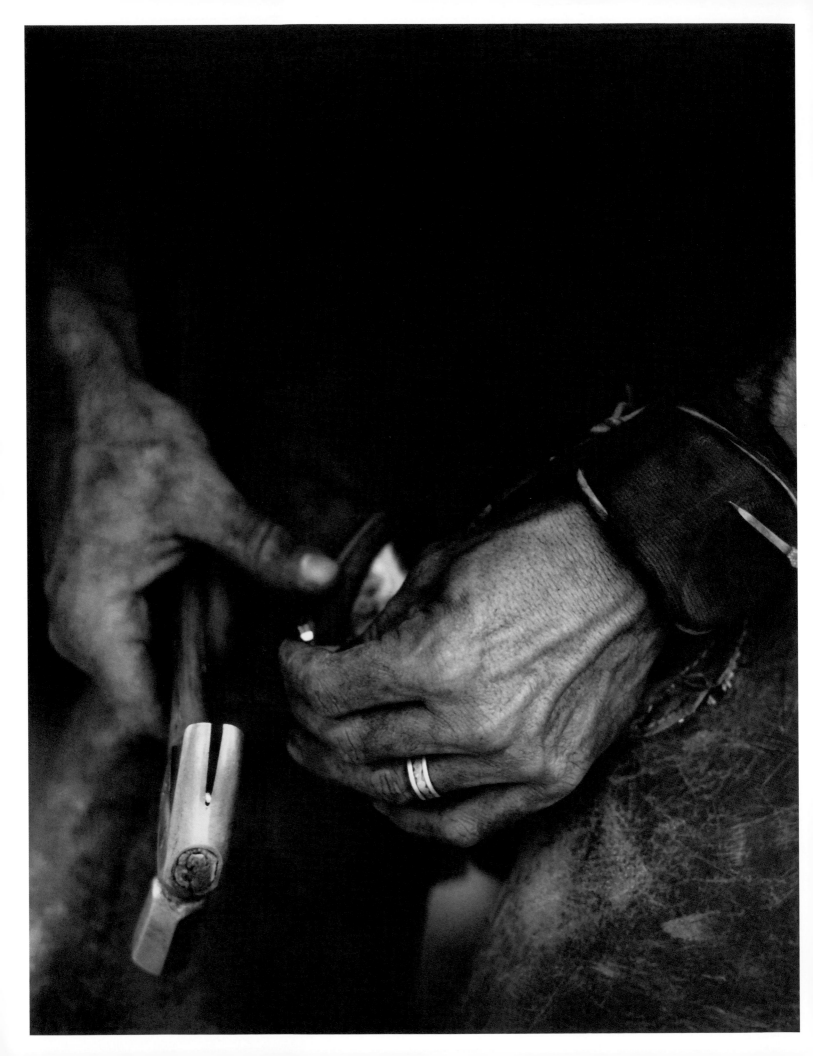

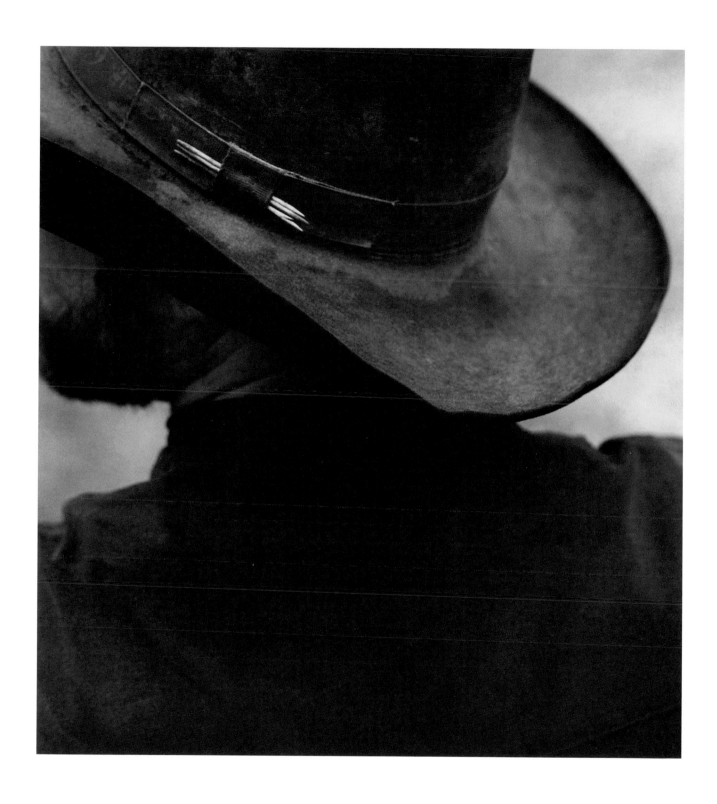

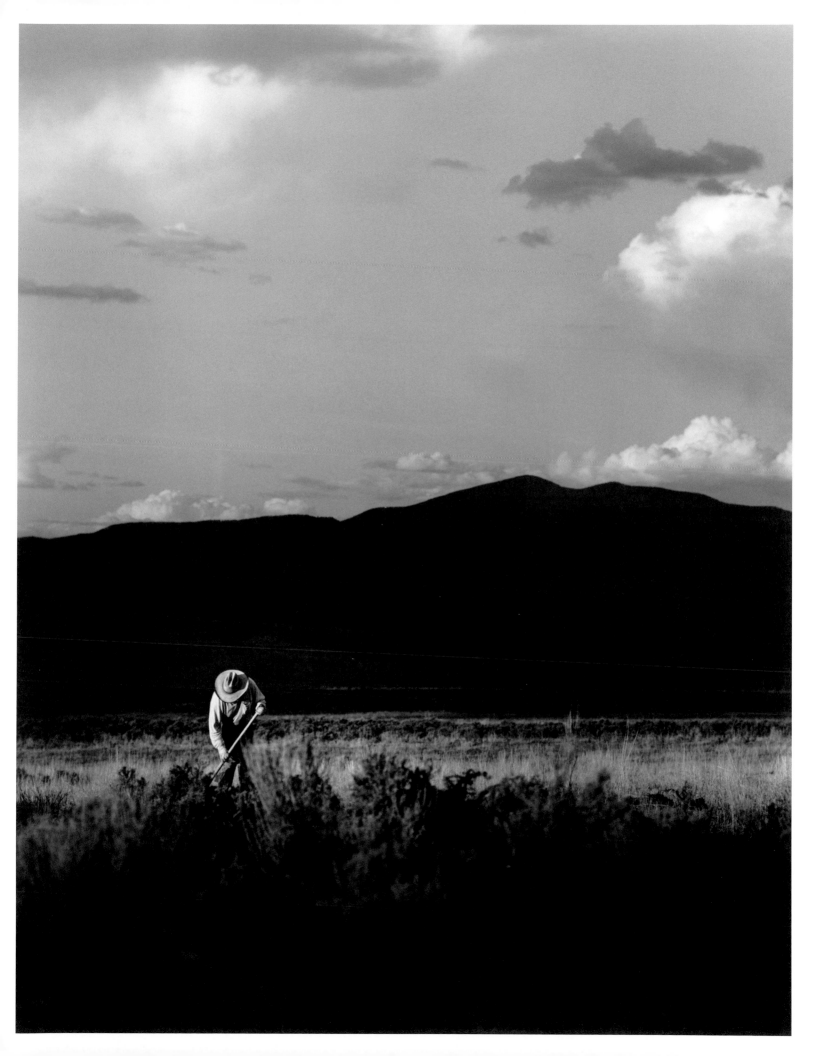

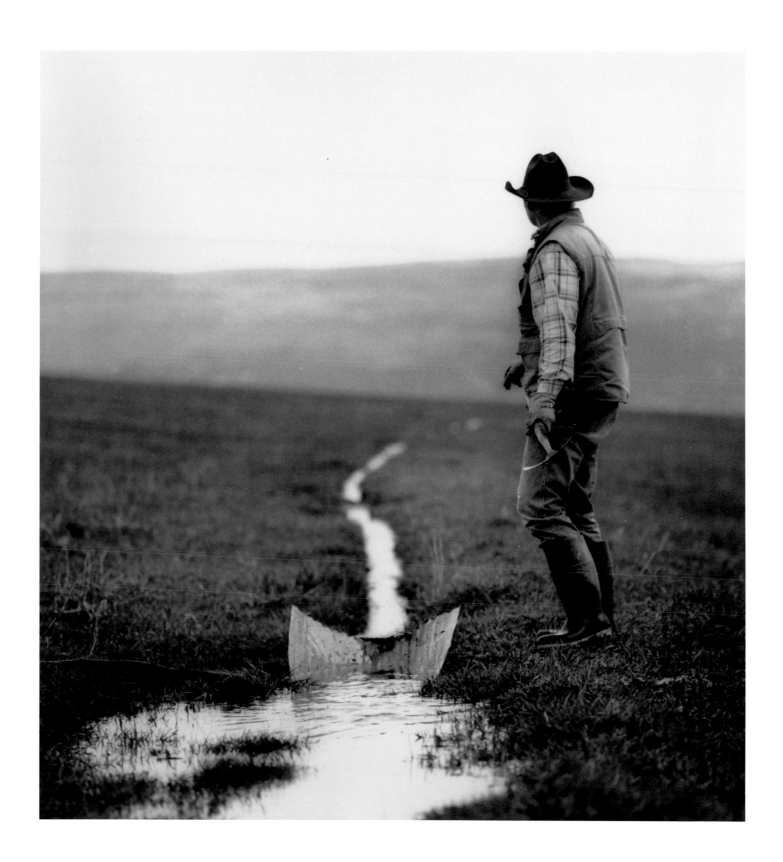

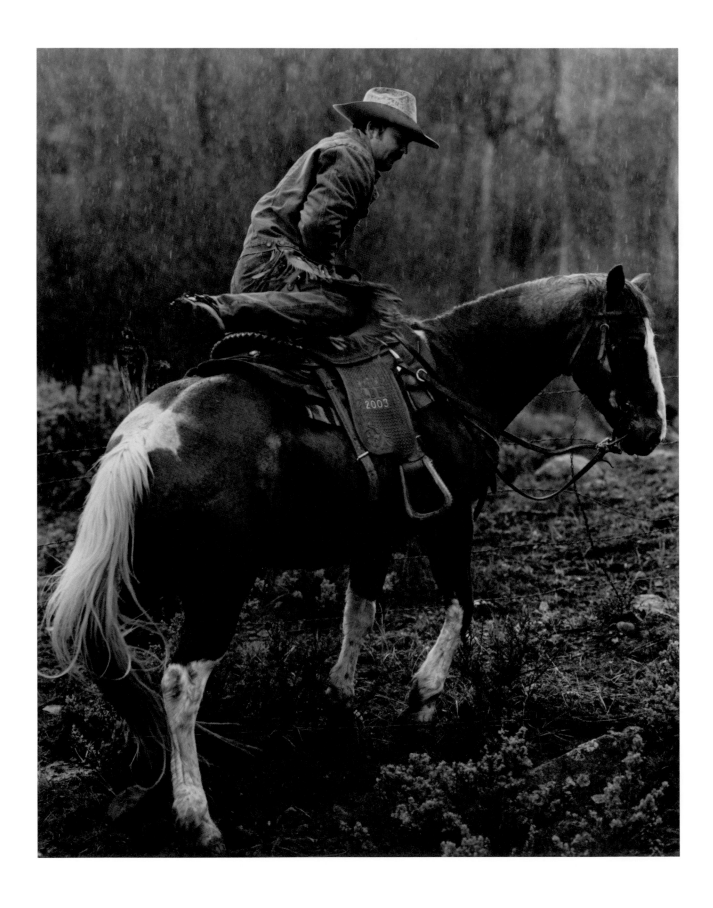

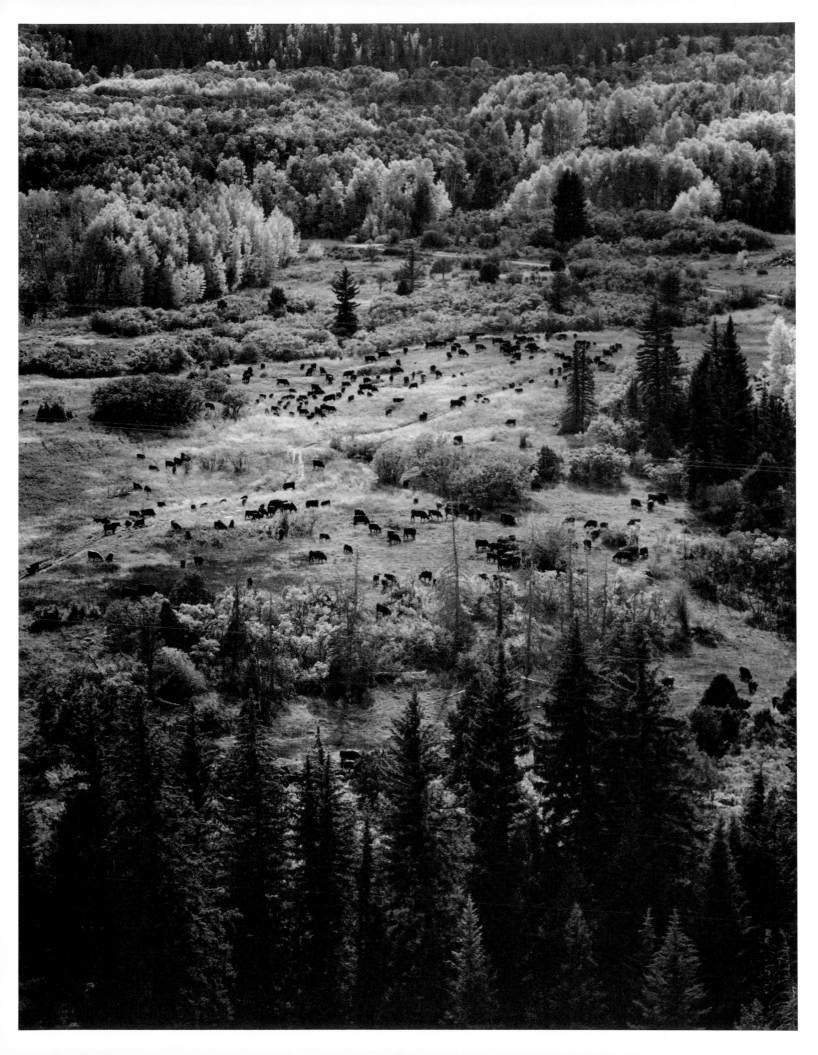

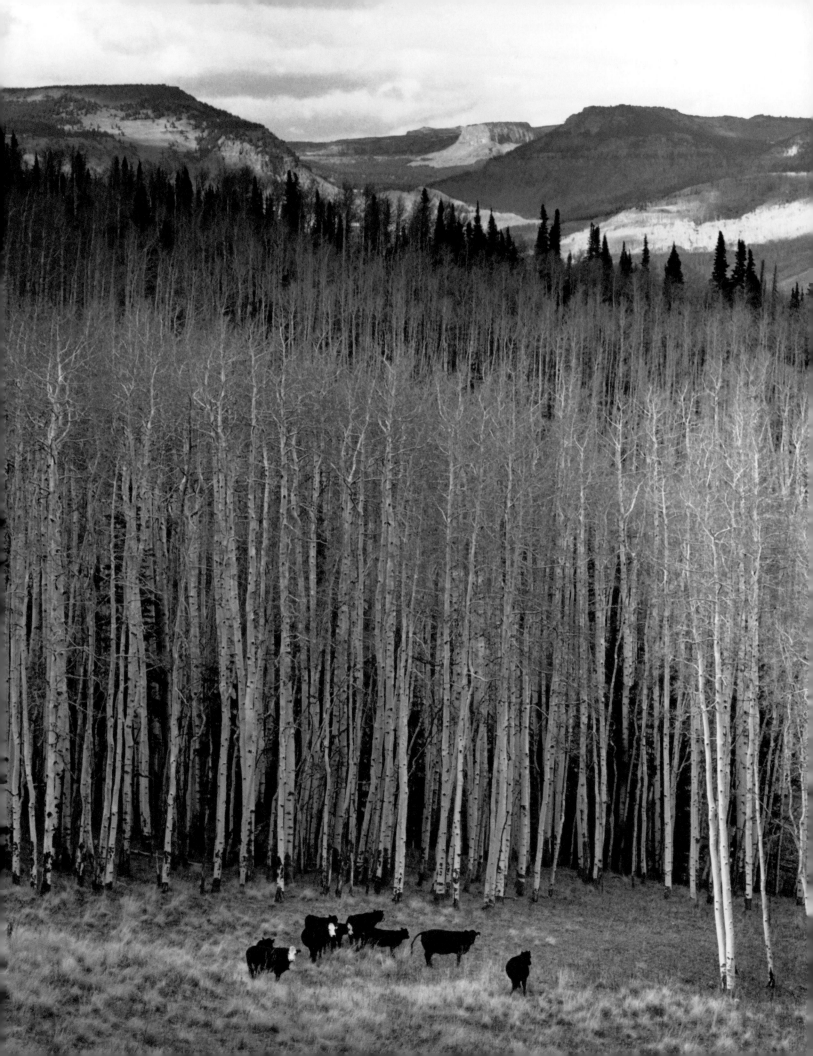

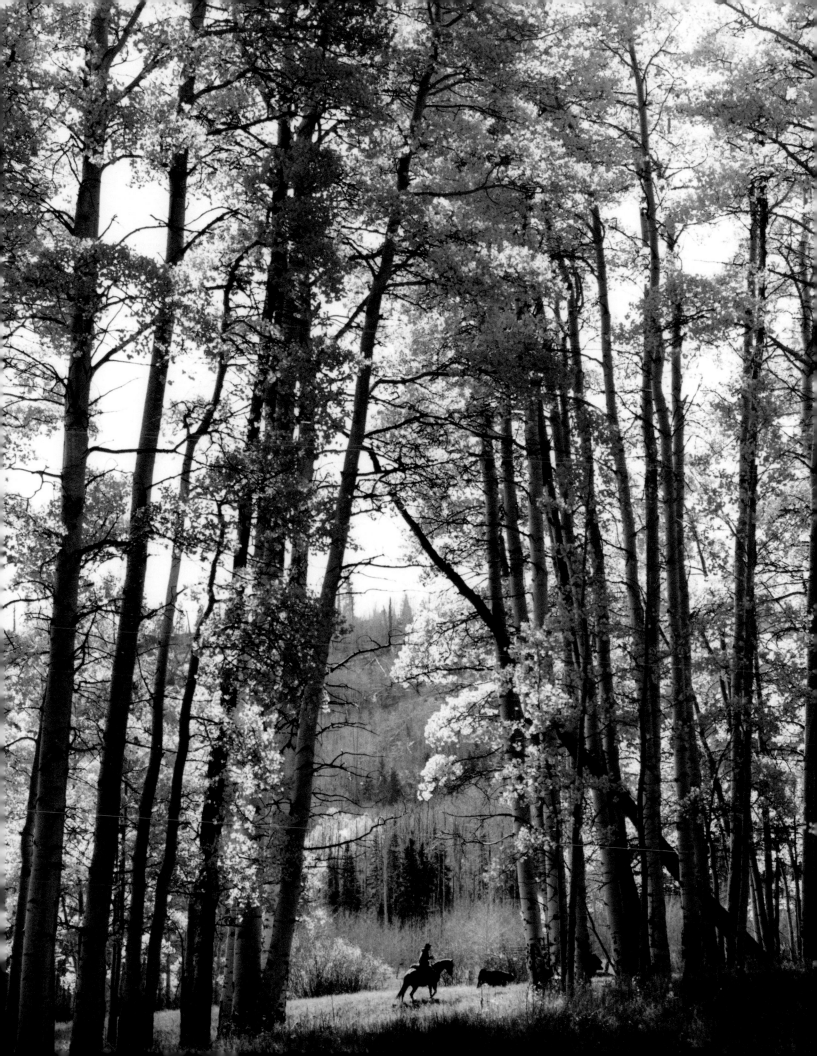

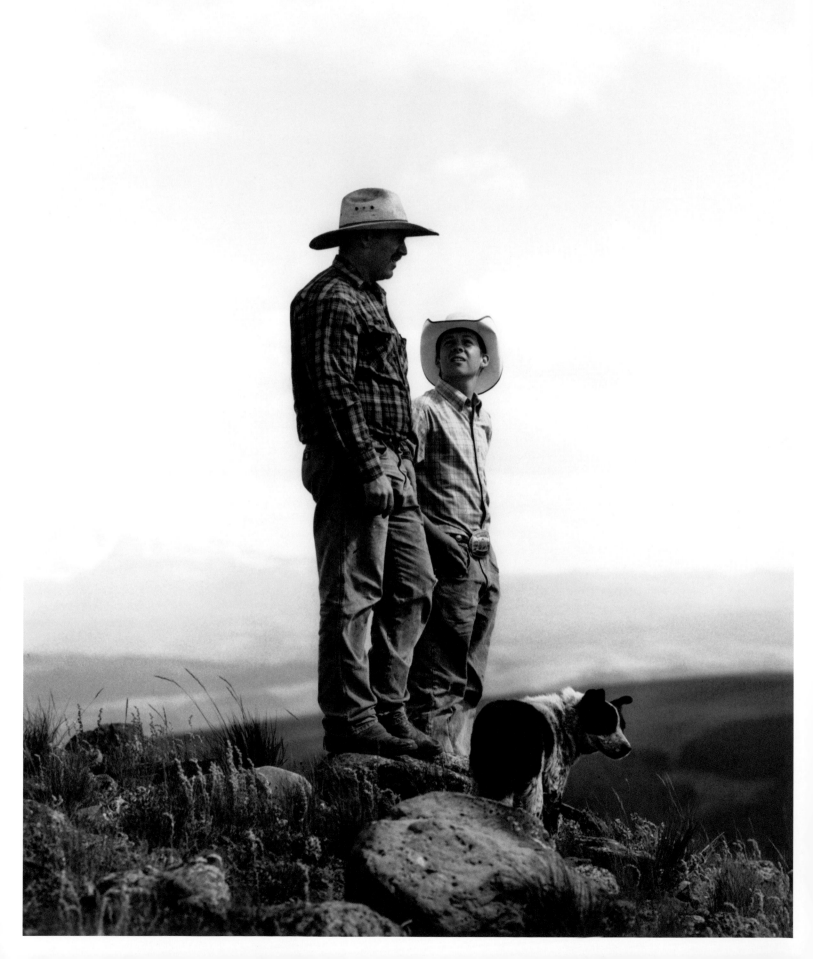

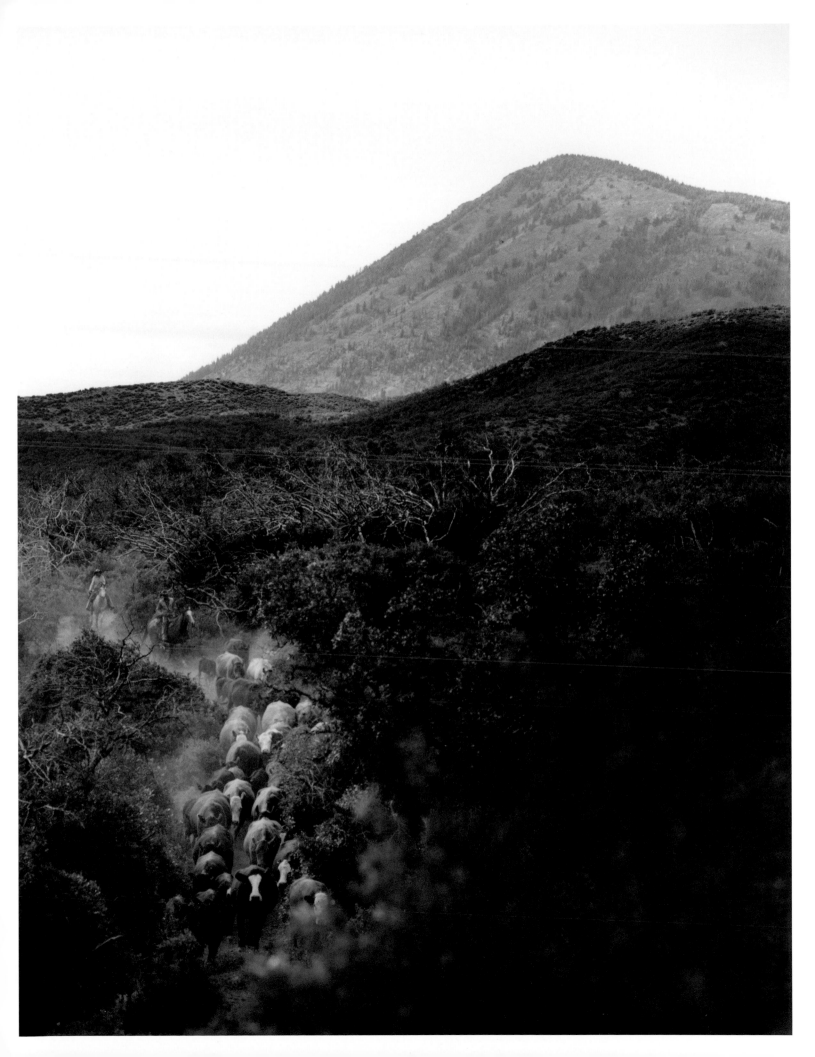

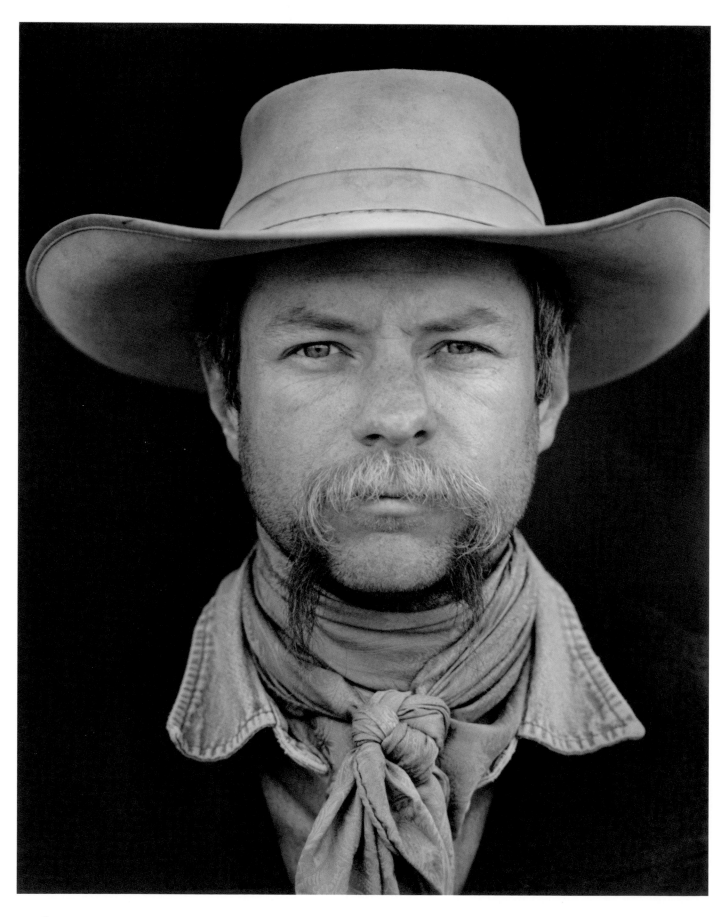

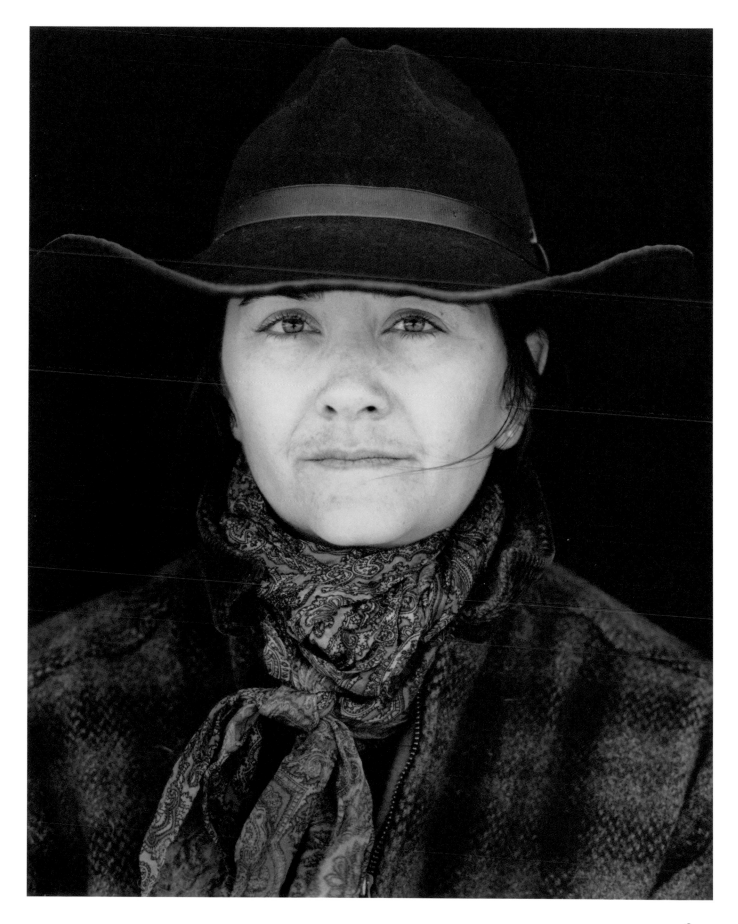

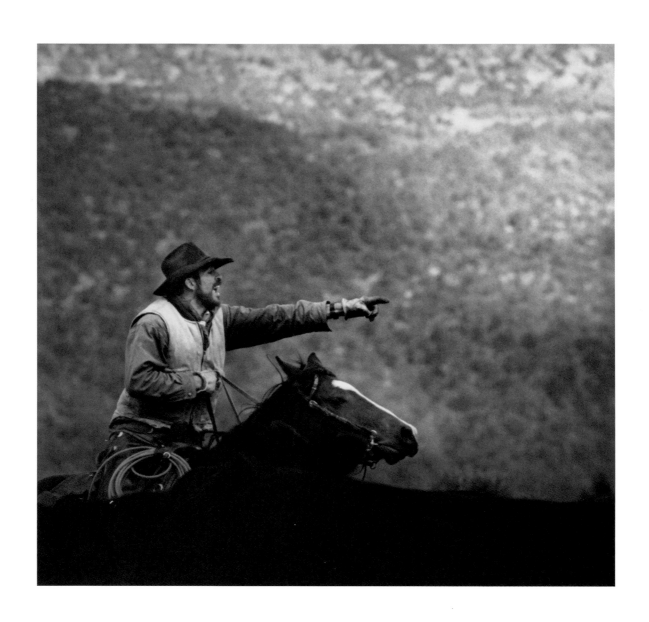

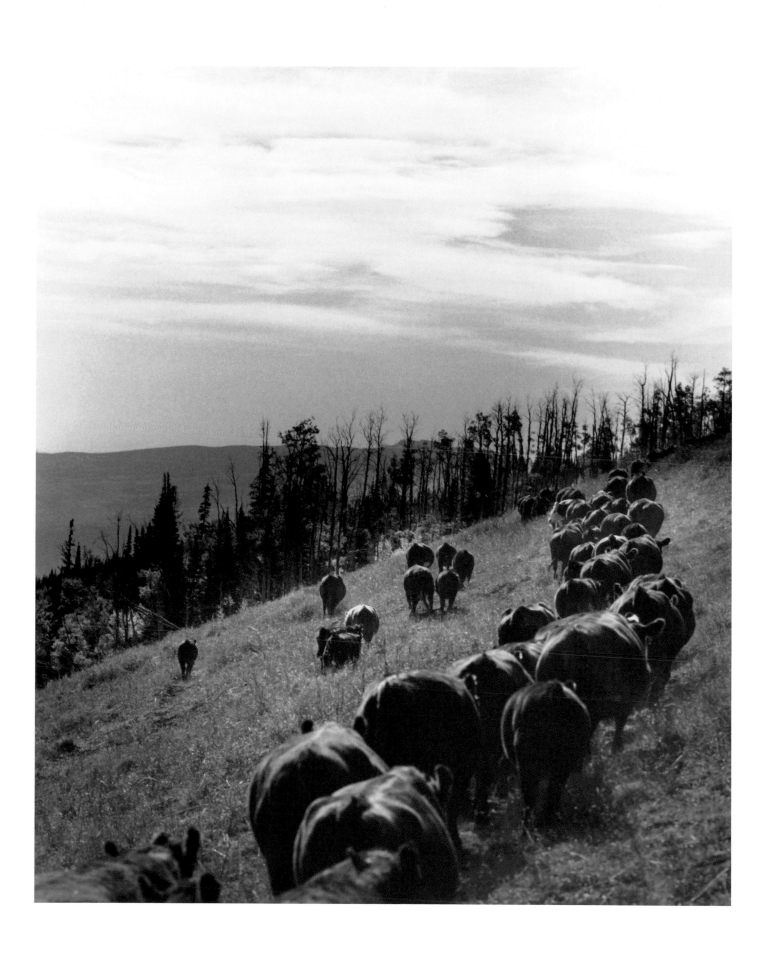

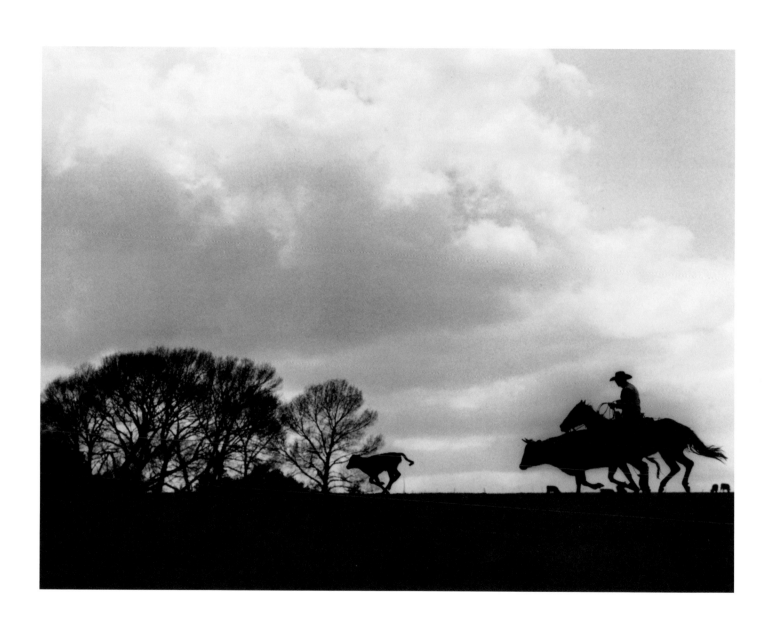

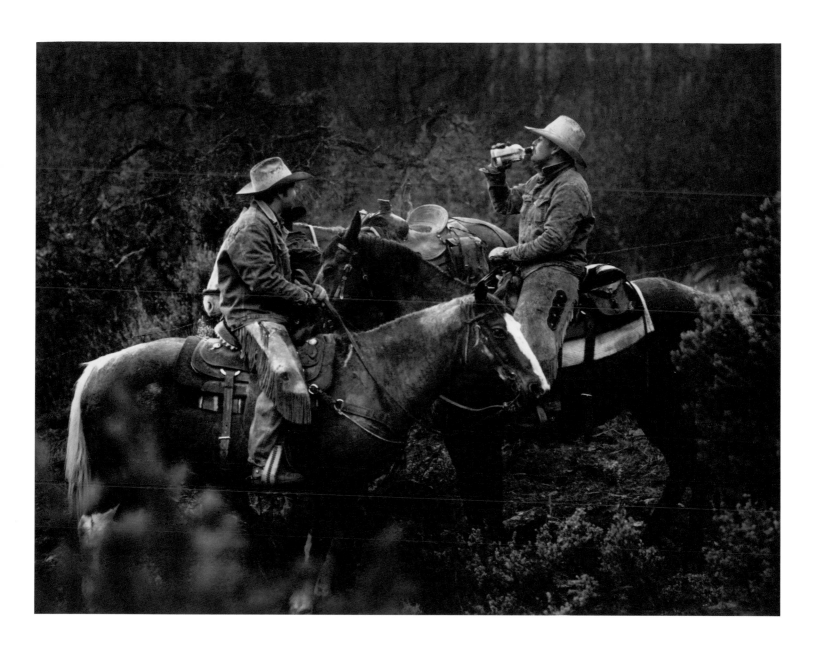

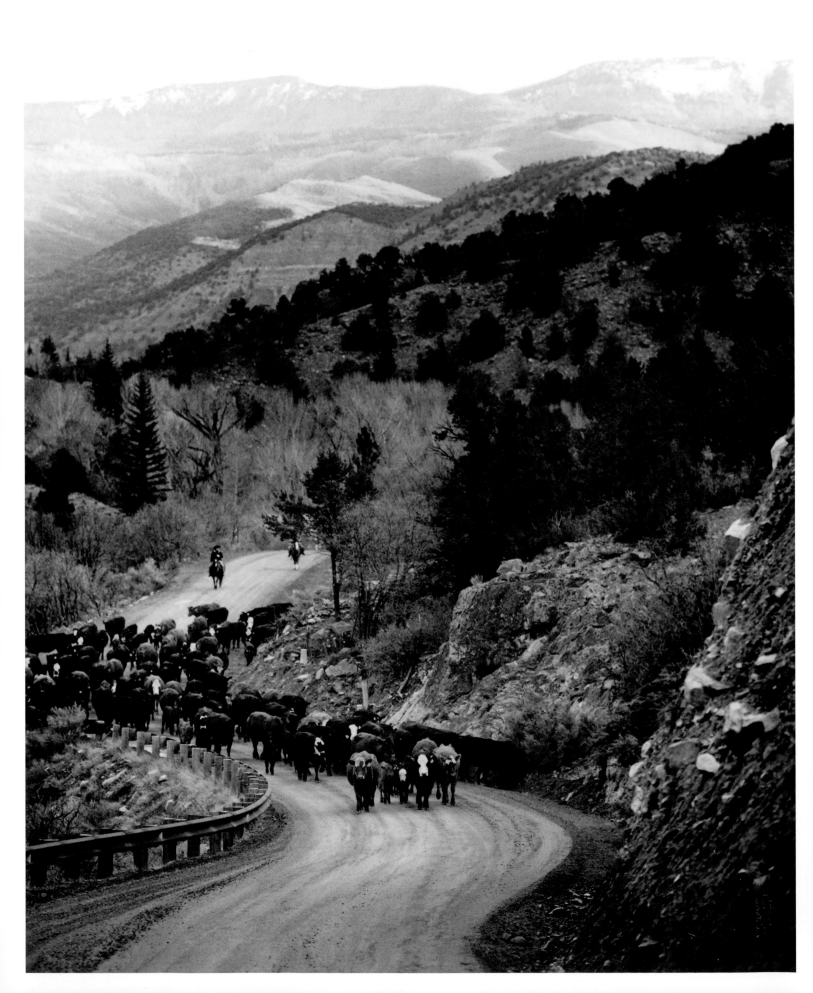

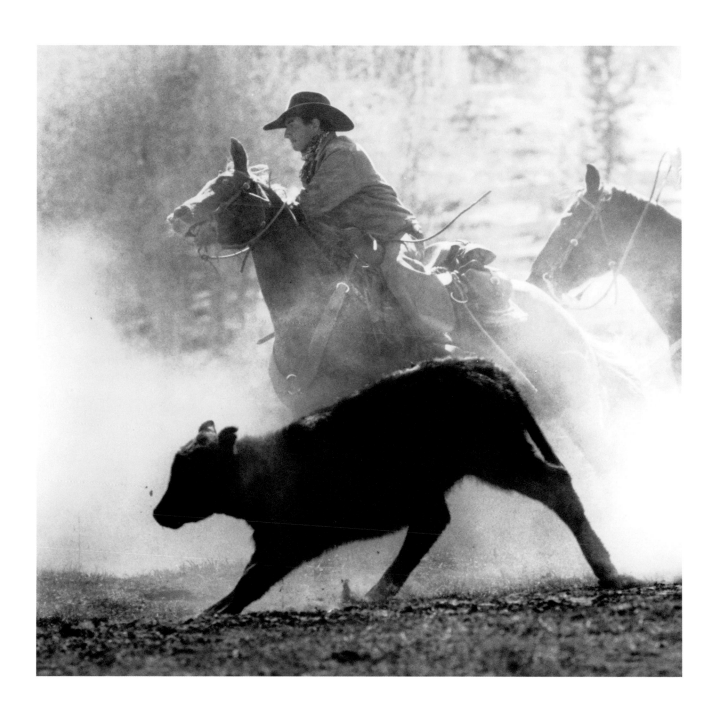

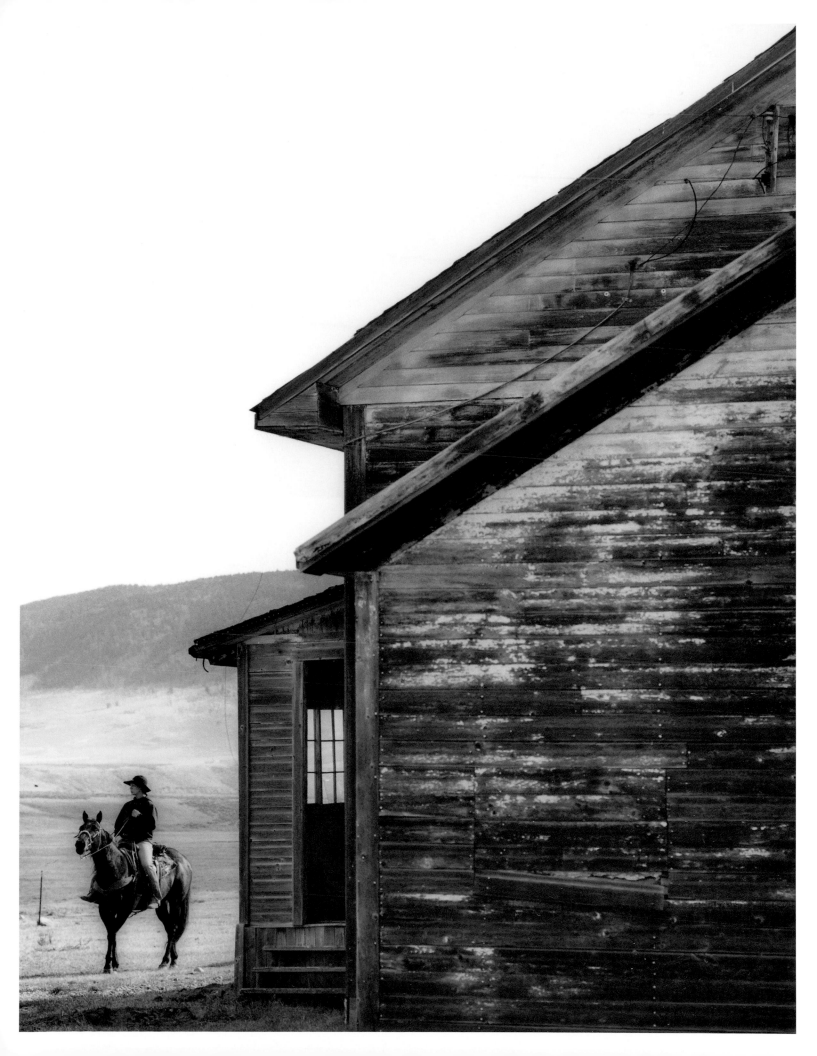

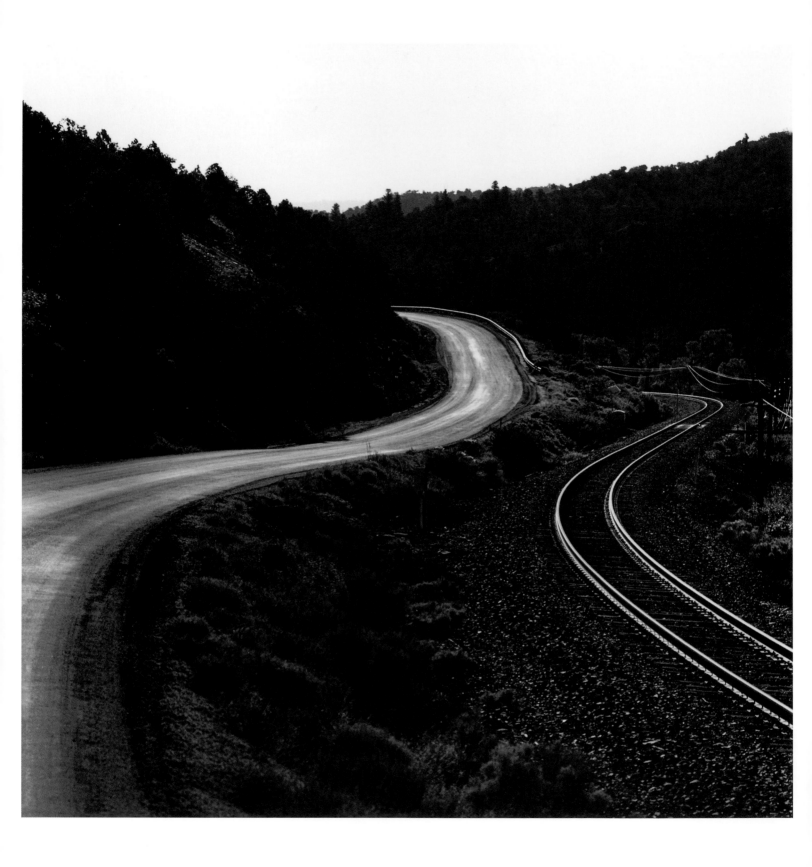

146

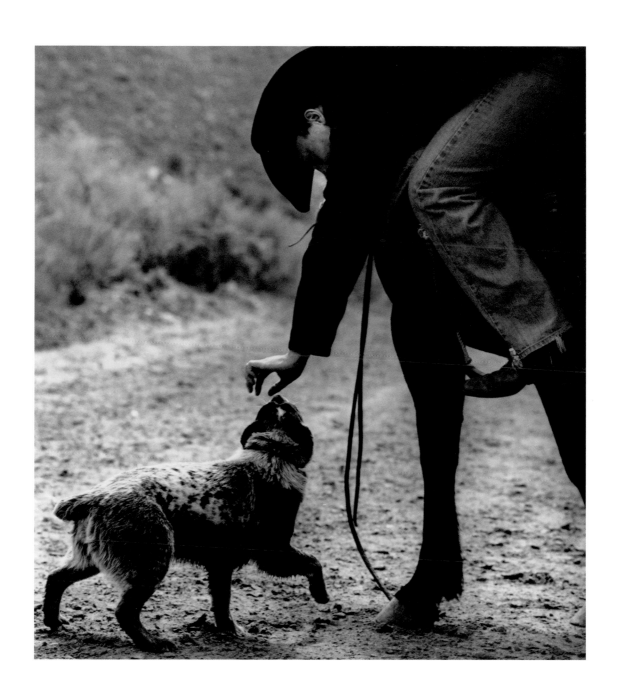

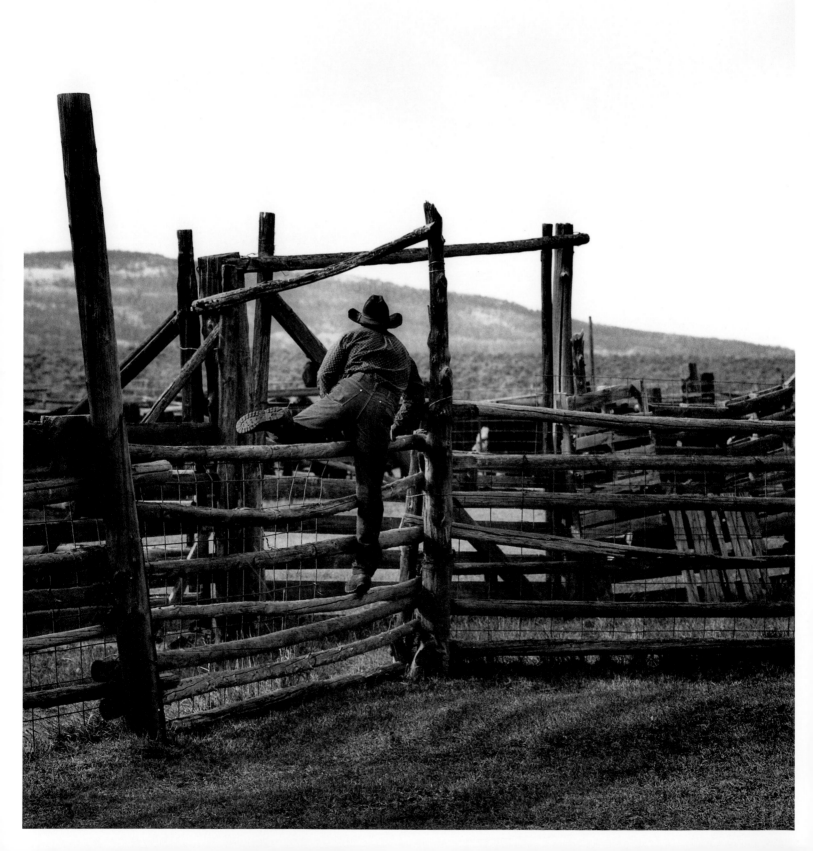

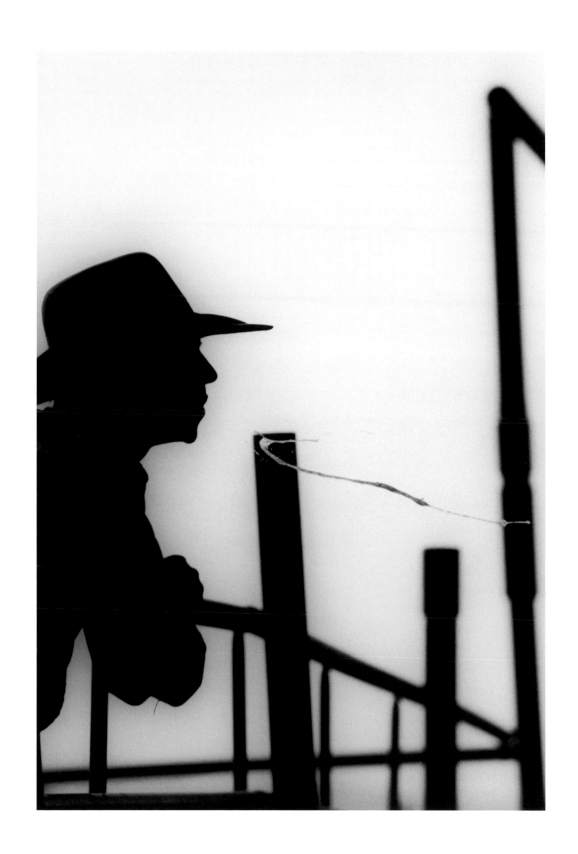

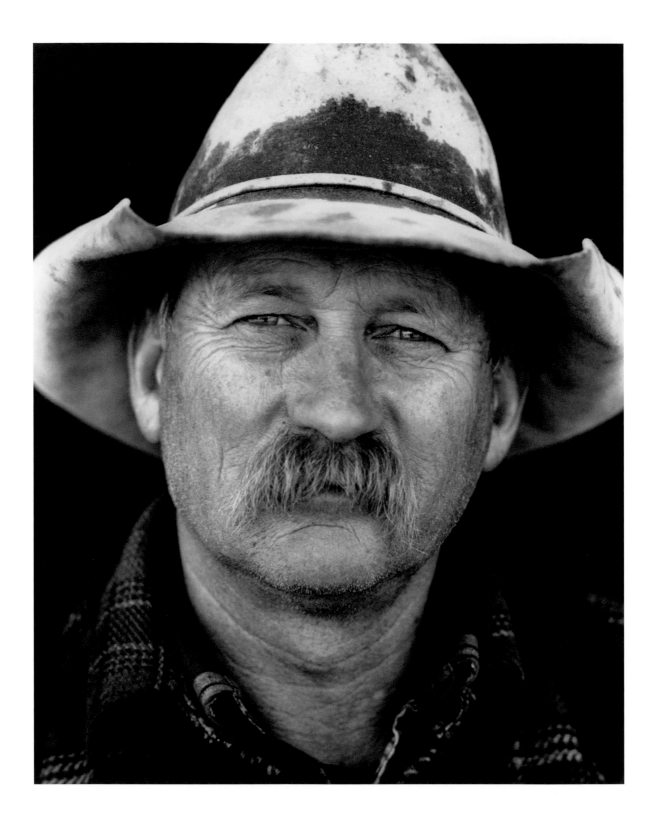

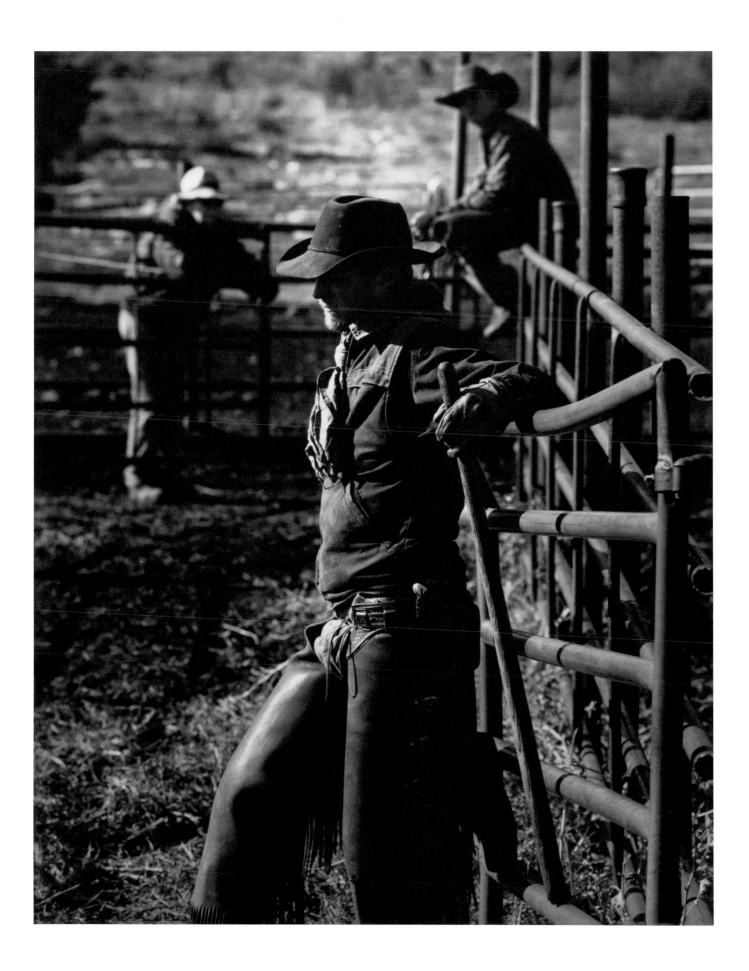

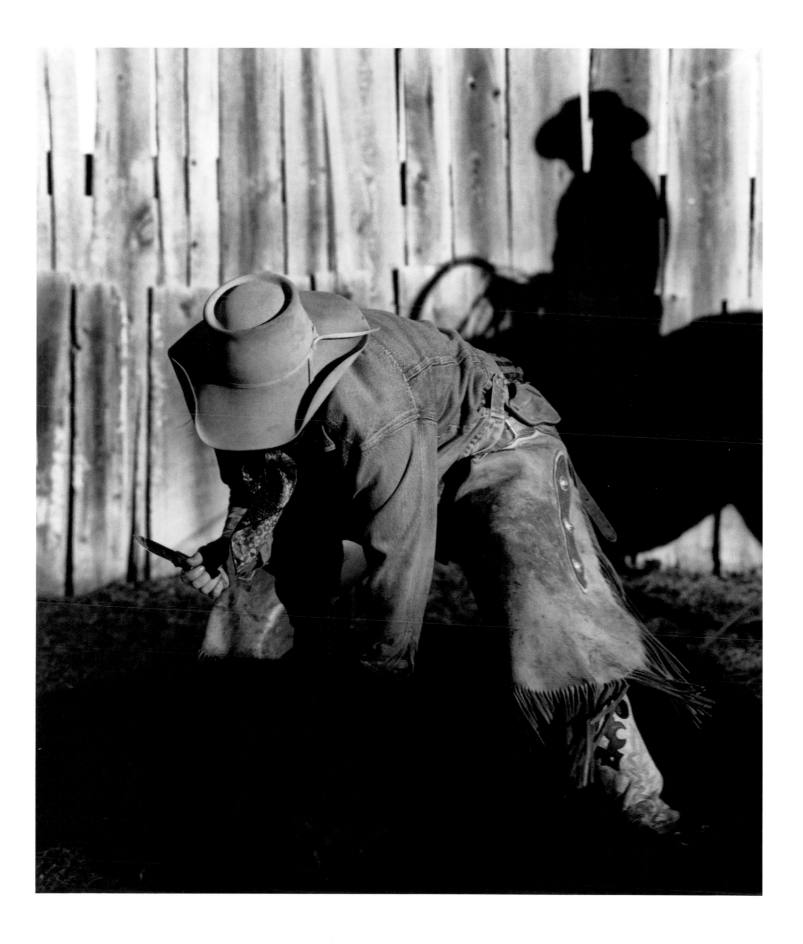

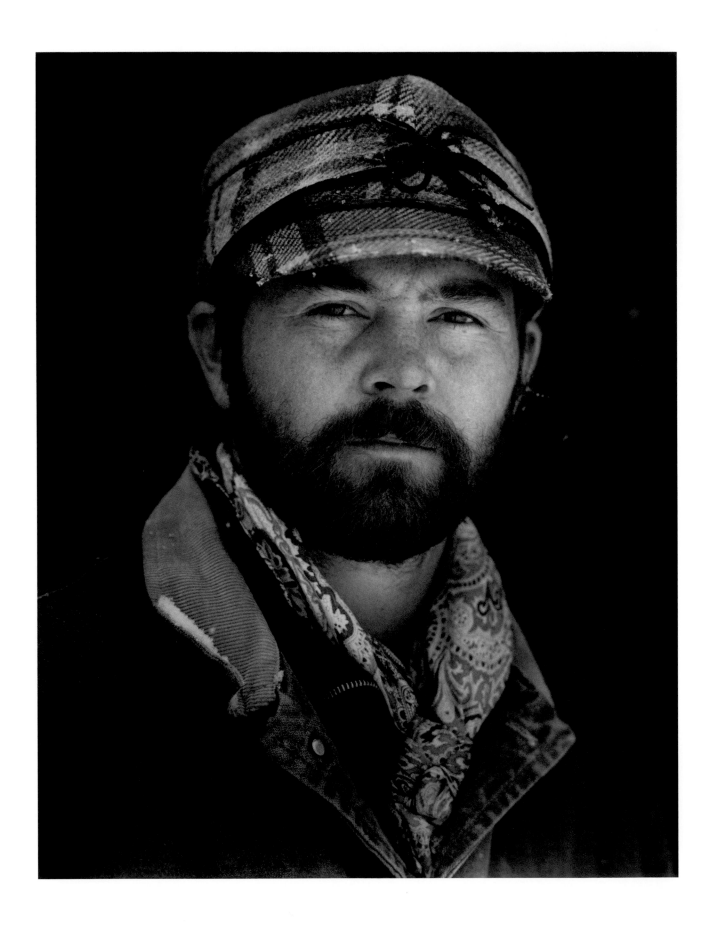

154

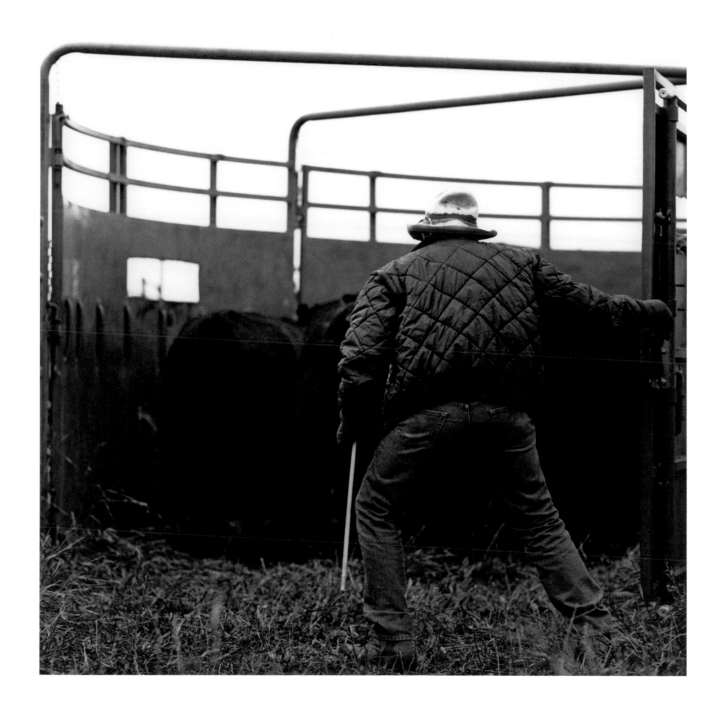

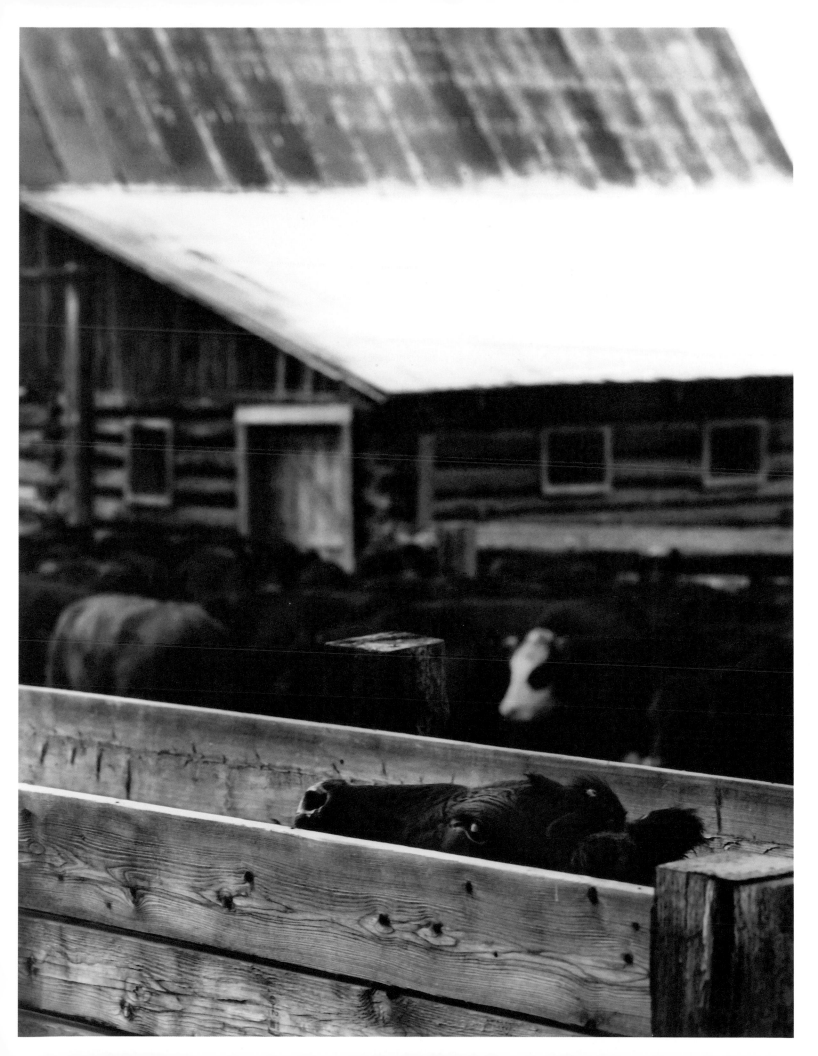

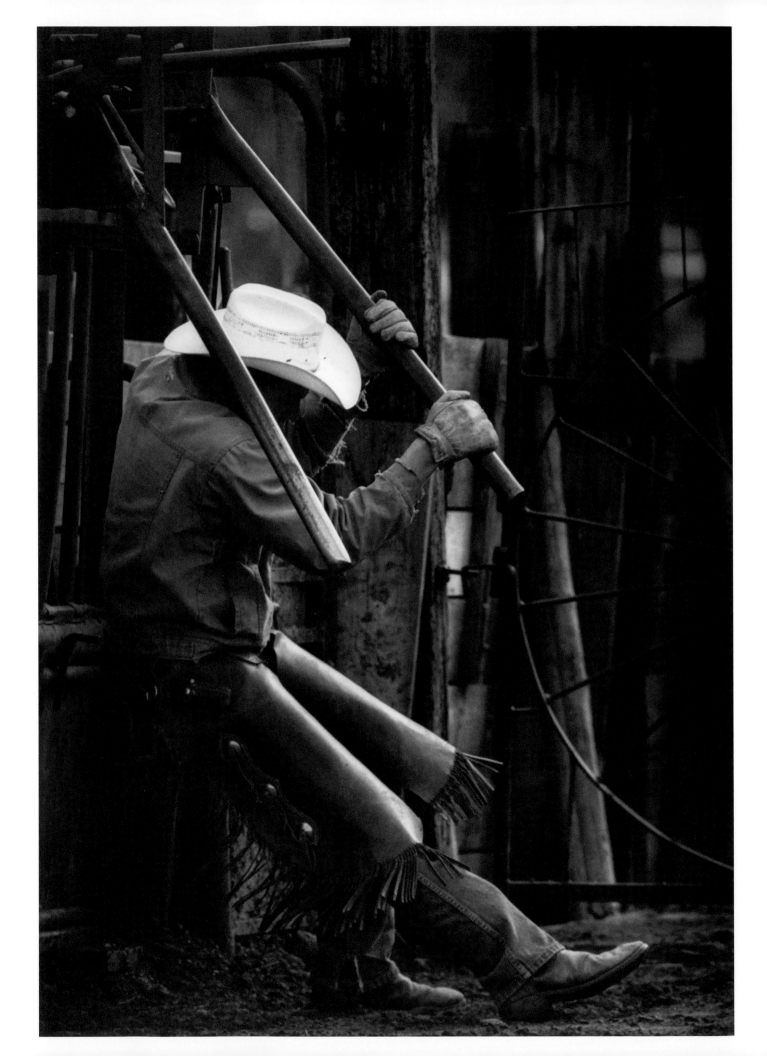

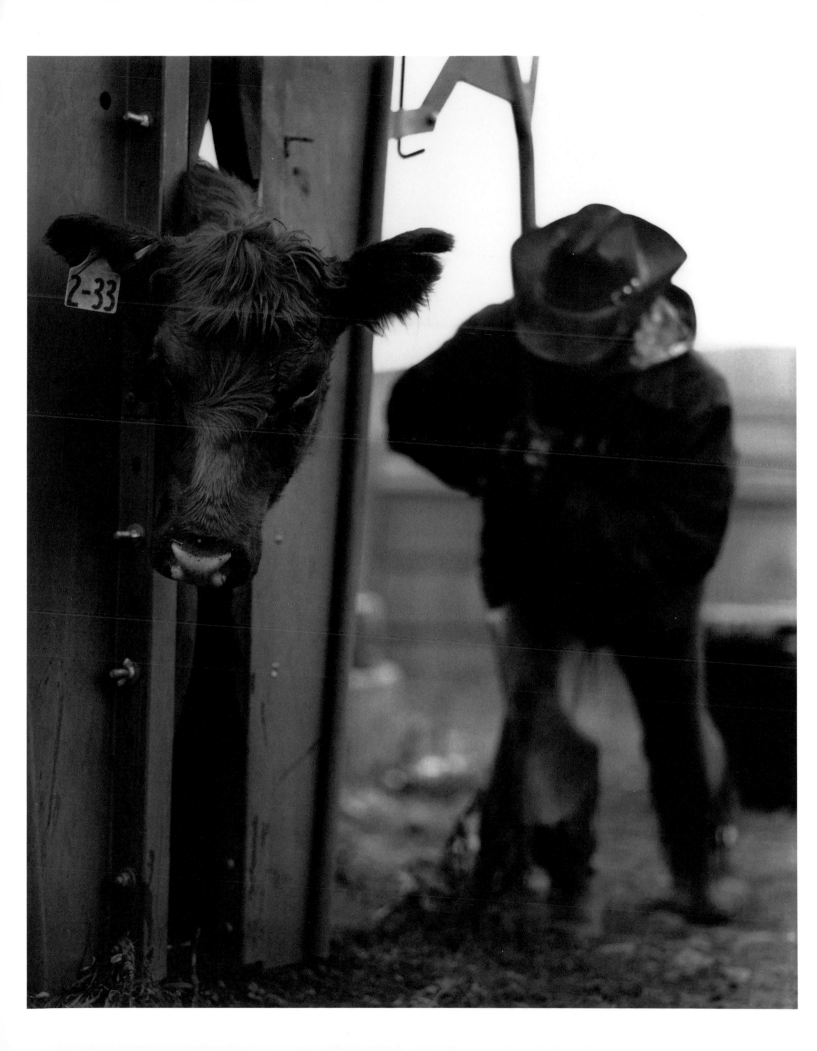

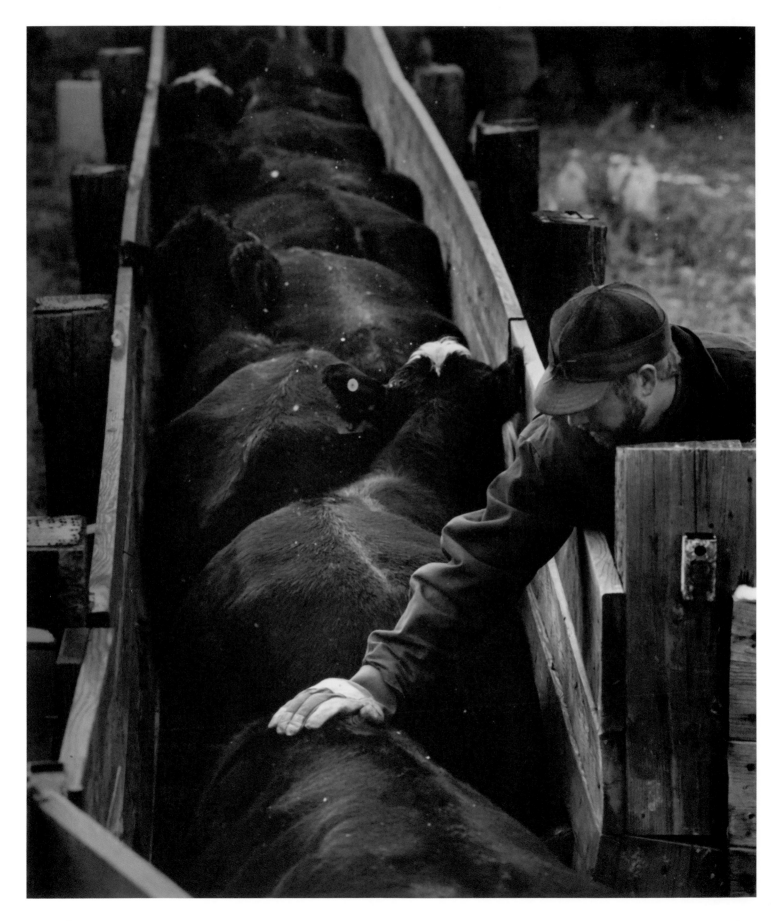

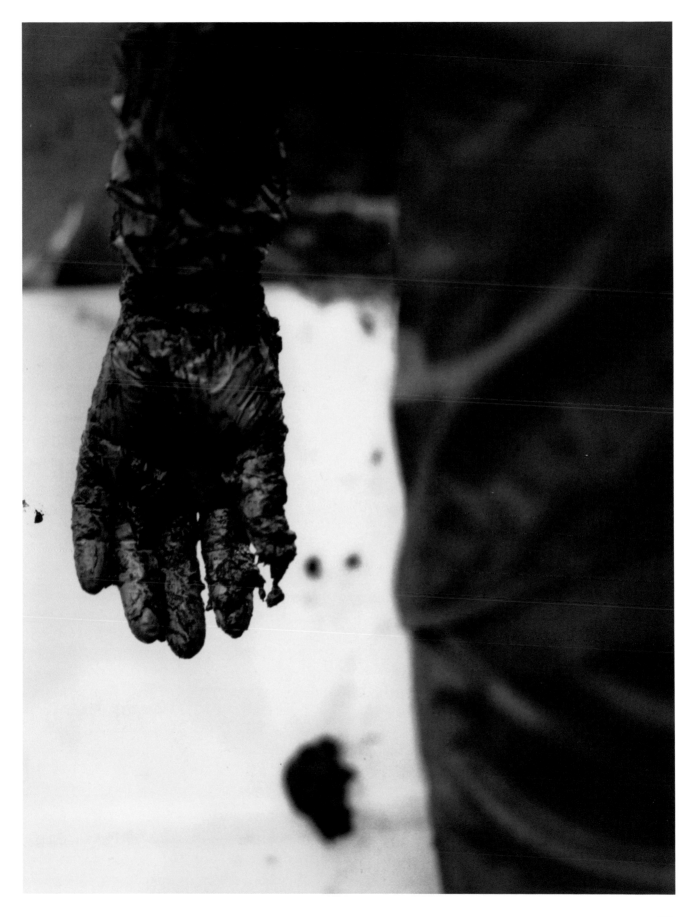

163

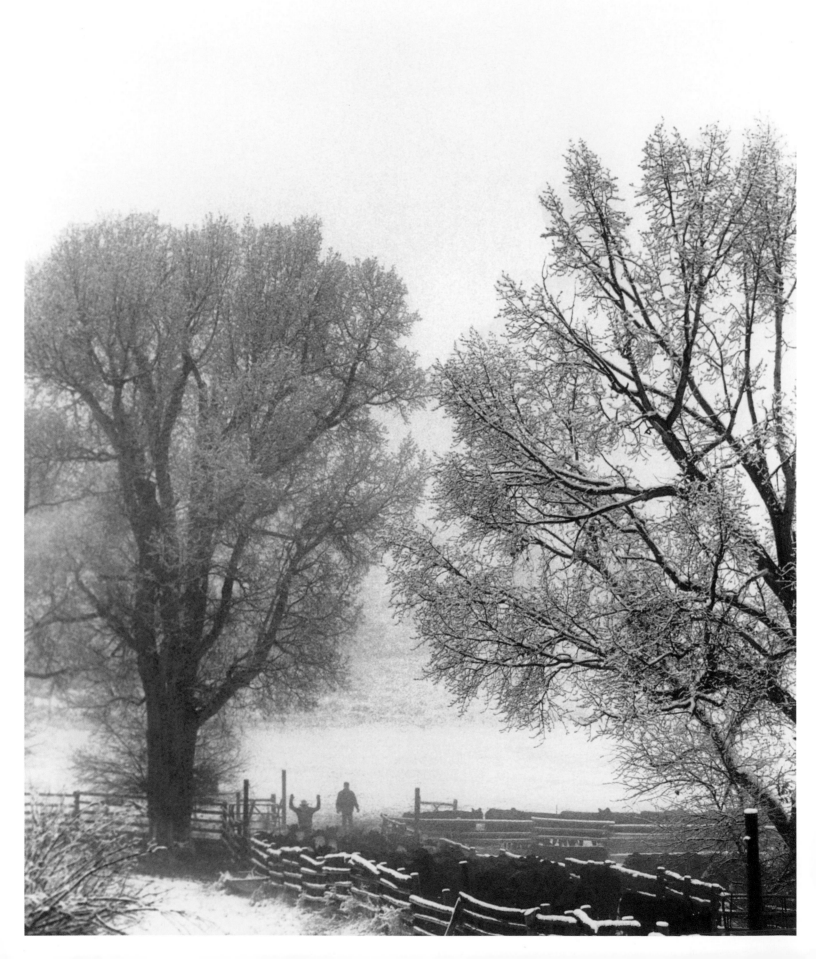

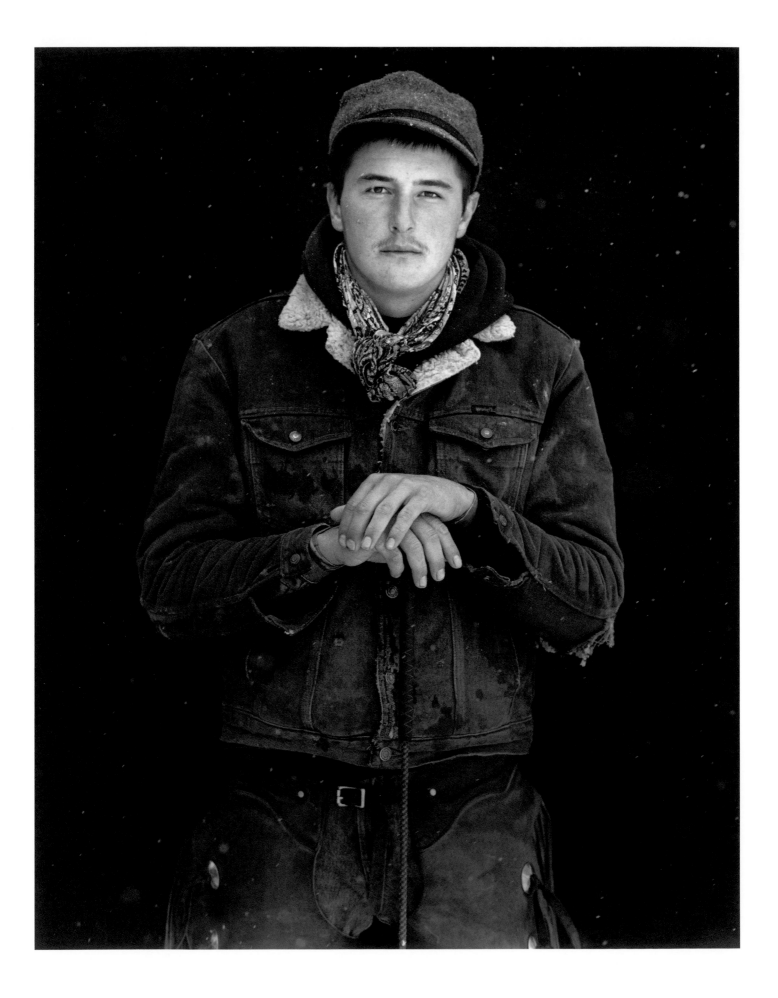

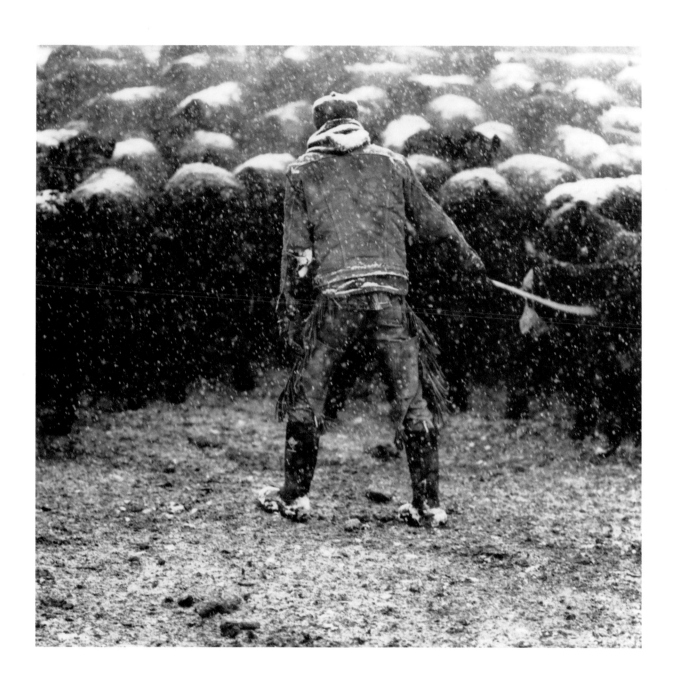

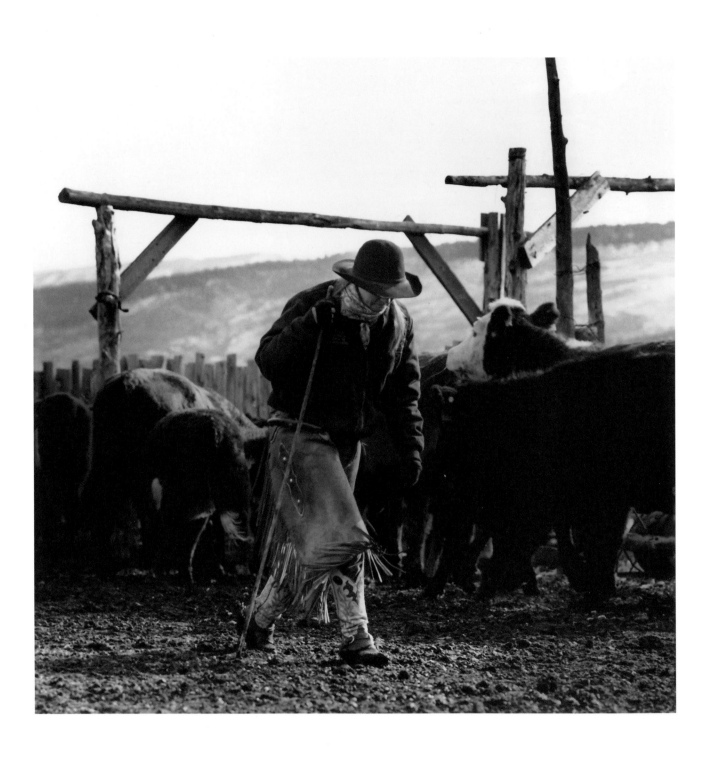

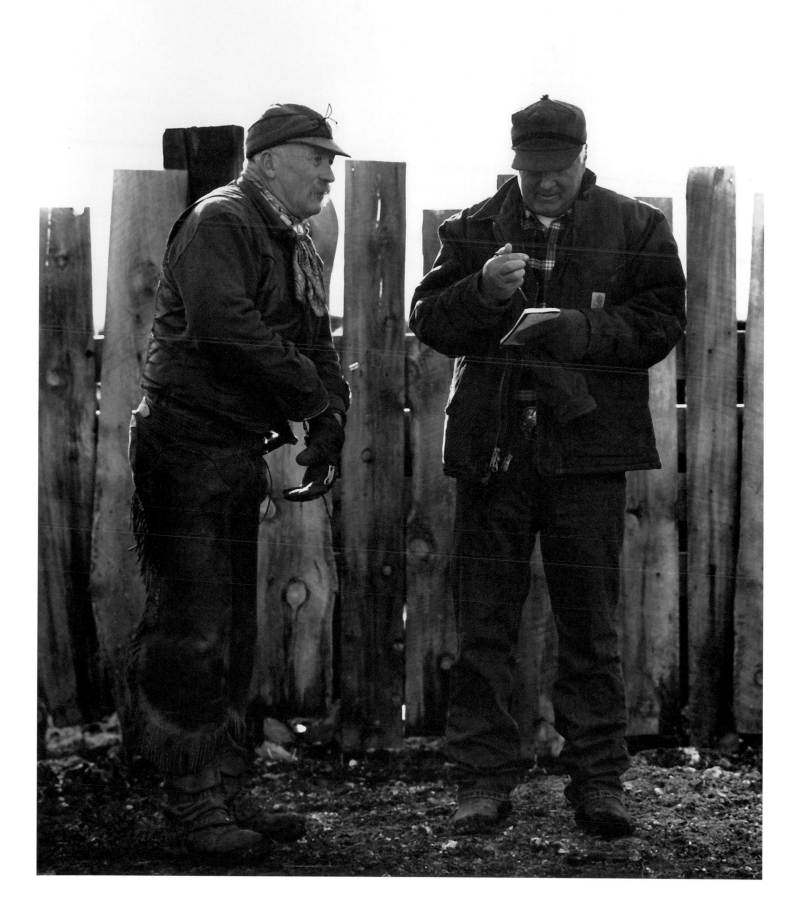

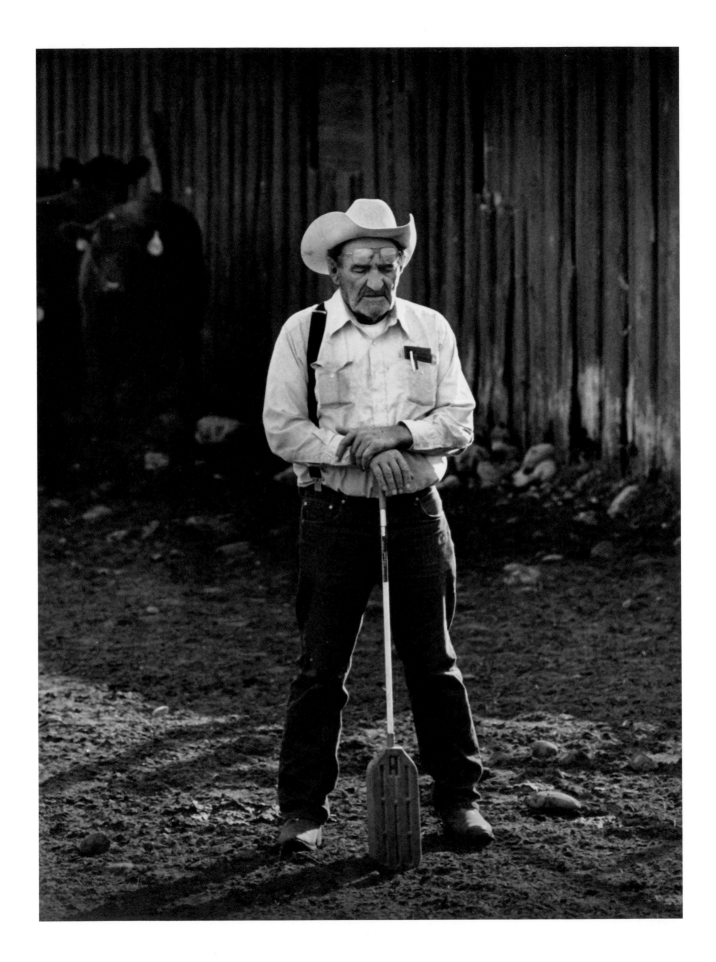

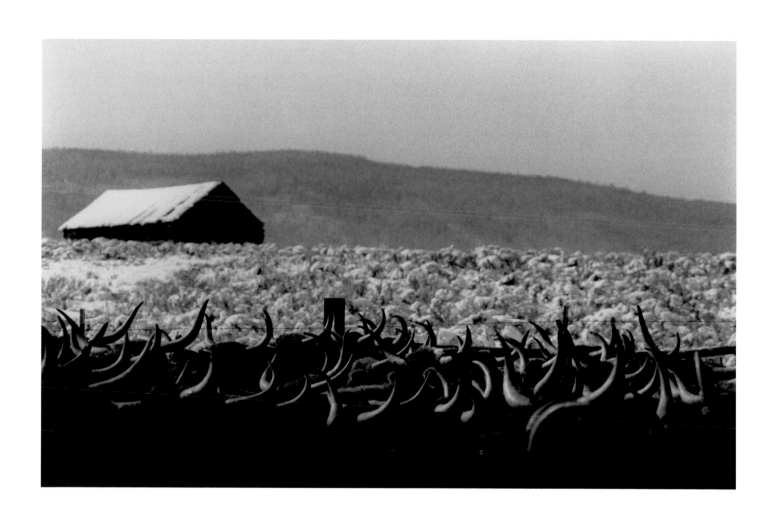

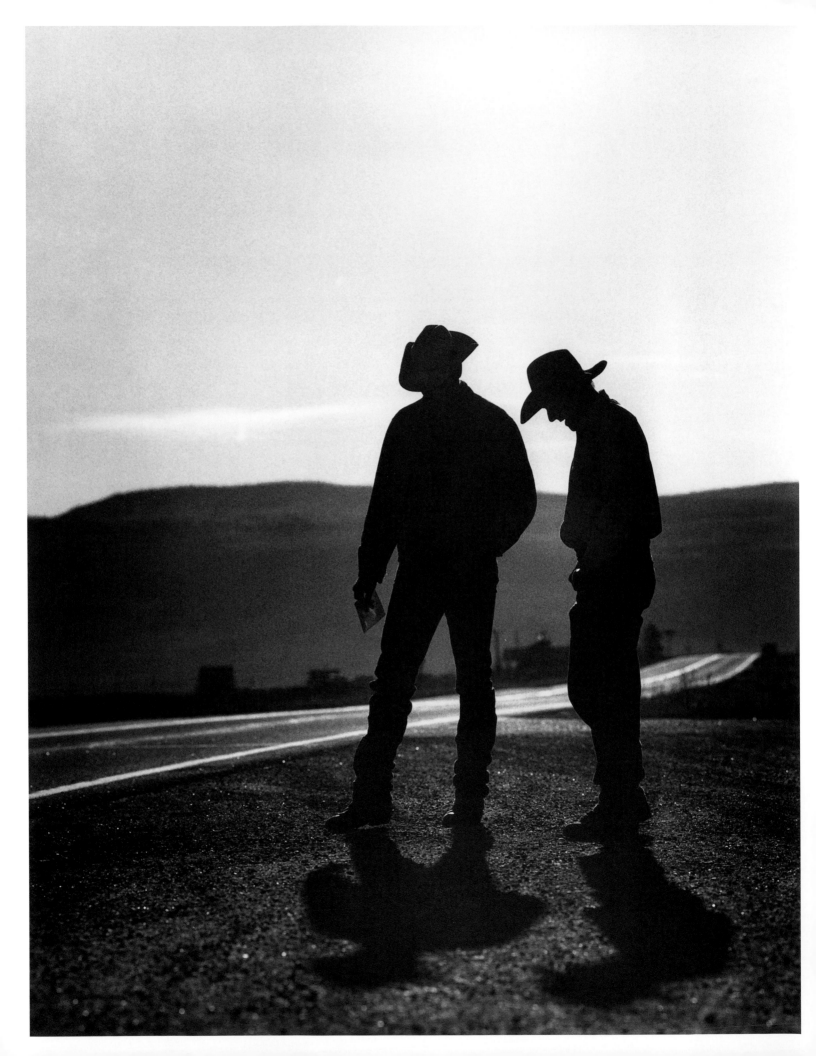

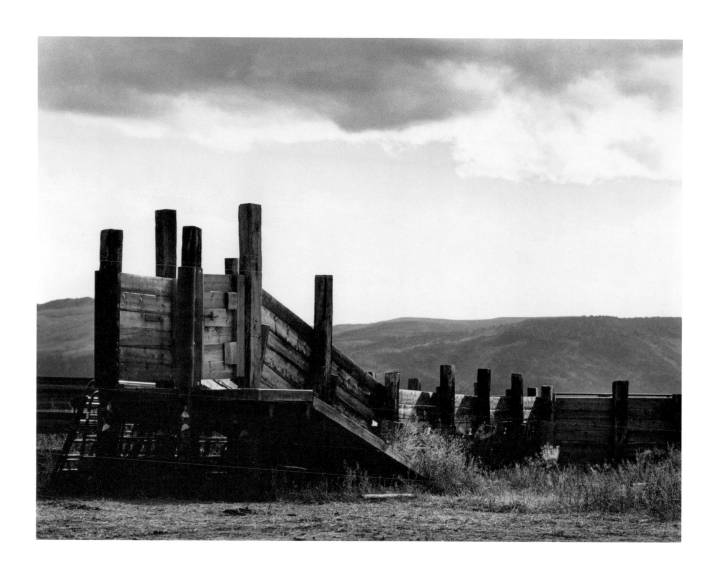

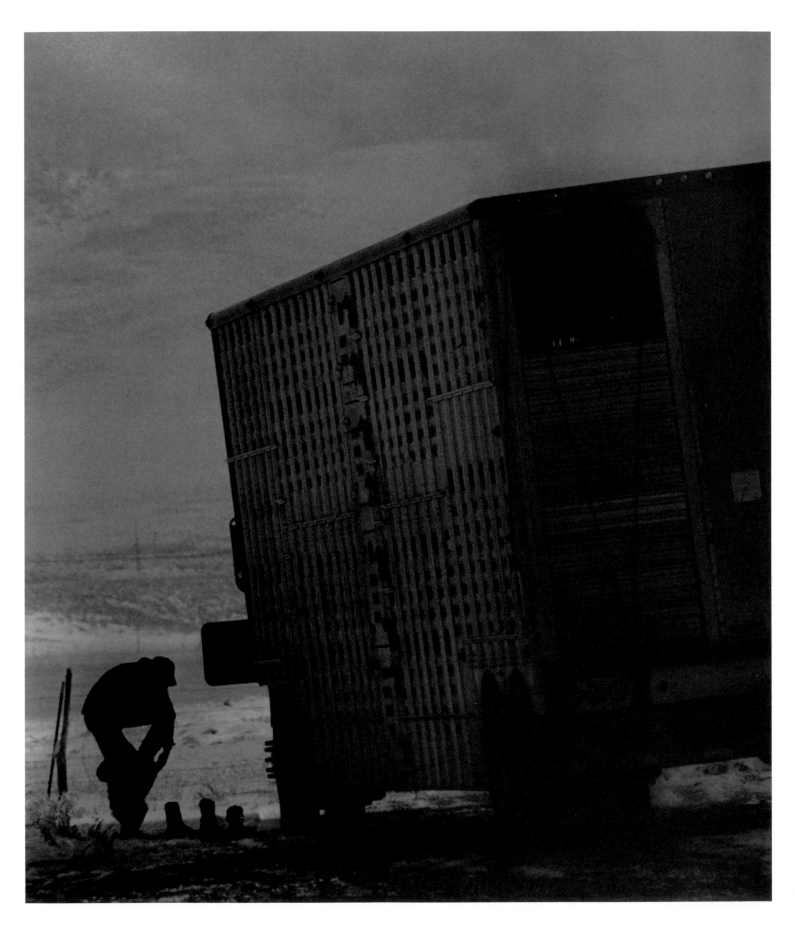

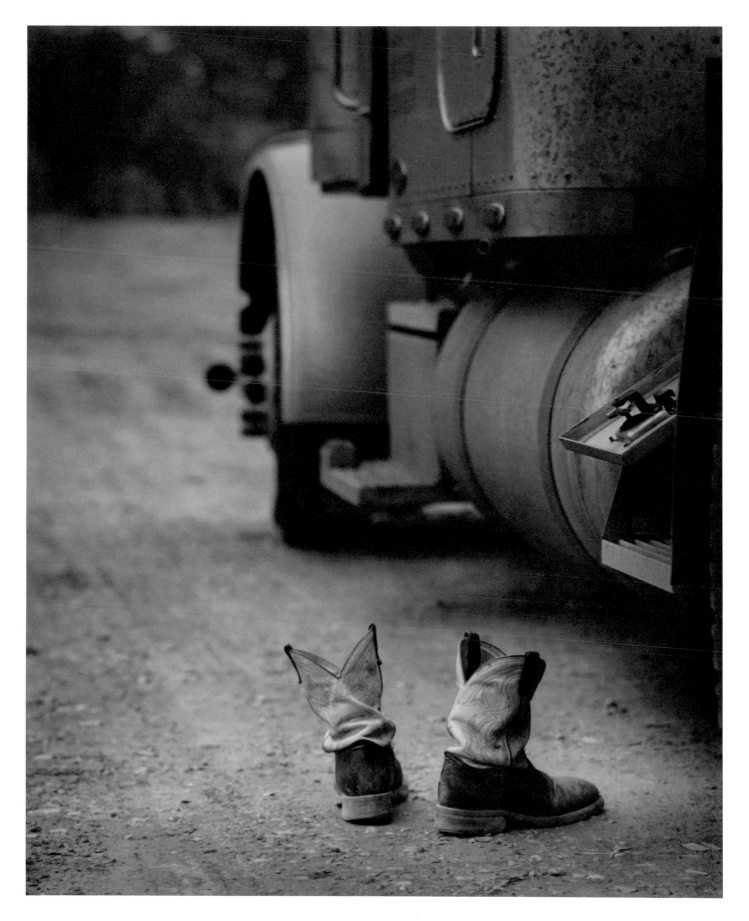

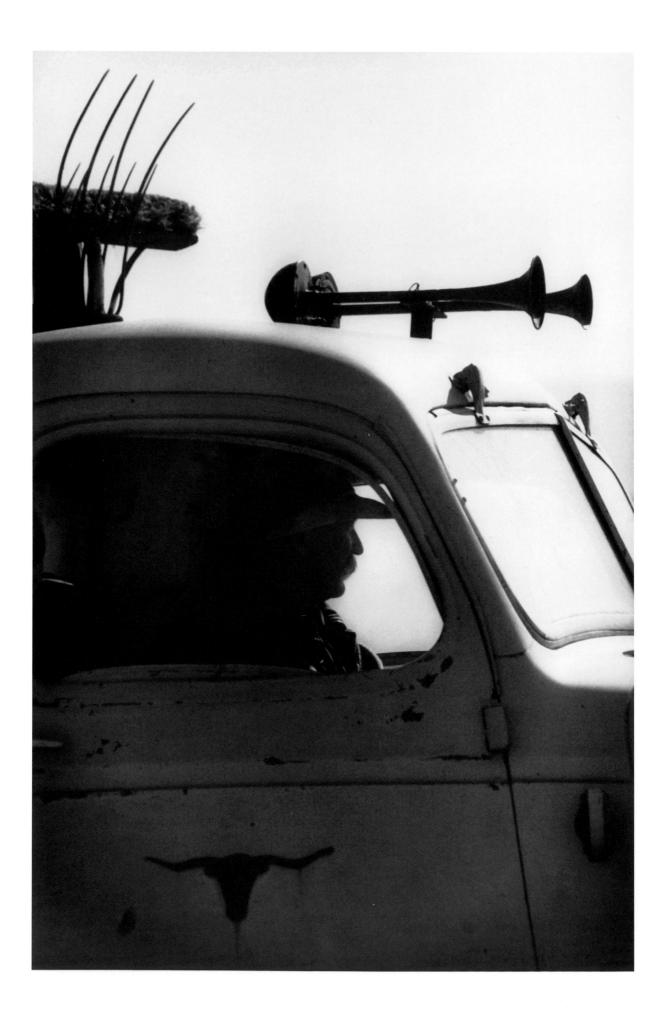

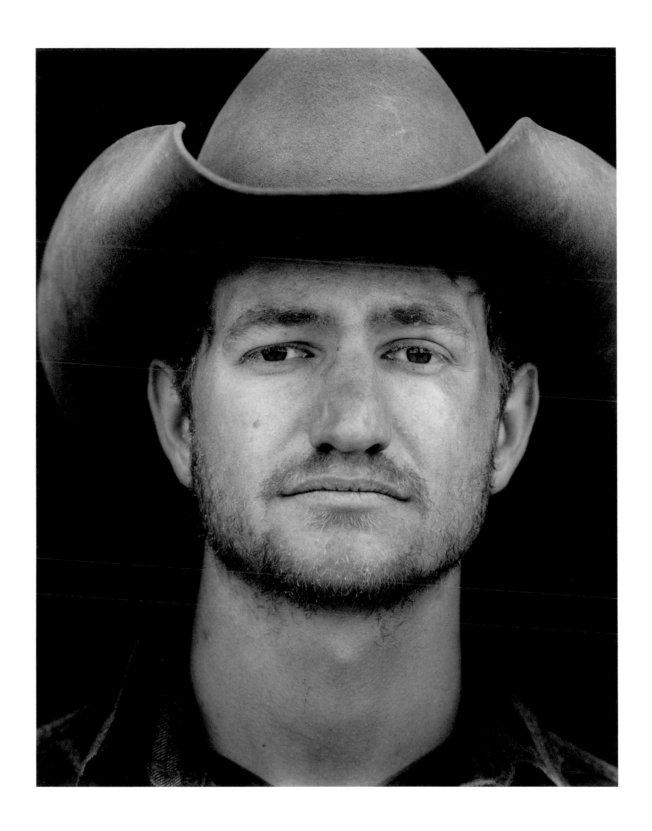

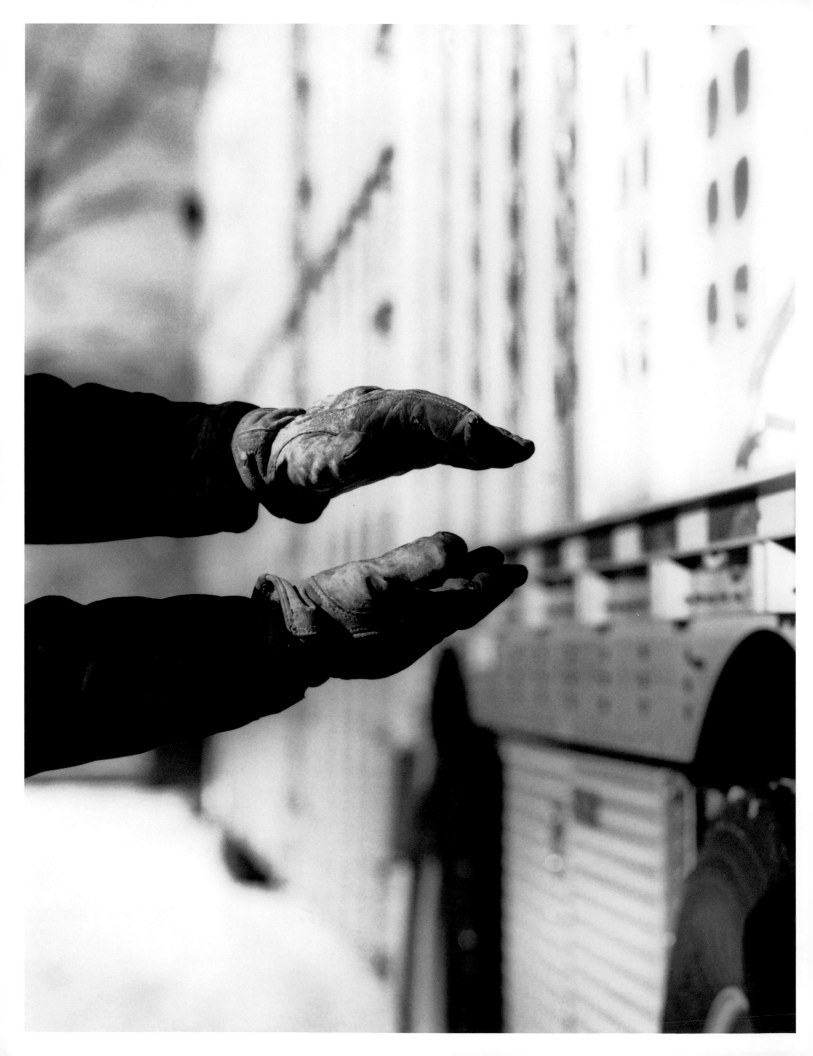

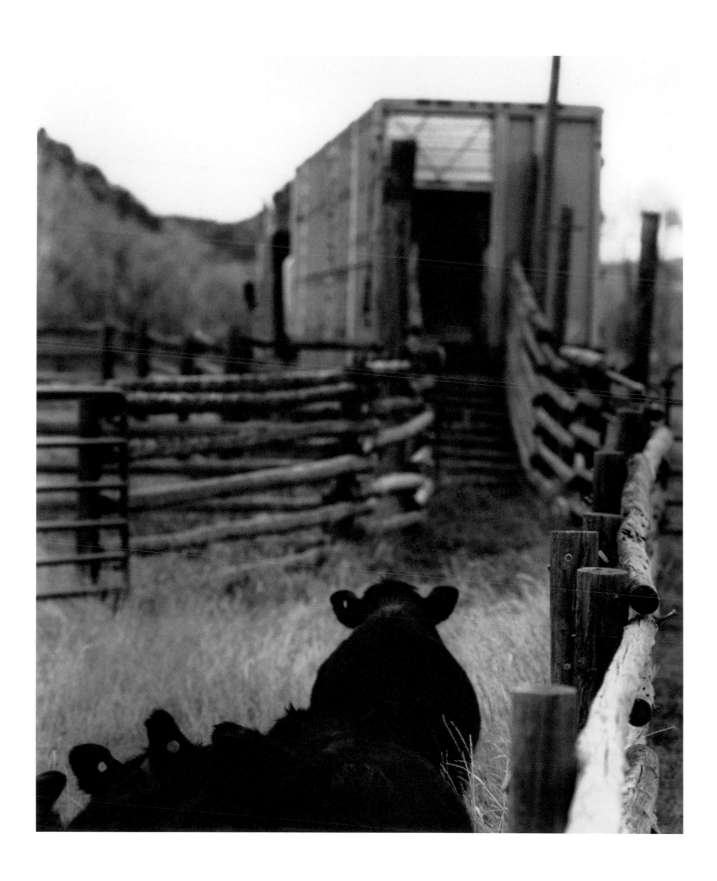

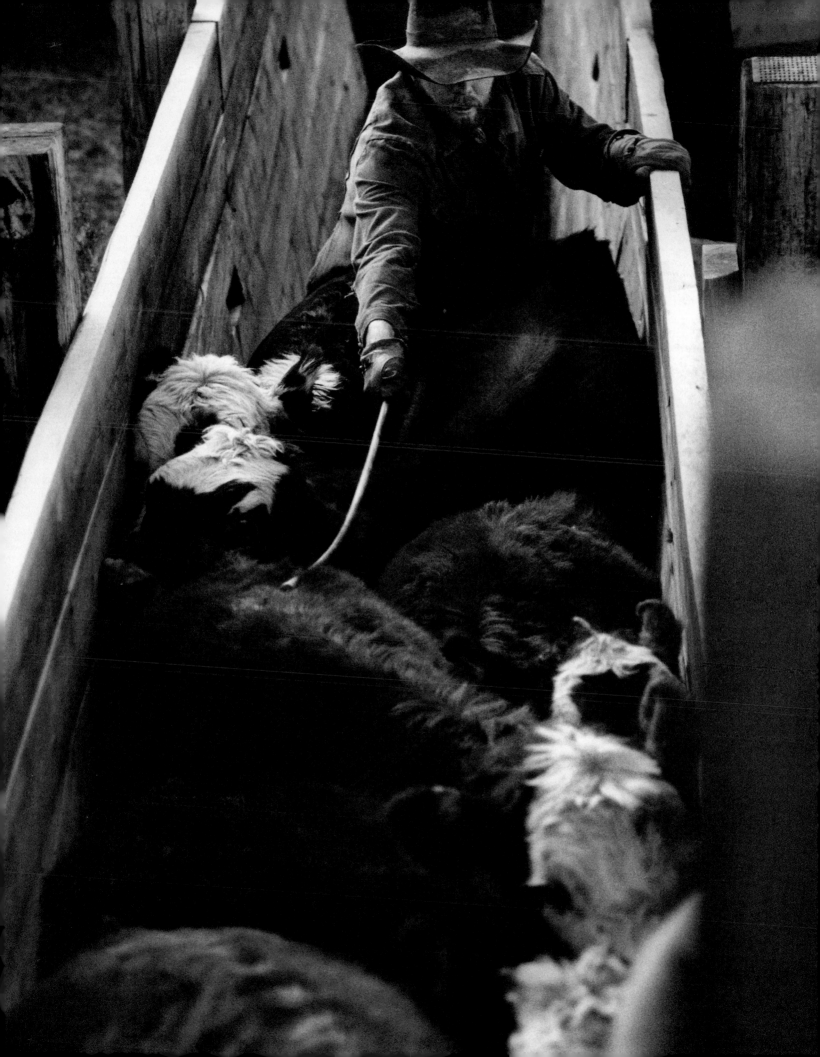

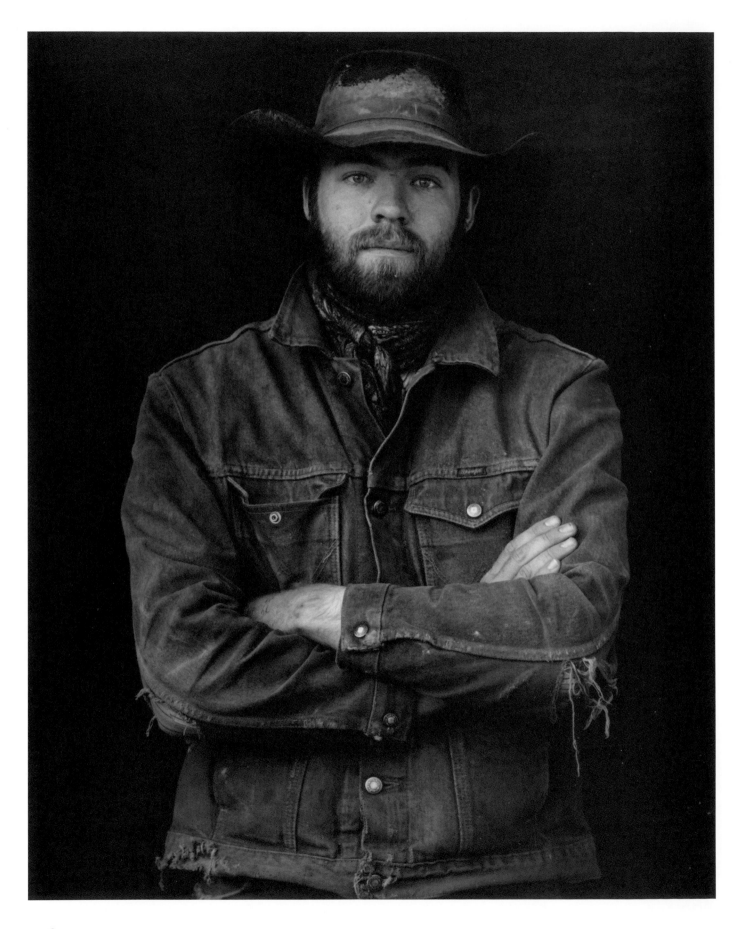

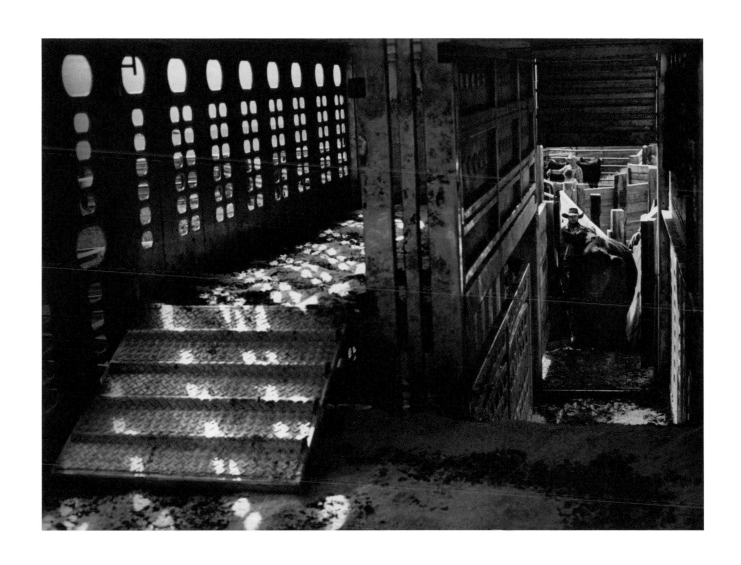

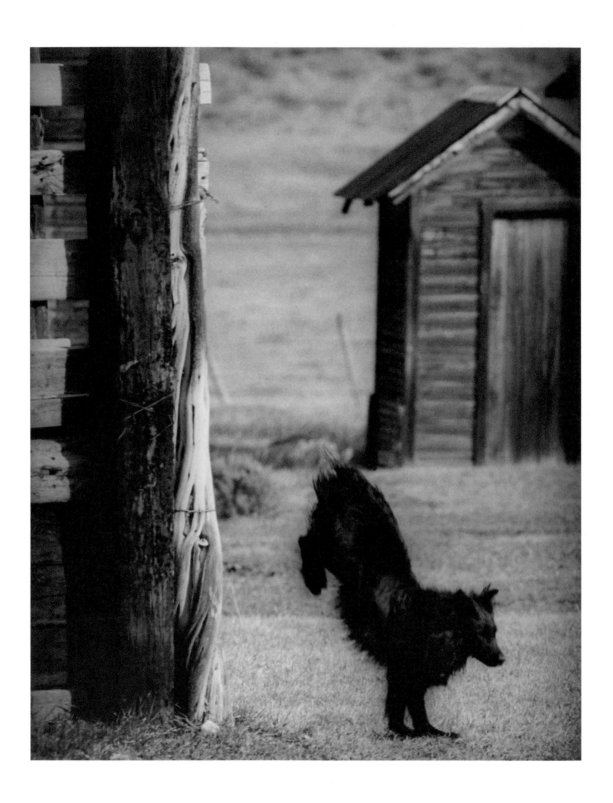

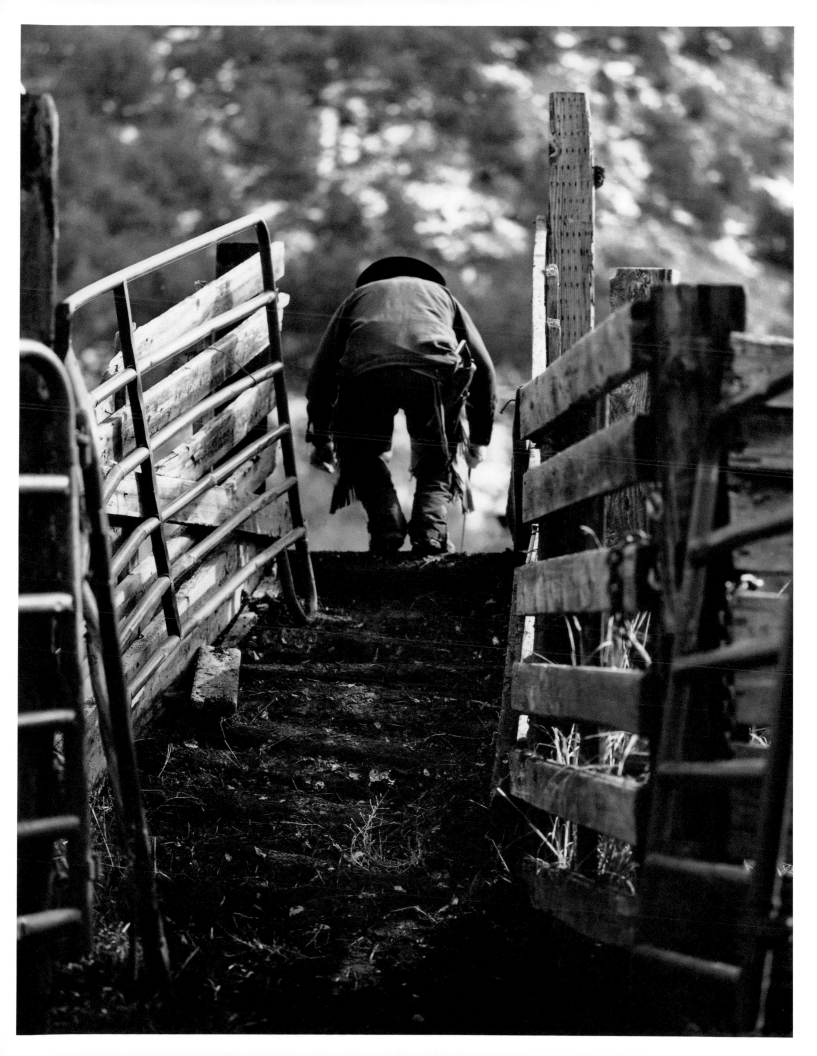

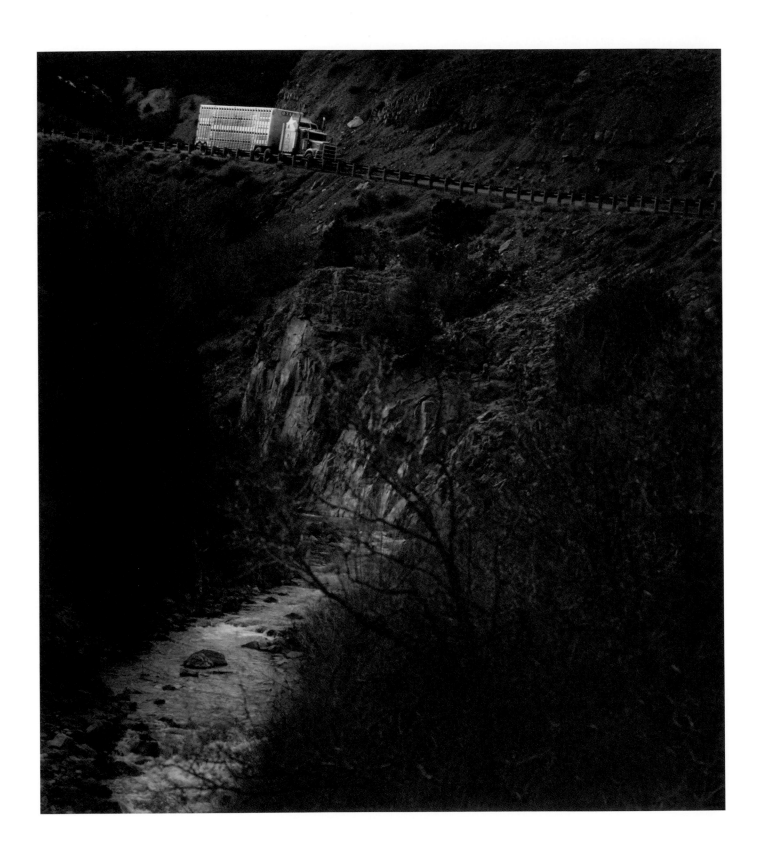

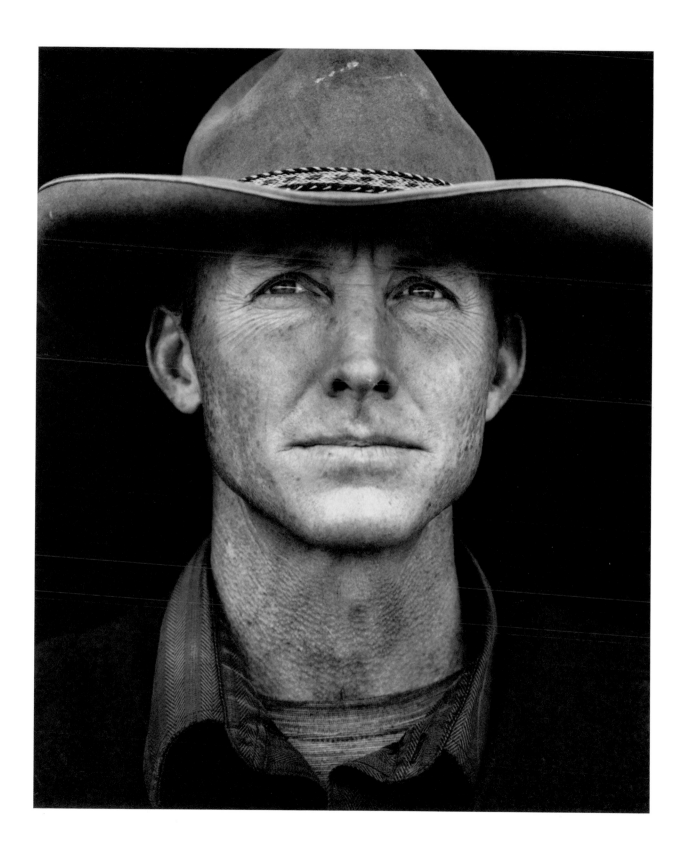

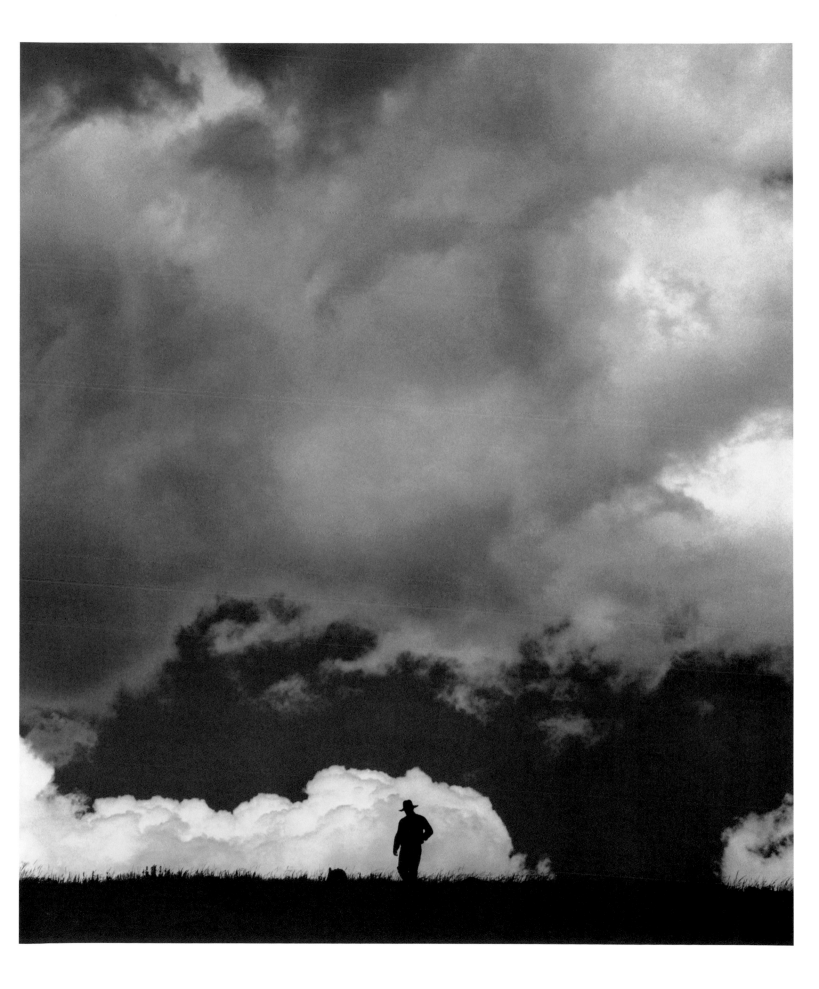

Heritage

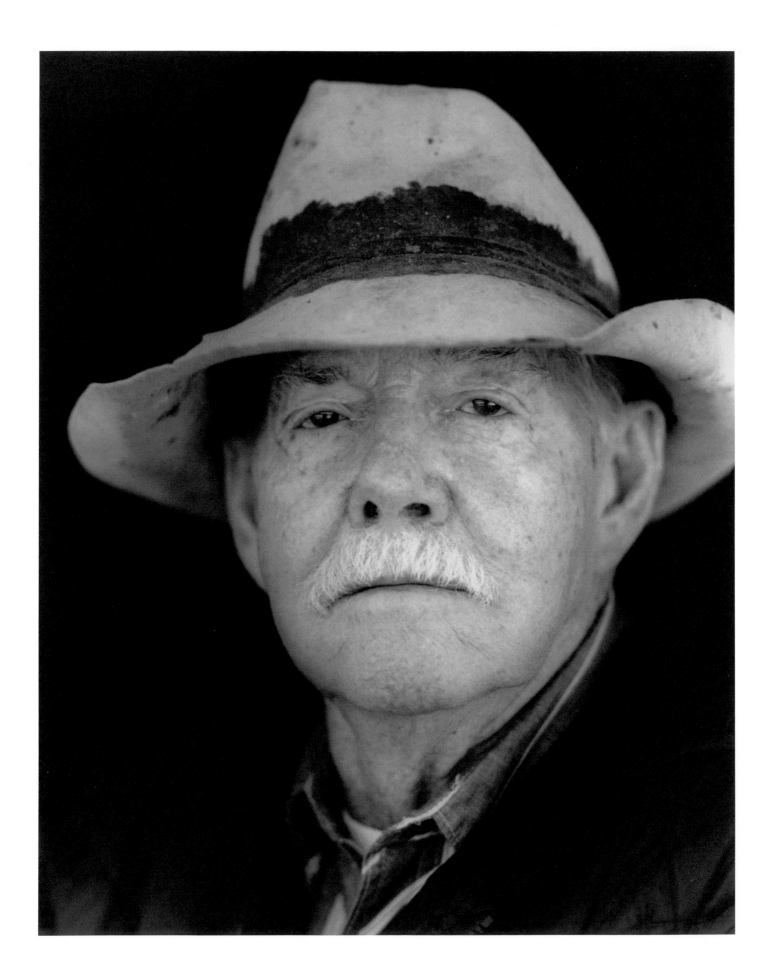

Vern Albertson // BURNS, COLORADO

When my grandfather Albertson come into this country, him and his folks and family had come from Minnesota, I think it was, in a covered wagon to Golden, Colorado, over there by Denver. And that's where my grandfather went to grade school. When he come here, there used to be an old tree that was part of the corral, along the little stream that runs through the corral up there. He told me, "I slept under this cedar tree when I first come over here"—in his sleeping bag, you know. He knew that he had to find a place where there were springs or water for the cattle through the winter. So that's why he homesteaded right up there. He married a MacMillan girl, Ella. They had homesteaded over near McCoy, right on what they call Catamount Creek. They lived in a little cabin. I wish it was still there, but the little log cabin he built had a dirt floor and dirt roof, and that's where my grandmother and grandfather lived for quite a while before they built the log house that . . . well, they didn't build it, but the Gates brothers who were in here, they built pret' near all the log houses that are here in Burns. They were pretty good building with logs.

My dad was born on Derby Mesa here, and when he was about twenty-one years old, he leased a place which is part of Nottingham's ranch now. His folks give him a milk-cow calf, and that was the first critter that he owned. He kept it for fifteen years, and she had a calf every year. About the only families on Derby Mesa at that time were the Gateses and the Albertsons. They were very close, and it was only about a mile from the Gates place to the Albertson ranch. They were riding and playing, and they all went to school in the little one-room schoolhouse that is still there.

I was born in 1935, at home, over at what they called the Flatiron Ranch, which is owned by Nottinghams now. But my grandfather bought it, and then my dad lived on it and leased it from his father, and so that was where I was born. We didn't have any electricity or running water. And when people used to ask my dad if we had running water, he'd say, "Yes, we did. You got the bucket and ran down to the spring to get water." When I was about six years old, my two brothers, Chuck and Frank, and my cousin Ben Wurtsmith and I used to go to the sawmill up in Derby Creek and get the trimmings off of boards that were about an inch wide each way. And we'd take those strips and make stick horses out of 'em. They'd be about probably four feet long, and up on one end we put string around it, and that was our bridle. We'd tuck 'em between our legs and ride our stick horses all over the country. Sometimes we'd build a little fire somewhere, and we had a real small piece of wire, and we'd get the wire hot, and we each had a brand that we'd put on our stick horses. We even had pastures where we'd put string around the trees. When one of the stick horses got a little worn out, or we decided they were too old, we'd throw 'em off over the hill. So one time, several years ago, we had some cattle that got down Derby Creek, below the road, and I walked off from the top of Canard Hill down into Derby Creek to head 'em off, and as I was walking back up through there following the cattle, I happened to see this piece of wood and picked it up. It was a part of one of the stick horses with the WX brand on it. I don't remember what my brand was, but I'm pretty sure this was Ben Wurtsmith's. That's quite a prize, there, that piece of stick horse. I'd like to find more, but I don't think there's any chance.

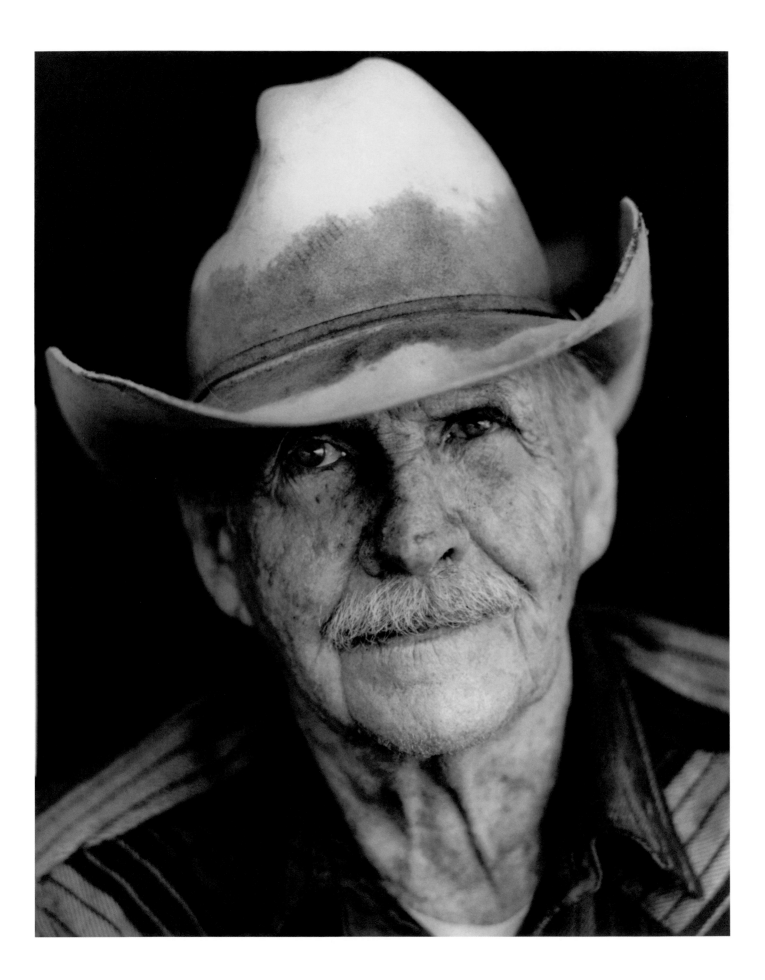

Ben Wurtsmith // BURNS, COLORADO

I was born in 1930 over there where Vern lives, in that big house over there. We didn't have no doctor, but Gramma Gates was good at delivering babies. I don't know why they didn't throw me out when they saw me, but they kept me. I believe there was thirty-three or thirty-two of us first cousins, and we pretty much grew up together. You know, you couldn't have picked a better place in the world to grow up. We were wild as Indians, and our folks, I guess they prayed for us and then forgot about us. They'd let us go to the high country when we were just little buggers. Camping. And we knew how to take care of ourselves by the time we were in middle grade school, I'd say. And that country back in there was all brand new. It was wonderful. And this community was always . . . I'll tell you something, I've never locked my door. I've never taken the keys out of my car. Now don't you tell anybody! I never have, and I'm gonna try to die that way. It was just the most wonderful place to grow up, and our cousins to play with. And our people had faith. They were Christian people. And it just could not have been no better, I'll tell ya.

There was just a very few cars around then. When you saw a car, you gawked at it. People were still riding in buggies, and mostly on Derby Mesa I remember seeing rubber-tired carts, and they drove horses around with them. It was during the Depression . . . I remember that everyone was getting a dollar a day—the hired hands—and grub, and a place to sleep.

I don't want you to take my picture. I'm not photogenic. I've been called the ugliest man in Burns. You remember old Charlie Forster? I heard Bud Gates tell him this. He said, "Charlie, I'll sure be sorry when you die. Because then I'll be the ugliest man around here!"

I'll tell you somethin' about me. Vern maybe knows this. But I think I was born to boss. I'm bossy. And if I'm around a hay crew, I want to boss. Well, when my kids got old enough, you know, in their forties and stuff . . . I know I didn't want to be bossed, and so I decided it was time for me to quit bossin' 'em. And I quit. I just retired and quit. Got out of their hair. And I think that was a relief to 'em. But . . . I'd still like to boss somethin'.

I always wanted to be a cowboy. That's all I wanted to be. I've followed cows around all my life, and I was plumb happy doin' it. Couldn't have been better. Now I'm old, and I still think I made the right choice. And somehow God provided me with the best wife that anybody ever had. I've been just so lucky! Just fortunate. I count my blessings all the time. We had four kids; the first one died. He was born with a heart defect. A little baby. Today they can save them, but not back then. I think Vern'd say the same thing—we've just been blessed with this country. And I love to punch cows. And I don't like to punch cows with dudes. I like to punch cows with Vern and the old-school guys who knew how to do it. His dad and Uncle Orris. I lived to drive cattle, I guess, and move cattle here and there, and I like to feed cattle in the wintertime. About everything you did was gratifying. Good, gratifying work. And you know, I think I was in debt most all my life. And I just had faith that I would some way get above it all. And did finally! I just can't imagine anybody being any happier than me.

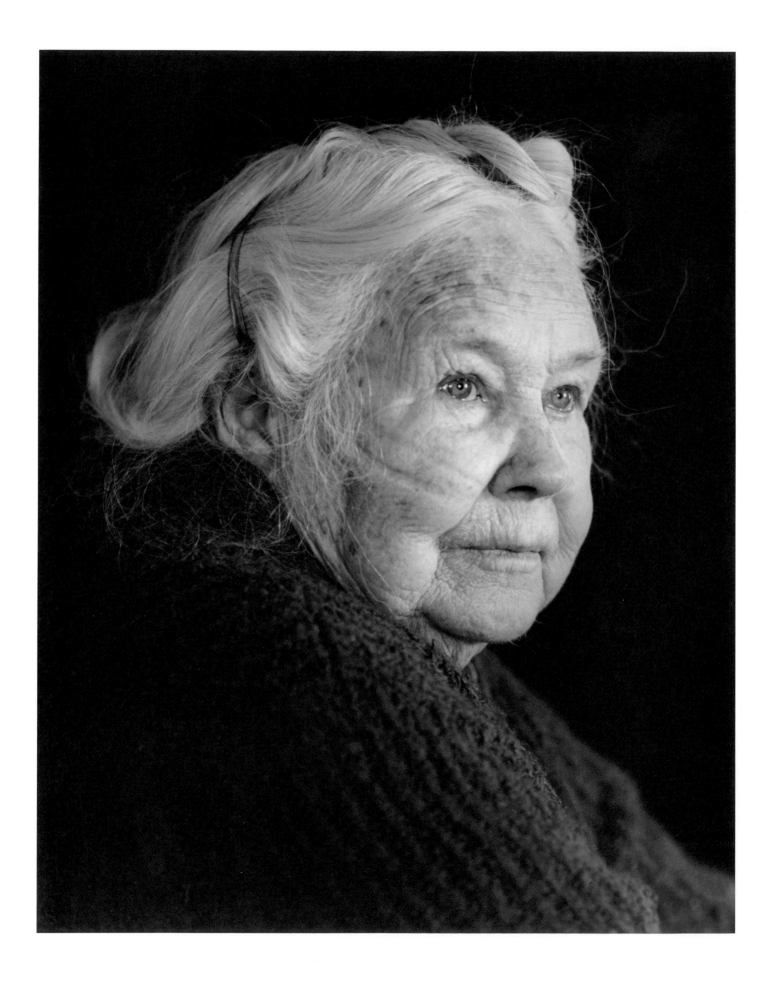

Rose Horn (1930–2015) // McCOY, COLORADO

I was born on December 20, 1930, in Arvada, Colorado. I never grew up right here; we lived over in Jefferson County on a dairy. My dad had milk cows, shorthorns, and then he got sick, so then he bought some Jersey cows. And he passed away when I was eleven years and eleven months old. I was the oldest of seven kids, so my baby brother was nine months old. And you got up to milk cows in the morning, and milk cows at night, and got it ready for the milkman to take. It seems like I've been milking cows forever.

I never went to high school. Eighth grade's all. I had brothers and sisters to take care of, and we lived eight miles from town. My mom never had a car, so we never drove. If we wanted to go to town, we had to walk, and then hope somebody'd come down the road and pick us up. We grew up riding horses, more or less, and walking. And I remember one time, we wanted to go to a picture show—they had the Saturday matinees—we walked clear to town to go to a picture show. It was *Our Vines Have Tender Grapes*, with Margaret O'Brien, and then after the picture show, we walked home. We had to get the milk cows in.

We never had a lot for Christmas, 'cause we never had that much money. If we got something for Christmas, it'd be socks, or jeans, or clothing. It wasn't toys. As far as me wanting dolls, I had enough little kids for dolls. I had live ones.

If we ever butchered beef, we'd have to can it. The best thing that ever come to a ranch was electricity and a freezer. Then we wouldn't have to stand over a cookstove and can. It musta been about '56 when we got electricity over in Golden. When we came to this place, it already had electricity. And we had a party line on the phone. You said what you had to say. You didn't sit there and talk very long. Then you was listenin' to other people pick it up; you'd listen, and if it wasn't interesting, you'd just hang up again.

The Fourth of July, we always had a picnic in the community where we had horse racin' and foot racin' and all that kinda stuff, and that's when I met my husband, and then we had a square dance that night, and he was there, too. But I went with another guy. It musta been about three years afterward that we got married. I was twenty-one, I think. When he asked me to get married, I told him I'd have to think that one over. I wasn't quite ready yet.

I'm not really much of a housekeeper or cook. Well, I had to do my cookin', but I'd rather have been outside than inside. I worked in the field with hayin'. I rode a lot. I irrigated. I'd go out and help feed, 'cause we fed with a team then in the winter. We sold milk, and cream if we could. If we separated cream, why, we'd set a can down by the railroad track, and there was a little passenger train that come through. You put a little flag by the track, and they'd stop and pick up the cream and take it to Denver, and then bring the cans back and set 'em off.

We seen our neighbors quite a bit. The first neighbor was right up here, about a mile away. And then there was another neighbor there too. He'd go down the road about every day. We knew the Schlegels, and we knew the Wurtsmiths. There was Gates; we knew them—Bud Gates, Marge Gates. Albertsons, we knew of them through buyin' bulls. The families in Burns haven't changed much. That's one area where there's a lot of older folks yet. Just regular ranch folks.

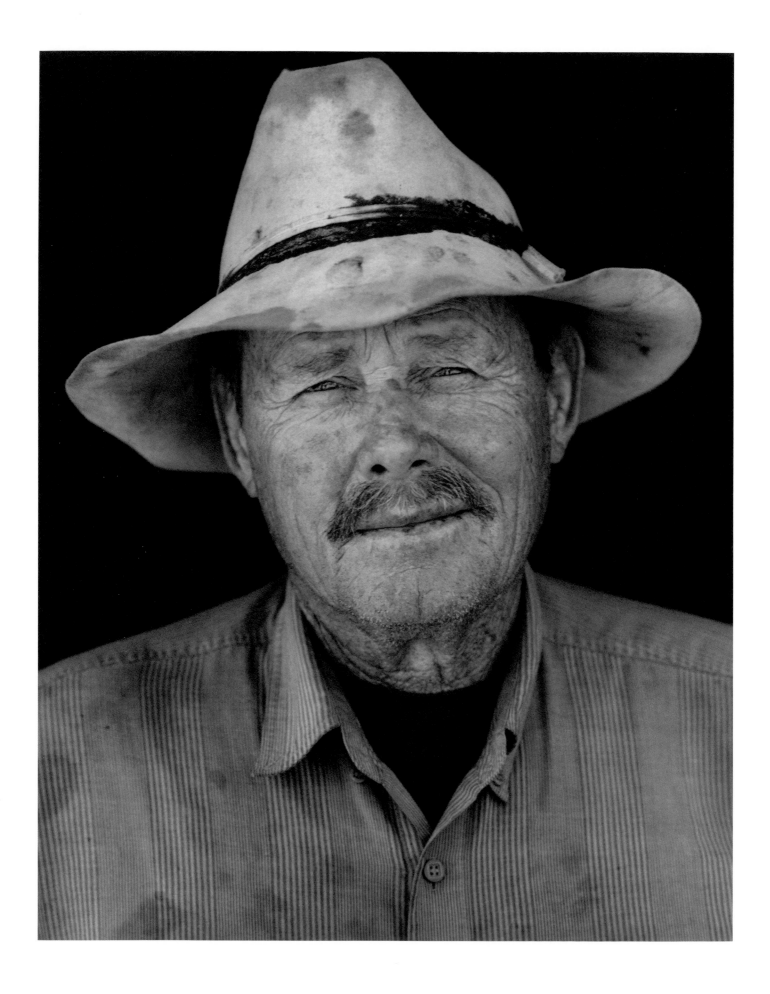

Nick Strubi // BURNS, COLORADO

Well, we was Swiss immigrants. They came to Hayden. Dad had some family over there that had come before him. They worked over there in the coal mines till they got enough money to make a down payment on this little place here. I guess the price was right, and they wanted a place of their own. And they were able to add some land to it over the years. Dad got the place in '34, I think, and I was born in Steamboat, in the hospital over there in '39. Mom was staying over there with my uncle. It was so cold that he got up every half hour to start the truck, because he was afraid it wouldn't start and they wouldn't make it to the hospital. Growing up, it was fun most of the time. We didn't have a lot of money, but nobody did in those days, seemed like. As long as we had enough to get by, why, we didn't feel like we were poor. Our folks always took good care of us. Everybody had to pitch in and had their own tasks. Course the big job was puttin' up hay. He did it all with horses, of course, so it took a long time. It wasn't something that I really enjoyed. We used the horses, too, and we did some of the different jobs, like rakin' and mowin' and stackin' the hay.

We rode to school down there by Ben Wurtsmith's, every day that we had school. Most of the kids were a little older than I was, but I knew 'em all. There was Ben, and the Albertson boys, the Wards, all the Gateses. We didn't interact a lot, 'cuz we were some distance apart. It was primarily us two, my brother and I. We had to be around close. We'd go fishin' or huntin'. I do remember the isolation in the winter. Not that it bothered me that much. We would read, I s'pose. We had a radio, but we didn't listen to that much. It was battery operated, and we didn't want to run the battery down. We didn't have any electricity in those days. Not until the fifties. I remember how handy it was. It was really a boon to the ranchers. The lights and the appliances. The refrigerator and freezer. I think eventually we even got a TV. But they weren't much good. They were always on the blink. We just had a booster over here on Castle, where you could get one station, or two at the most. My parents just worked like crazy. My mom would work in the hay field and then leave her team and go in and cook. We would bring her team in; she usually raked. They worked like the dickens. I don't know how they could do it, even, but they got through it. Everybody pitched in as much as possible.

The house I grew up in burned down. I went to school that morning—I must have been in the seventh or eighth grade—and Mom and Dad went to Glenwood to shop. Along about in the afternoon, the neighbors came and got me out of school and brought me up here, and the house was completely engulfed in flame by then. One of the neighbors had gotten here in time to dip water out of the ditch, and it was gettin' the best of him when more people arrived. And so when we left in the morning, we had stuff, and when we come home, we didn't have a thing. Of course, we had a lot of good neighbors that pitched in and helped us with the new house, but it was kind of a shock.

My two kids would like to have this ranch, but the way the prices are, you can hardly pass it on to them. The inheritance taxes are completely outta reason. As far as passing it on, it has a tremendous value, but you have to pay so much income tax on it. Ranching is finished in this area, unless they figure out some way to pass it on to the next generation without all these taxes. You can't buy it over and over again, every generation, and keep it goin'.

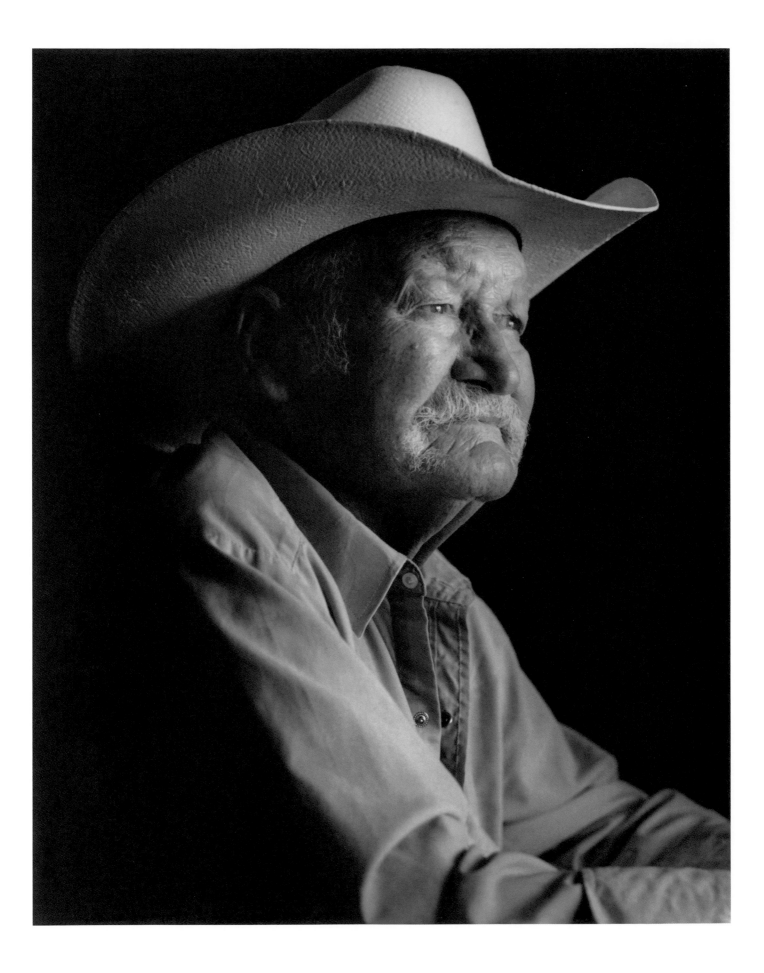

Punch George // OAK CREEK, COLORADO

They call me "Punch," is what they call me. I used to help everybody with cows and whatever, you know, punchin' cows. That's how I got that name. I think I was about nine when I got that name, and it's been with me ever since. You come here now, and somebody asks for Otto George—that's my real name—nobody knows him. It's always Punch. I was born in Bailey, Colorado, on the other side of the hill, in 1925. I'm eighty-nine, just about ninety. We lived on a ranch over there, but right after I was born they moved up here, to Oak Creek. Course they brought me with 'em. I quit school in the eighth grade. I met my wife in the third grade, and we stayed together all that time.

Andy Maneotis, he was the biggest sheep man around here then. He was a Greek fella. And I worked a lot for him, helping him dock and gather his sheep, till I got a little older. Seemed like the war broke out too soon, or something, and I went right into the service, into the Marines, when I was seventeen, in 1942. They sent me right over there to the South Pacific. I was over there for over three years. Then I come back to the States, and it wasn't too long after I got back that the war ended. And then I married my wife, the one I met in the third grade. She waited for me, and so we went that route.

Before that, I was working at anything I could get, really. My dad moved to Salt Lake, and I lived here all alone since I was eleven. I lived in an old shack in Oak Creek in an alley, which was all right. But there was no water, no nothin'. And that's where I lived. You know, I didn't have no help when he was here, 'cause there was no work then, you know; we's just comin' out of the Depression. I can't say that I remember anything about Christmas or holidays when I was a kid. It was just another day. I guess 'cause I was on my own and there was nobody around, ya know, so I just worked. Everybody burned coal, but a lot of them lived upstairs, and that's what I done, packed coal upstairs. Get it for 'em and things like that. And I even racked pool balls in a pool hall one time.

We used to go over there to Burns all the time to go rodeoin'. I didn't rodeo myself. I just messed around, is all. I never did get good. And besides that, I had too much work I had to do. Just before ya get to Burns Hole, ya start down that steep hill and cross the Colorado River; right on top, before ya start down, is where the rodeo grounds is. We was over there a couple three weeks ago, my daughter and I, and their rodeo grounds is all caved in. A lot of it's still standin', but it's pretty shabby.

I didn't claim to be a cowboy, but I liked to think I was. I had a lot of horses when we got on the ranch. I liked draft horses awful well. We had around four thousand head of cattle that we loaded on the train, and they hauled 'em to Nebraska, but it took 'em four days to get there. No feed, no water. And when Mom and I got there, we couldn't recognize our own cattle. They was all ganted up and hungry and dirty and . . . oh, geez, it was terrible.

I never will forget this one time, we was drivin' our cattle up to Yampa, and they'd all be on the road, and here'd come the traffic, and this guy come up and couldn't get through, so I had a guy back there to tell him, "Well, just hang on till we get two or three more cars and I'll take ya through." Well, this guy pulled out that big ol' pistol and said, "We'll go through right now." And they took him through. That's the things that happen to ya, that's all. Lotta experiences on the ranch.

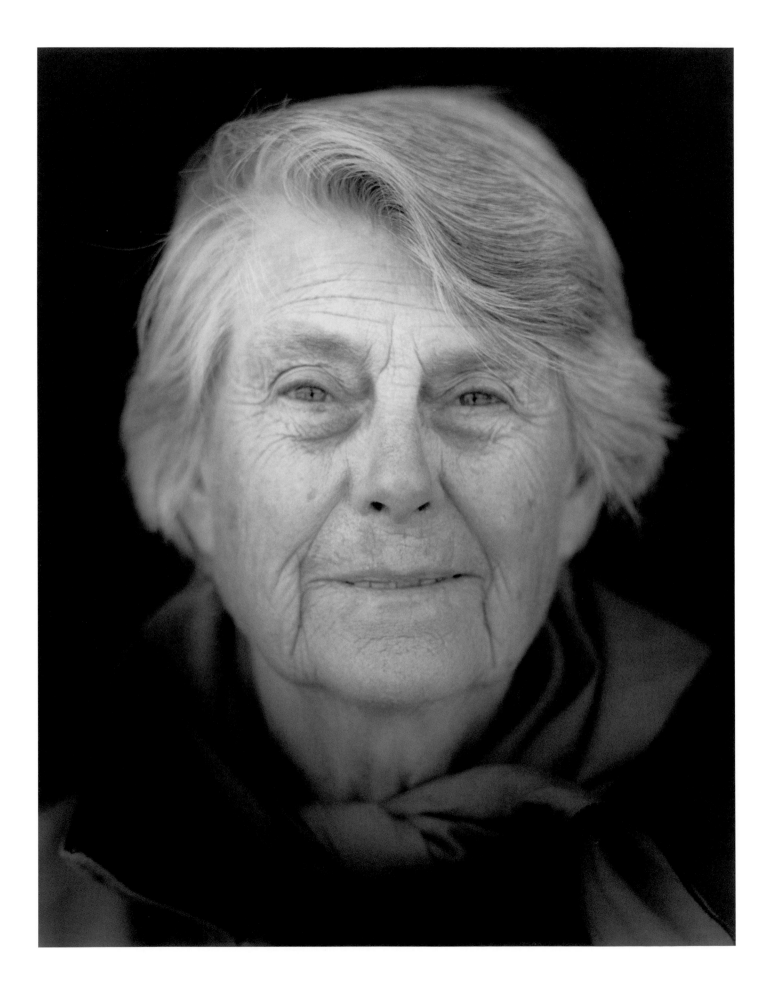

Virginia Rossi // PHIPPSBURG, COLORADO

I was born in Montrose County in 1930. We were on a 160-acre typical homestead, and I was born in January, so we had to go into Montrose and stay in a hotel until I was born. And then they couldn't get home for a long time, and finally my dad had gotten ahold of the neighbors, and they came down to the main road with a team of horses, and they pulled our car to the homestead, which was ten miles from the road. Our homestead was in San Miguel County, twenty-five miles from Telluride.

A homestead was typically a combination of everything. You had your animals, and you tilled the soil to plant food for yourself and for the animals. On the homestead, it was very isolated. The nearest neighbor was about three miles away. And we could only have summer school. We started in May, soon as the snow went away, and walked three miles through the wilderness—sagebrush, oak brush—to the schoolhouse. And we did that all summer long until it snowed, and then we had to not have school anymore. Typically school went from May to November, depending on the weather.

We were completely happy. We didn't know any better, and we always had something to eat. It was just a beautiful, beautiful life. We didn't want for anything. I would read books about these girls who had two pairs of shoes. One for Sunday and one for everyday. I would say, "Oh, my goodness. Two pairs of shoes!" That was awesome! My mom made all our clothes. She sewed on the old treadle sewing machine. As we were sitting there and she was sewing, she would tell us stories about her growing up and Bible stories she had memorized.

My mom was a little bitty thing. She was barely five feet tall, if that much. And my dad was almost six feet tall. I thought he was a giant when I was a little kid. I thought he was *huge*! But six feet isn't huge! He was really quiet, and he loved to fish. His quiet time was to go off with his fishing pole. And of course the homestead wasn't making enough money—no cash to pay the taxes and buy the necessary things like flour and sugar and stuff—so he would work away from home in sawmills during the week. The chores of the homestead were pretty much left to his wife and kids. There were five of us. I had four sisters, and I learned to milk a cow when I was five years old. I graduated from high school in Nucla with a class of twelve, and there were two other students that lived in the area, and one time we were walking down the street of this little town of Naturita, and I found a dollar bill. One dollar. Oh, man! So we went to the little café. Three hamburgers, three bottles of pop, and I had a dime left over. Nobody believes me! What does a dollar do now?

I met my husband, Joe, at a Labor Day dance in Oak Creek. There were so many single guys there, and of course they were all after the schoolteachers. That was the typical thing in mining towns as well as at ranches and stuff, because there was a shortage of women. So when there were young, single schoolteachers coming to town, oh, boy! Joe said, "I get first pick!" or something like that, I don't know.

We lived there, in the house where Joe was born. We still call it the "Home Place." I was used to rural life—I mean milking cows and all that kind of stuff—so that wasn't anything new. We raised nine children, and they started in working. The two older ones started driving the power-sweep machine when they were five and six years old. Now it would be child abuse. Somebody would report us. But it worked out really, really good.

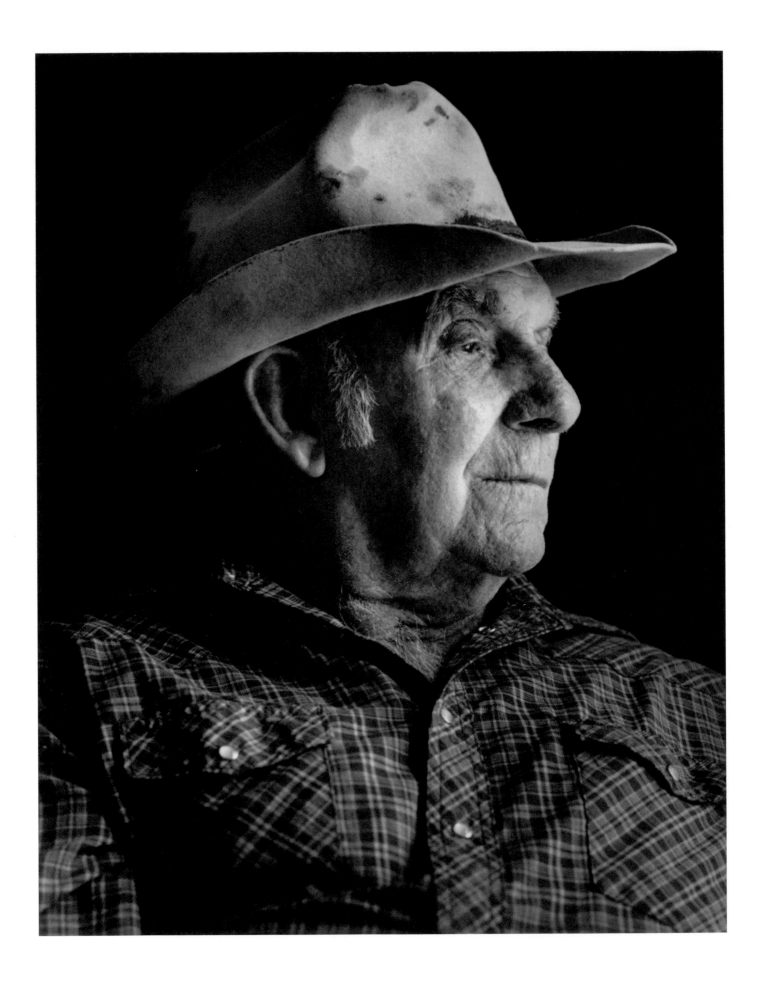

Bud Gates (1929–2016) // BURNS, COLORADO

I was born in Grand Junction in 1929. My mother was gonna have twins, and she was a pretty small woman, and they decided to have her down there, handy to a doctor, and then they brought us up here. At that time we were over at the first place—that was my grandfather's homestead. There were nine kids, and my father decided, "All I'm doin' is workin' for the other kids and not gettin' anything for myself." So he sold his part of the homestead and moved over here.

I was raised with four sisters—no brothers—an aunt and an uncle, all about in the same range. But the only other ones that was here were Ben Wurtsmith, Donny and Walter Gates, and the Albertson boys. They was clear over across the creek, so we didn't communicate too much that way, but the community was always havin' picnics about once a month. We went to school at that little schoolhouse over there along the road. In one year there was all eight grades in the one-room schoolhouse with wooden benches. I went there eight years with the same teacher, and she was pretty strict. Matilda A. Phillips. She was a good teacher. I always felt like you had to bring her somethin', and mice was the only thing I could catch. She didn't appreciate that very much. Ben Wurtsmith started over at the Bailey School, and later he walked from Derby Creek up here to go to school. Ben and I were always good friends. Buddies. He was always tryin' to get me to saddle up and take off for Montana or somewhere. Just kids.

We's poor folks, but we's proud. Didn't know anything else. There were so many of us, and my mother usually set the table for twelve or fourteen every time there was a meal. It was usually nothin' very fancy, but it was just good, wholesome food. And if you could eat two potatoes, why, you'd eat two potatoes. She always had meat, eggs, milk, and butter.

We wasn't bad kids, but we were always gettin' into some kind of mischief. Ben and my twin sister set the barn on fire once. They'd found some tobacco and papers. Bull Durham. So they got down in the cow barn, out of sight, and rolled them Bull Durham cigarettes, and of course lit 'em, and they were smokin' 'em. With that straw there and whatnot, pretty soon they had the barn on fire. The hired man got blamed for the fire, and we sat up there and watched my mother and aunt packin' big tubs of water, tryin' to put out that fire. I don't think we told anybody about it till a good many years later. They fired the hired man. We kept the secret for a long time—till we's big enough not to get whipped.

I started working with the hired man when I was about five, and when I was a little bit older, I used to do a lot of cowboyin'. My dad was a cowboy, too, but he didn't take me by the hand and lead me through it. He just said, "Here's your horse. Get with it." I worked with my dad on the ranch for twenty years, and he always kinda let me learn it by myself. And when I come back outta the service, he said, "Are you sure you wanna ranch the rest of your life? You know by now it's pretty tough." I said, "Yeah, I been two years in the army, and all I could think about was red-and-white cows and green grass." So he decided to make me his partner in this ranch. And of course that made me feel like pretty big pumpkins, and I worked here another twenty years.

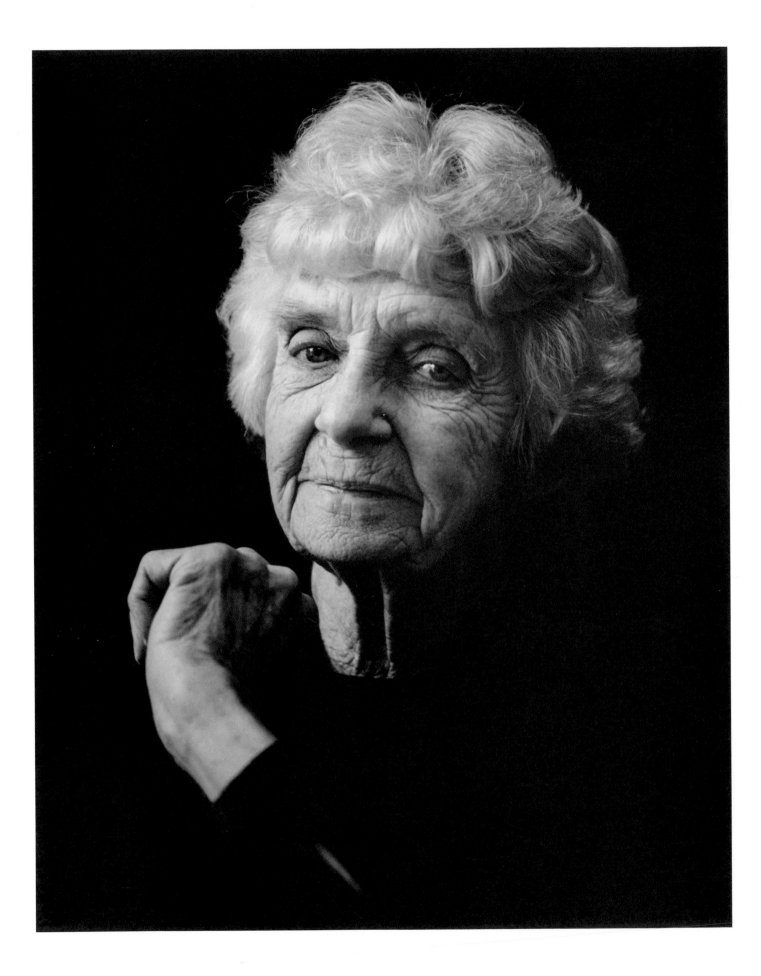

Margie Gates // BURNS, COLORADO

I was born on Wolcott Divide, and I was a home birth, on November 23 of '31. I was born in the Depression, of course, and jobs were few and far between. My father had been on the ranch in Radium that his father had homesteaded back in the 1880s, and he had to sell the ranch because his brothers and sisters in California were needing money. This left him kinda without a place to go, so he worked for the McLaughlin family, at State Bridge. He more or less managed the ranch for Mrs. McLaughlin. The ranch was up on the Wolcott Divide, and that's where I was born. We lived there in a little two-room cabin.

My first memories are from when the McLaughlins decided they were gonna sell that ranch. That meant he had to find another job. So he went to Alma, Colorado, where there were jobs in the Lincoln mine. And I can remember—I was about three years of age—I can remember that the first summer we were there, we lived in a tent. And I remember my daddy making little stools out of a sign, for my brother and I . . . little stools for us to sit on. And I remember the man coming by, looking for his sign! My parents were wonderful. I was a daddy's girl, and I sat on my daddy's lap every morning. My mother's cooking was wonderful. She could always cook meat, whether it was wild meat or whether it was tame. Chicken, pork, turkey, or ham.

My dad leased property up Gypsum Valley, and we lived on what they used to call the Congdon Ranch up there. He leased it, and we did haying and had cattle, milk cows, some sheep. I was just starting high school in Gypsum, and I herded sheep every day, and I learned very early on that you can stay out as late as you want to, but you're gonna be at the breakfast table, and you are gonna eat breakfast. And then by eight o'clock you had to be out with the sheep, gettin' 'em up on the mountain to eat for the day. And I'd bring the cows in every night before Daddy got home so he could milk 'em.

I rode every day, and I remember having a runaway. My brother, he wouldn't saddle my horse for me. He said I had to learn how to saddle my own horse. He was five years older than I was, and he kinda thought he was my boss. Anyway, one day I went out to the corral, and his horse was saddled, and I thought, "I'm gonna ride that horse" rather than saddle my own. So I got on the horse. He saw me get on it, and he said, "Don't go out the gate. You stay in the corral . . . don't go out the gate." Well, what did I do? I went out the gate! And the horse took off. I rode him all the way and finally got him turned around. I was on the main road, and luckily I didn't run into any vehicle comin' at us. But I had him stopped and turned around and comin' back by the time my father and my brother got to me. And I didn't get spanked!

I married Bud before I got out of nursing school. I met him when he came out to Gypsum to go to high school. I was in elementary and he was in high school. Bud was raised with girls, and so he knew how to talk to girls . . . give 'em a hard time, and all that kinda thing. And he'd walk along the fence there at the school, and we'd all—you know, silly girls—we were all out there lookin' or doing something. And he was just really nice and smiley and fun to talk to. And I fell in love with him. That's it. I was twelve. Yeah, I've loved him ever since I was twelve. You know, that's the way it is. And that hasn't changed.

AFTERWORD // MICHAEL CROUSER

In the cold and snowy early spring of 2006, I was invited out to northwestern Colorado by my friends Matt and Hope Kapsner, as Matt thought it might be good for me to photograph his neighboring ranchers during calving season. I was not interested. I was in a terrible creative malaise following the death of my mother, and for nearly a year prior to this invitation, the idea of looking through a camera held no fascination for me.

Eventually, though, I was convinced to go, and on my first visit to Sweetwater Ranch—or The Old Martin Place, as it is sometimes called—I met ranchers Steve Hammer and Todd Schlegel. They were kind and welcoming, and they went about their work monitoring the newly born calves and feeding cows in the snow as I rode in their trucks or trudged behind them while they were on horseback. Despite my ambivalence about making photographs, it felt good to hold the Pentex 67 to my face by its carved wooden handle again. It felt good to wipe my condensed breath off the cold viewfinder and try to compose an image. It felt good to breathe good air and meet new people, and I was instantly intrigued and somewhat rejuvenated by the work and the way of life I was seeing.

Later that spring, I returned to the area for a branding, with prints for my new friends. Brandings are not for the faint of heart. There is blood and spit, smoke and fire. There is the smell of burning flesh, and there are branded and castrated calves yelling for their mothers and nervous cows yelling for their babies. There is also dirt and manure and laughing and beer. The air is crisp, and there are sloppy joes and potato chips on paper plates. There are torn shirts and stepped-on hats. There are yelled-out phrases like "Son of a buck!"—as cowboys, I've found, don't swear nearly as much as photographers.

The whole thing seemed about perfect to me. It seemed I was in the right place to learn and work, to breathe and create. An earthy, rough, simple, age-old, and yet disappearing culture. My mother's family had been farmers in Wisconsin, and at one point while in Colorado, I recalled Mario Vargas Llosa's words from a different context, "We approach our ancestors . . ." I was in

the right place. I'm not a cowboy. I'm not a rancher, and I won't ever be or ever pretend to be one. But I was in the right place.

As this project progressed, I found myself intrigued not so much by the ways in which ranching life and work had changed over the years as by their constancy—the traditional elements of traditional lives, the raw and basic elements of a hard and basic culture. There is the mending, by hand, of miles of barbed-wire fences. There are long-abandoned homesteads, still used by neighbors for their crumbling corrals, grass, and water. There are the animals the ranchers work with, the animals they guard against, and the animals they raise for slaughter. And there is the landscape, which frames and defines these people's niche in ranching and which, because of its beauty and richness, may ultimately, and perhaps ironically, hasten the demise of this traditional way of life.

The men and women I have met, photographed, and become friends with in Colorado are often fourth-, fifth-, or even sixth-generation ranchers. And I find it amazing and nearly unbelievable that a young rancher can step out of his or her front door into the brisk morning, with snowcapped mountains ringing their view, saddle a horse, and set out to ride among the cattle, knowing that their great-great-grandparents, people they never met, had the exact same experience on the very same piece of land. But this is a life that the grandchildren of these ranchers may not have the option to choose. As time passes, family trees grow more branches, and ranchland becomes more valuable. Some young, would-be ranchers feel the weight of exorbitant inheritance tax; others face the complications inherent in distributing familial land among a new generation, many of whom don't feel the draw of ranching but understand the potential windfall of being next in line. For some who want to ranch, things fall into place, and they continue the family tradition. Others need to "go to town and get a job." The land in this region of Colorado is becoming more valuable and practical for development than for growing hay, grazing cattle, housing ranching families, and employing ranch hands. As it does, ranching disappears. And as these family operations vanish, so too do the traditional methods of labor—branding with hot irons, working from horseback, and supplying water to acres of grass fields by digging and constantly modifying irrigation ditches with a shovel—along with other aspects of ranch life, such as wearing traditional clothing specific to a certain kind of work and a certain kind of history.

The project was not easy. Making these pictures proved to be a challenge, yet thankfully, it was one that pushed me to grow and improve as a photographer over the past ten years. That is always the goal in personal work, but sometimes the progress is hard won. When photographing ranchers, I found that despite my best efforts and intentions, it was difficult to plan the time and place to accomplish what I had hoped to do. I decided early on that the working title for this project would be "You Shoulda Been Here Yesterday," as I heard that remark so often upon my arrival at a ranch. Someone might say, "You shoulda been here yesterday. We had six bulls fightin' and bellerin' in that corral all morning." Or, on a predawn phone call I might hear, "We decided not to chase cows today, but you shoulda been here yesterday—we swam a few across the Colorado River." It was frustrating, but that is the nature of ranching, and that is the nature of photographing ranching. Also, in past projects, my subjects were always restricted to relatively fixed spaces, leaving me to watch and compose from an obvious source. But here, the focus, the interaction, the place to look—these could have been anywhere, and once found, they could move rapidly away or be over in a moment.

At one point, already six years into this project, I felt that, through no lack of effort, I wasn't doing my best work. I was frustrated by my results and felt I needed to rethink my approach, or my method, or the parameters of the project. Something. One day, while driving the long road between Burns and Yampa, I took a pen and drew the letter "T" on my wrist so that I would see it during the rest of the drive and for the rest of the day. It stood for two things. First, I was telling myself to go "toward" my subject. Toward a better picture. Toward what's difficult. It meant move your feet, move your butt, move your brain and make something happen. It didn't mean manipulate the situation; rather, it meant don't sit back and make the picture you are accustomed to making, the composition you know, or even the safe choice. In other words, "T" was also for "take a new kind of picture." I was having pep talks with myself, out loud, even while standing in a herd of cows in a snowstorm. I'm certain the cows thought I was crazy, as would have any human within earshot. I started moving physically closer to my subjects, rethinking perspective, perhaps even putting myself slightly more in the way than was customary for me. I started expanding the series to include important inanimate objects and even started shooting in severe sunlight rather than insisting on diffused light in a place that has over three hundred days of sunshine a year.

All the images in this book were shot on Kodak Tri-X film, either with a Pentax 67 or a Nikon F4, and when someone would see me loading my cameras, I was invariably asked, with near disbelief, why I use film. I have always believed that how you say something is as important as what you say. And if you feel that photography is a form of personal expression and a reflection of yourself—which I do—then everything you do in the making of a photograph matters. For me, that means tactile photography. It means holding, loading, rewinding, and stashing film away in a pocket. Maybe even dropping the film accidentally in the dirt and going back to look for it. It means processing film in liquid, hanging it in air, and printing the image with light on paper. It means using chemicals that still remind me of the first time I smelled them forty years ago. The prints dry overnight on a screen and are held up to light in the morning to judge their qualities. Sometimes I feel that my photographs have more in common with ceramics, or even mud pies, than with digital photographs. This isn't retro; this is who I am and who I've always been, and whether the viewer knows it or not, these photographs are as much a reflection of myself as they are a record of the last vestiges of an American tradition.

With *Mountain Ranch*, I've tried to make something rich and true in my own fashion. I've tried to make an artistic record of a disappearing culture, and I hope that I've been respectful in my treatment. I'm glad it took me a while to make these photographs, for it gave me an education, and I'm glad it took a while for me to be pleased and content with the images, as this gave me a chance to improve. I hope that the ranchers will see this work as something authentic, correct, and real, as I know this is important to them. When these people speak highly of one of their fellow ranchers, they use the expression "the real deal." It indicates someone who is of the tradition, who knows their stuff and lives it. The people in this book are just that, the real deal.

ACKNOWLEDGMENTS

In my lifetime I have been the recipient of an extraordinary amount of kindness, and nowhere has this fact been more evident than in the mountains of Colorado while making these pictures. There are projects that can be executed by a photographer in a solitary fashion, and there are those that would be quite impossible to carry out without the kind and continued assistance of others. Without question, this one falls firmly into the "kind and continued assistance" category. There are three entities without which this book quite literally could never have been made, and they deserve more thanks than I can give here.

Not only did the Kapsner family of Matt, Hope, Bryce, and Quin make the L Quarter Circle Ranch on Sweetwater Creek my literal second home during this ten-year undertaking, but the beginnings of the series were, indeed, Matt's idea. For a decade I have been the beneficiary of their warmth and welcome and have become a proud member of their family. "Kindness" and "generosity" aren't full enough words to describe their friendship, but those are the words I have, along with "thank you."

Around the time I began making these photographs, I met Audrey Jonckheer, of Kodak, who encouraged me to apply for project support from her company. At her prompting, I did so, and I have since been the fortunate recipient not only of the beloved Tri-X film that is the guts of these images but also of her unflagging friendship and continued belief in my work. For these things I will be forever grateful.

After I made the initial images of this series, of ranchers Steve Hammer and Todd Schlegel, and brought some of the results to a subsequent branding, Steve's wife, Melinda Hammer, seemed to see the potential of the project. She began to introduce me around the region, to such a degree that I made the acquaintance of nearly everyone who appears in this book through an introduction by Melinda. Without her I would not have known the assorted Schlegels, the Gates family, the Kujalas, the Albertsons, the Wahlerts, the Scotts, the Strubis, the Horns, the Georges, or the Rossis . . . and then where would I be? The warm welcomes I received throughout

Garfield, Eagle, and Routt Counties were largely due to Melinda's kindness. My sincere thanks goes out to Melinda, and to Steve Hammer, with whom I rode, walked, and drove on many days and for many hours during these ten years. The Hammer family—Steve and Melinda and their children, Taylor, Marley, and Miranda—exemplify the most important and still somehow unexpected benefit of this type of project: the friendships that last well beyond the making of the project itself.

This book seems to be full of vast, empty spaces and solitary figures, but in actuality it is quite full of wonderful people who have become my friends. In addition to those I've already named, the following people either appear on these pages, facilitated the making of these pictures, or were simply and importantly a pleasure to be around while I figured out this series. They all have my undying thanks for their patience and generosity in allowing me to observe their lives, ride their horses, borrow their four wheelers, and eat and drink with them in their homes: Dillon and Samantha Kujala (Sam called me one morning to tell me that one of my cameras was hanging on a fencepost at their ranch) and their children, Cheyenne and Levi; Tel and Ashlie Gates and their boys, Tilden and Toren; Rod and Jackie Schlegel (Rod once found my monopod on the ground in a remote meadow two years after it had fallen off my saddle, and Jackie once laughingly said to me, "You and your dead animals . . ." and pointed me toward the bull skeleton under a tree); Ryder and Jenna Becker (Ryder appears on the cover of this book and throughout); Vern Albertson (who inspired the back section of this book with his stories of growing up on a ranch in Burns, Colorado); Jesse Albertson; Nick and Pat Strubi (Nick once told me it was a good thing I was there that day, since otherwise, that fencepost I was leaning on would probably have fallen right over); Stace Strubi; Nicki and Steve Flick; Madison George (who appears in this book's photographs first as a twelve-year-old and then again at age twenty-two); the late Rose Horn (whose long white braid and barn jacket seem such perfect icons for this collection); Dale and Rena Horn; Nathan Horn; Adam Horn; Chelsea Horn; Gary Horn; the late Bud Gates and his wife, Margie Gates; Kip and Leslie Gates; Keith and Kendra Scott; Kurtis Scott; Kensie Scott; Michael Rossi; Tommy Rossi; Aura Schlegel; Jerad Schlegel; Joel Schlegel; Bobby George; Denise Lombardi; Morgan George; Clayton "Stretch" Stallions; "Cowboy Dave" Simmons; Kevin and Jelaine Wahlert; Hunter Ferguson; Nate and Kim Adam; the late Jay Adam; Teresa Adam; Colton Martindale; Sam Boles; Justin and Amy Marquardt and their girls, Clover and Violet; Virginia Rossi; Belinda Rossi; Randy and Sherri Schlegel; Jacey Schlegel; Jim and Jan Rossi; Dean and Susan Rossi; Orlando Llacua; Whit and Tiffany Gates; Myles Roberts; Topher Dalrymple; Gary Hintz; Dick Love; Bill Schlegel; Frank Stetson; Bud Jacox; Ginny Glenn; Lindy Brackett; "Punch" George; Rita Nelson; Ben and Mildred Wurtsmith; Willie Graham; Maynard Smith; Steve Conlin; Debbie Stevens; Curtis Capoun; Trevor Schlegel; Tsering Norbu; Tashi Langthe; Tharchen Norbu; Sylvia Stocker; Adrienne Brink; Mary Stephens; Ern and Liz Mooney; and Sumner Schlegel and Jim Brink.

Thank you to Gretel Ehrlich, for her perfect foreword to this book. To Susan Burnstine, for continued feedback and encouragement. To Melanie McWhorter, for her invaluable consultation. To Johnny Cataneo, Sally Mars and Jim Arndt, who all took several thorough trips through this collection over the years, at my request, in order to give their opinions. To Maria Ferrari and Alberto Fregenal, who were generous with their time and kind with their input and who formed a small international design and social cadre around this project. To the editorial team at the University of Texas Press, including David Hamrick, who had enough confidence in these pictures

to sign them up as a book, Casey Kittrell, Angelica Lopez-Torres, Bailey Morrison, and Nancy Bryan. To Jean-Luc Autin and Anne-Laure Autin, for helping me to realize the best reason for projects like this. And heartfelt thanks must also go to the galleries that have represented me over the years for their belief in my work, especially those that have represented and shown this series over the past ten years: Verve Gallery of Photography, in Santa Fe; Corden-Potts, of San Francisco; and ClampArt, of New York City.

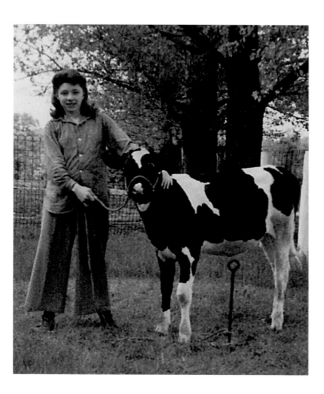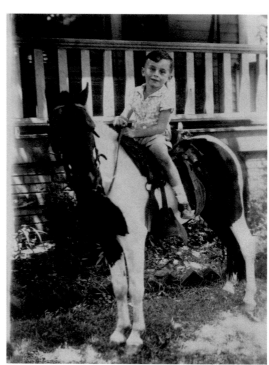

This book is dedicated to the memory of my wonderful, extraordinary parents,

Carmen Leone Seils Crouser,
Wisconsin farm girl and artist,

and

Richard Louis Crouser,
city boy and writer from Ohio
who did all his horseback riding at birthday parties